PIXEL
SURGEONS

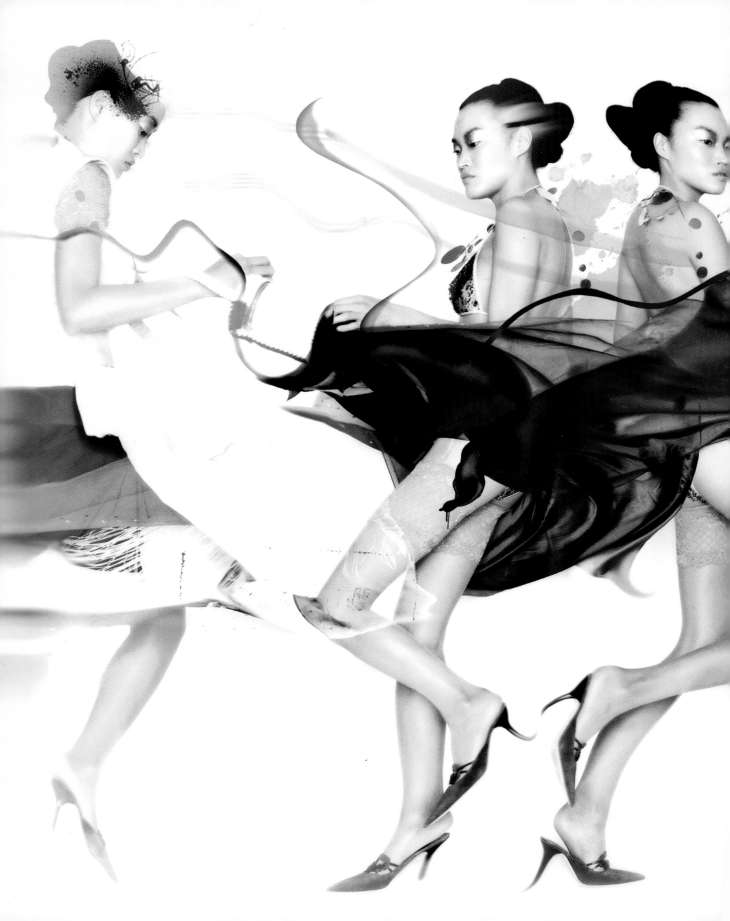

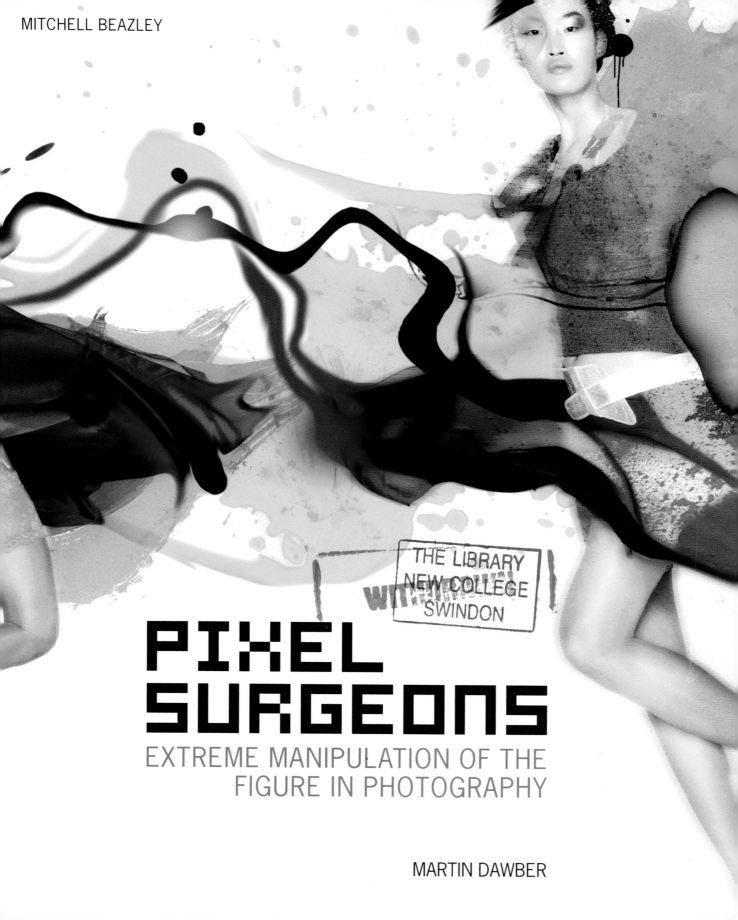

MITCHELL BEAZLEY

PIXEL SURGEONS

EXTREME MANIPULATION OF THE FIGURE IN PHOTOGRAPHY

MARTIN DAWBER

This book is for my mum, the original impetuous happy-snapper.
"Vision is the art of seeing what is invisible to others."
JONATHAN SWIFT (1667–1745)

Pixel Surgeons
by Martin Dawber

2006000909

First published in Great Britain in 2005 by Mitchell Beazley,
an imprint of Octopus Publishing Group Ltd
2–4 Heron Quays, London E14 4JP

Copyright © Octopus Publishing Group Ltd 2005

ISBN 1 84533 157 5
A CIP catalogue copy of this book is available
from the British Library

Set in News Gothic and Samson
Colour reproduction by Bright Arts, HK
Printed and bound in China by Toppan Printing Co. (HK) Ltd

Commissioning Editor Hannah Barnes-Murphy
Executive Art Editor Sarah Rock
Project Editor Emily Asquith
Copy Editor Kirsty Seymour-Ure
Design Peter Gerrish
Production Seyhan Esen

Half title page Christos Magganas, *Self Portrait* 2000
Title page Sarah Howell, *Colour Me* 2004
This page Colin Thomas, *Zip!* 1998

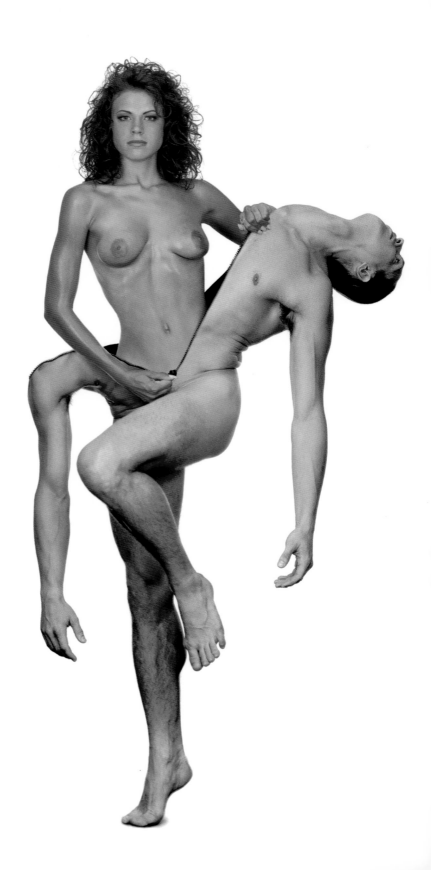

CONTENTS

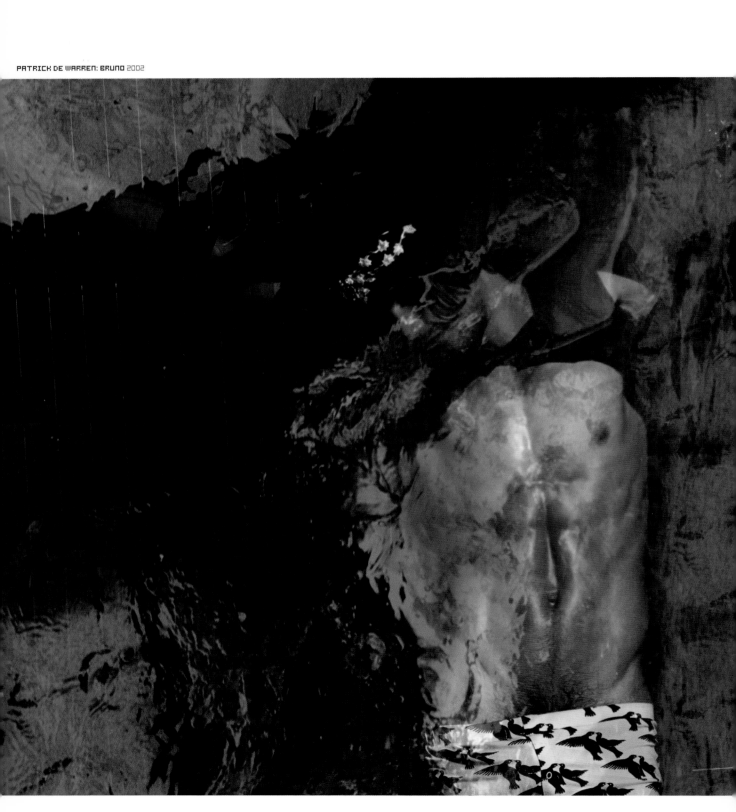

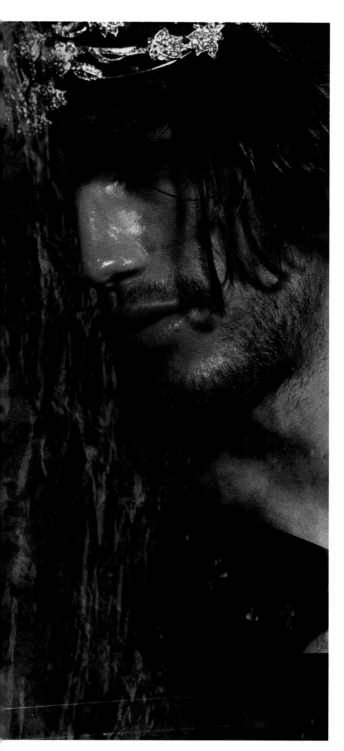

FOREWORD

PATRICK DE WARREN

In fashion photography, there has always been a blurred line between reality and fantasy. The challenge has been to excite, entice, and seduce the public. Yet the world has become numb and spoiled, bombarded as it is with an onslaught of images. The call for greater stimulation has forced photographers into ever more daring approaches, and the digital realm has created a new arena in which to experiment with fashion photography.

Manipulation – of environment, clothes, models, lighting – has always been an essential factor in provoking a strong response from photography. The difference today is that the manipulation is visible and bold, where in the past it was more subtle. Even now, the latest trend is to go back to a behind-the-scenes approach, using the slightest manipulations of form that pull us in without our being able to say why.

The digital process in photography is reflective of the open approach of the modern age. The freedom to bring an inner vision to life without having to manipulate a live situation ironically gives a more natural fluidity, a more seamless transition from initial inspiration to final product. It allows a process that is more art than machine. Photographers are no longer restricted to the limitations of budget, weather, and the normal confines of the world. The boundaries are being pushed to breaking-point and what emerges is more reflective of the artist's soul.

Fashion photography never stops surprising us, making us dream, possessing us in some way or another. It digs deep down, using any means to seduce us. The new image-makers create worlds evolved from the fruits of their imagination. Fashion photography needs fantasy because fashion is a step past reality – without fantasy, fashion wouldn't be able to renew itself. Ironically, fashion becomes more sincere by crossing the fine line between fashion and art, by referring back to a more noble age and looking forward to a time when photography will truly express fashion's ideals.

INTRODUCTION

"I am a camera with its shutter open..."
Christopher Isherwood (1904–1986) [1]

When has fashion photography ever really only been about photographing clothes? From the founding fathers of the form up to the extrovert shutterbugs of today, these photographic images tell the viewer as much – if not more – about the person behind the camera as about the designer of the clothes.

George Hoyningen-Huene framing his natural body shapes; the wistful, romantic gestures of Cecil Beaton; Bruce Weber's silver-print, hard-bodied Abercrombie boys; the "two fingers up" irreverence of Terry Richardson – all are explicit characteristics within each of their celebrated cells that, consciously or otherwise, inevitably trap the photographer between the lens and their models. Richard Avedon asserted, "My portraits are more about me than they are about the people I photograph." Sometimes the garments don't even register at all – think Sarah Moon's Yamamoto editorials that lyrically disguised the fashion via her blurred, camera-shake signature style. David LaChapelle's heavily manicured compilations are now so full of visual information that the fashion reference becomes totally camouflaged under his formidable artistic licence.

Nearly all of the images that still resonate after the magazine pages have been scanned and discarded are confirmed testaments of style over content – inevitably, most uphold the doctrine of "art for art's sake" under the *Ars Gratia Artis* motto of Metro-Goldwyn-Mayer rather than pursuing the deeper reasoning of Baudelaire, Coleridge, or Wilde.

Today's photographic images satiate our visual appetites with risk-taking narratives that push back the boundaries of the traditional, flouting conventional taste with ever more risqué and iconic imagery that is increasingly conceptual and perverse. Steven Klein's intense 62-page exposé of Brad Pitt, which dominated the pages of *L'Uomo Vogue* (May/June 2004) and built on his revelatory 1999 shoot for *W* (again with Pitt – then styled as a victim of male rape), testifies to the advances that have been made under the banner of mainstream "fashion photography" – this intimate, mute exchange didn't even carry the *de rigueur* label credits for the designer clothes. Poetic and private, there can now be no looking back for today's fashion photography. The gratuitously glam look that pigeon-holed the majority of fashion photography in the previous century has definitely been elbowed out.

New York's Museum of Modern Art 2004 exhibition *Fashioning Fiction in Photography since 1990* put this new face of fashion photography to the test by examining what happened when serious photographers, including Nan Goldin, Juergen Teller, Cindy Sherman, and Philip-Lorca diCorcia, were briefed to shoot fashion editorials. The gloves were fully off in case there was even the slightest contention with the art world's notorious allergy to fashion in any guise, let alone photography.

"The artist's ability to effortlessly reposition and combine images, filters and colours with the friction-less and gravity-free memory space of the computer, endows them an image-making freedom never before imagined."
George Fitz [2]

What was once the reserve of the gallery has been challenged, as the fusion between fine art and editorial photography has morphed into a conceptual mannerism that has blurred the divide even more.

Fashion photography has always offered up its own unique magic mirror to the viewer. The images that it flaunts inhabit a world of make-believe. Even the stereotypical head-and-shoulders shoot for any Condé Nast cover will have been meticulously scrutinized and airbrushed to eliminate any blemishes that might persuade us that the model is actually human. Such pretence has always been taken as read in fashion photography: artifice is the norm, whether it be the well-lit glamour shot, the girl pouting over the car bonnet, or the overdressed model posed in a New York ghetto. There seems to be an accepted ambiguity of purpose of what, in effect, is never just a simple record of a model and garment, but the opportunity for each artist to indulge himself or herself in creative self-expression.

Anna Wintour (Editor, American *Vogue*) always claimed that "photographers – if they are any good – want to create Art." [3] Stemming from their involvement with alternative artists and designers in Paris in the 1920s, early instigators of fashion photography, Man Ray and Horst P. Horst, employed surreal imagery in their own ventures into the vernacular. During the golden age, their photographic contemporaries left the studios and salon catwalks and exploited the more risky world around them in attempts to invest their shoots with fantastical style and panache. Erwin Blumenfeld's black-and-white image of Lisa Fonssagrives swinging out from the girders of the Eiffel Tower – fanning out the plaid dress by Lucian Lelong (French *Vogue*, May 1939) – typifies the bizarre styling that whetted the appetite for outdoor and location fashion pictures. Richard Avedon's take on "Beauty and the Beast" for Dior in the 1950s with *Dovima with Elephants* is all the more shocking when you realize that the stomping elephants are really positioned (albeit chained) just behind the model.

Colour, first fully exploited in fashion photography by Norman Parkinson in the 1940s, increasingly allowed later photographers and stylists to exaggerate its potential when "painting" their illusory worlds. The gorgeously staged tableaux of Pierre et Gilles, which established a kitsch universe during the 1970s and '80s, and the flights of techo-fantasy that Jean-Baptiste Mondino continues to expose manipulate colour to promote illusion. Stylists have also taken more courageous steps as the times demand.

Vincent Peters photographing a semi-naked David Beckham for *The Face* in July 2001, dripping in blood (actually soya sauce), seemed not out of place against the ravages of a war-torn world.

In the digital age, the limits that the fashion photographer can aspire to seem endless. Supersnappers, such as Nick Knight, Solve Sundsbo, and Stephane Sednaoui have embraced this creative technology and fabricated totally illusionary scenarios in response to fashion editorials; offbeat images that could not have existed without digital technology. Publicizing the image within today's web-based culture, now taken a step further by mobile-phone camera technology, gives a techno face-lift to the reportage that stimulated the pioneers of the 1920s and '30s.

In most of these digital "illusions", the clothes and the models seem to hide beneath the vision of the photographer and stylist. In an age focused on individualism and self-design, these photographic metaphors seem to communicate in another language from that of the gelatine silver prints of only half a century earlier. A new medium for self-expression has arrived:

"With the total revolution going on in communications, there's been a big step from pure photography into what are the beginnings of a new medium. Technology has fundamentally changed my relationship with the image. I don't feel it's a correct description to say 'I'm a photographer'."
Nick Knight [4]

The 30 artists presented in *Pixel Surgeons* are proof of this continuing trend, bearing out the idea that digital photography is a vital ingredient in today's visual culture and one that is forever changing the way we view fashion.

1 Christopher Isherwood, *Goodbye to Berlin*, "Berlin Diary", Autumn 1930, London, Random House, 1939
2 Quoted in Michael Rush, *New Media in Late Twentieth Century Art*, London, Thames & Hudson, 1999
3 From the Preface to *The Idealizing Vision*, New York, Aperture, 1991
4 Interview with Gavin Stoker in *Total Digital Photography*, Issue 12, August 2003

TIM HANSEN: CUTLERY 2004

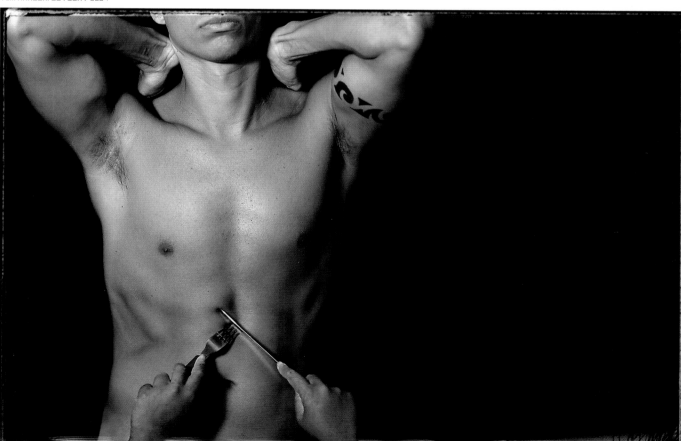

Expanding on the sophisticated elegance and simple poise that was the preserve of fellow countryman George Hoyningen-Huene throughout the 1930s and '40s in the pages of *Vogue* and *Harper's Bazaar*, Aleksey & Marina use 21st-century digital fakery to compose images of serene sumptuousness. Their fabricated imagery skilfully imitates the genuflecting camera of Hollywood's golden age when image reigned supreme and photography was no longer to be relied upon as a truthful witness. They manipulate light and shade to flatter and enhance their stylized figures, which surface like the slender stretched subjects of a Modigliani painting, and are portrayed with sensuous and sinuous lines. Stripping away the superfluous and ornamental, Aleksey & Marina trap their models like digital sculptures crafted with a gracious and seamless style. Their results are as single-minded and charismatic as the dramatic digital imaging found in Nick Knight's radical Yohji Yamamoto campaigns of the late 1980s.

ALEKSEY & MARINA

RUSSIAN

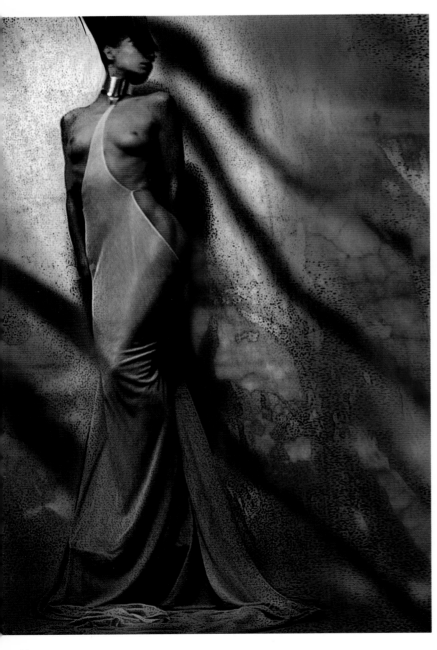

We – Aleksey Kozlov and Marina Khlebnikova – are a creative duo from St Petersburg, combining in our work photography, fashion, and painting. Aleksey has been a photographer since 1985, and Marina a fashion designer since 1990. We have been working together since 1994, having met on a shoot.

Our love for unconventional effects in photography led us to experiment with negative film. The results so inspired us that we left commercial photography and engaged in our own unique project based on photographing models. In our work we try to express our philosophy and our views on beauty and (at times, ironically) on erotica.

The process of creating our photos is labour-consuming and demands some time. But it all begins with an idea or theme. It can be something abstract, it can be a simple fetish, anything that draws our attention.

We make draught sketches and then shooting will be carried out by Aleksey using a Nikon FA camera and 35mm film. The most successful shots will be subjected to special processing by Marina. From control prints, we then select the most outstanding.

Our favourite artists include: (Aleksey) Russian 19th–20th-century classical-school painters, Dalí, Helmut Newton, Jan Saudek, Richard Avedon, and fashion designer Thierry Mugler; (Marina) French Impressionists, Art Nouveau, ancient Egyptian art, Helmut Newton, and fashion designer Philip Treacy.

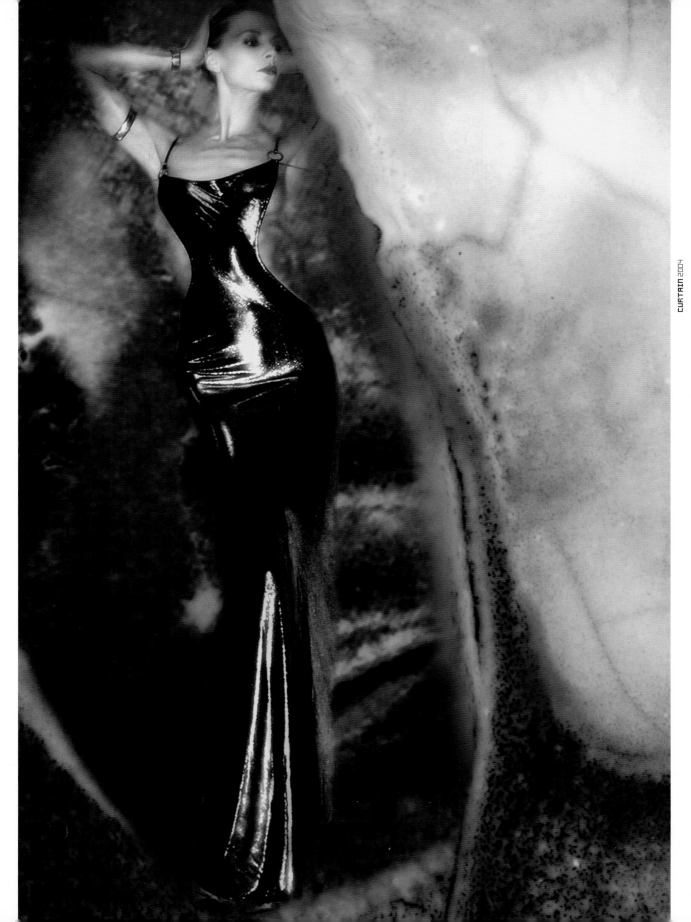

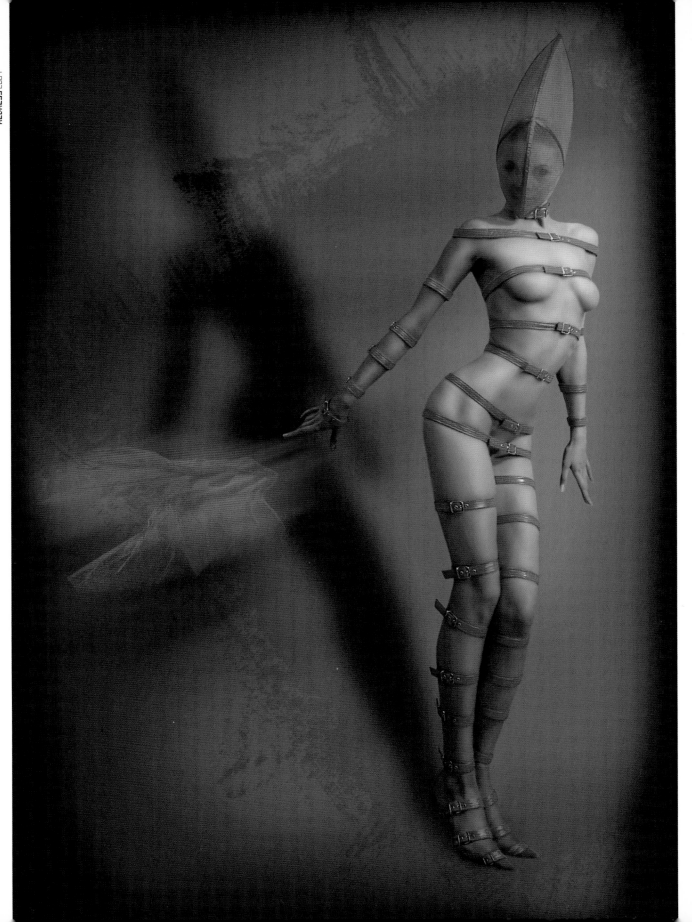

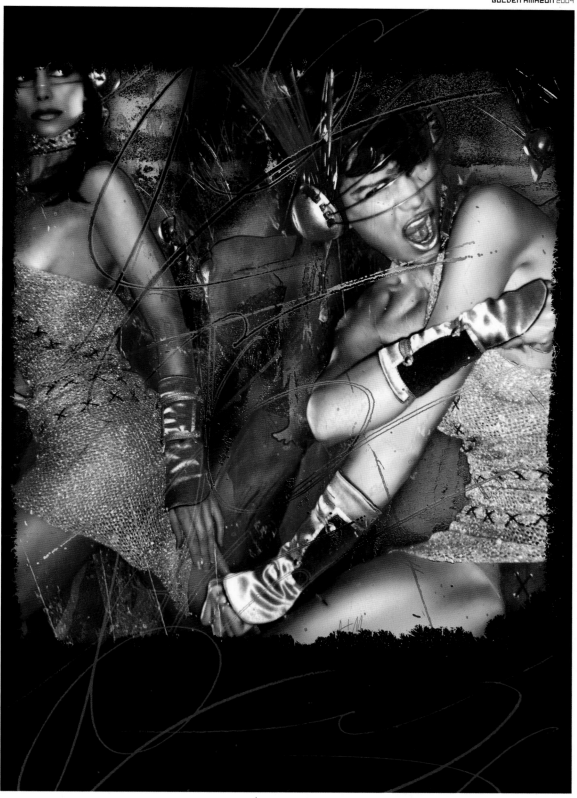

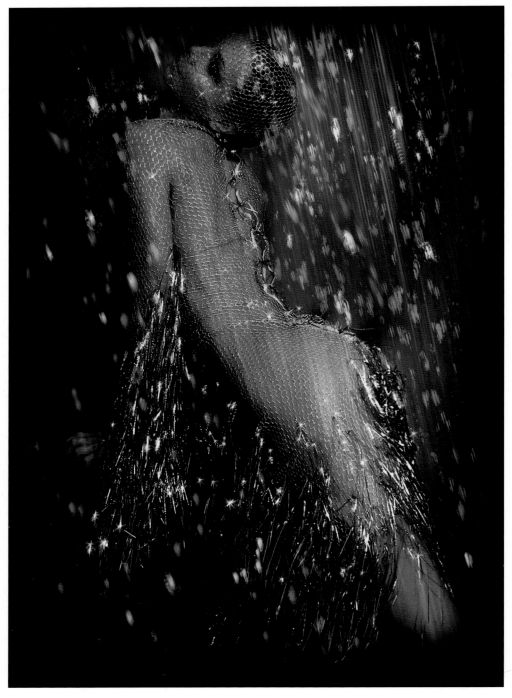

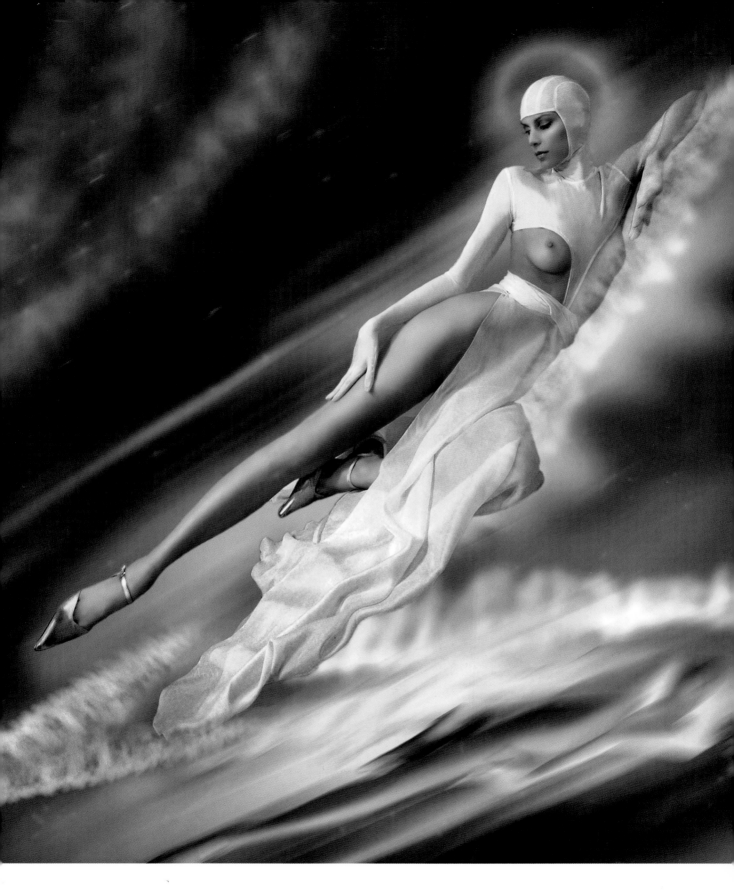

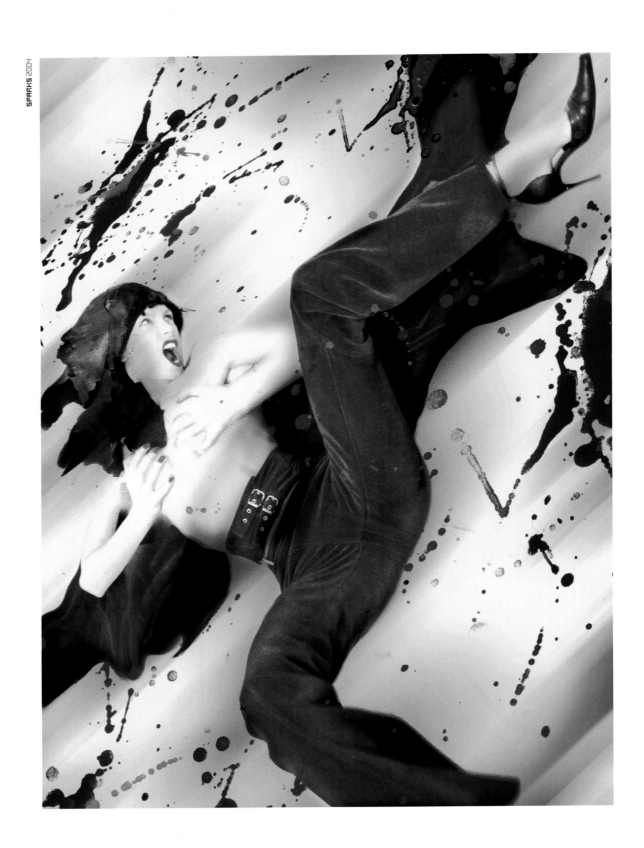

A + M

Corrie Ancone concocts her evocative fabricated images using an individualistic and multilayered illusionary technique. She submits to the viewer an expressionistic universe of make-believe, revealing allegorical characters that seem to inhabit a timeless stage. The heavy superimposed shadows slice and obscure her models like ritualistic masks of identity and the viewer is deliberately made to feel ever more curious about her characters. At times the models metamorphose into the rich undergrowth of their vegetative environment as if fused within one of Fay Godwin's close-up floral colour photographs of the 1990s. Corrie's creatures captivate by holding their secrets in reserve, as their iconic beauty teasingly suggests that they might equally proposition or threaten the viewer. They resemble digital revamps of the experimental colour photography produced in the 1930s by Madame Yevonde, especially the legendary "Goddesses" series in which she portrayed London's society hostesses as mythological characters.

CORRIE ANCONE

AUSTRALIAN

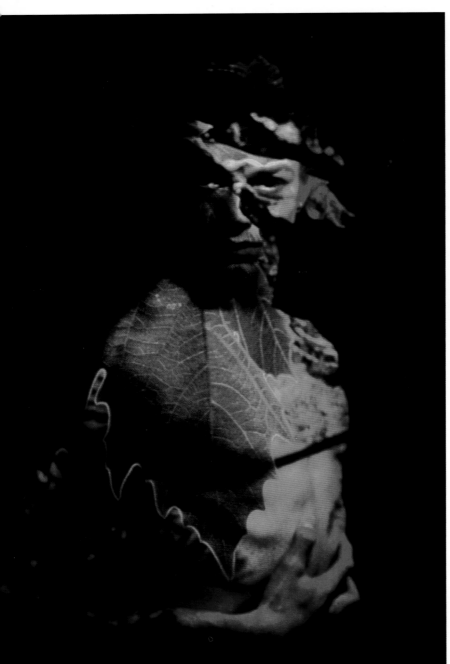

ARIES 1994

FEVERED DREAM 1997

Born in The Netherlands, I have since migrated to Australia. I studied arts-related subjects part time, then undertook a Diploma of Fine Arts in Adelaide at the South Australia School of Arts.

When I started out as an artist my key medium was painting, but falling in love with photography allowed me the spontaneity I was craving. I set up a dark-room with friends as I had developed a big interest in this medium. For the next two-and-a-half years I practised and experimented and read and read. Then I landed, almost by accident, in the film industry, as a freelance stills photographer.

I don't care for the certainty of what's in front of my lens, but the creativity, the fantasy, and the invention, that can gush from a thought. Between the certain and the uncertain there's a possible space, as in dreams and fables. My photography is similar to, and reflects, the techniques of the early European Dadaists, by whom I am influenced, along with Impressionism and Baroque. Drawing inspiration from mythology and nature, my creativity stems from my lust for finding and exploring sympathies between the human body and natural textures.

Using the technique of sandwiching stills, colours and images collide creating new visual and emotional images which are often painterly and surreal. My abstract landscapes, portraits and a pantheon of contemporary mythological beings, all are charged with sensuality and tinged with eroticism.

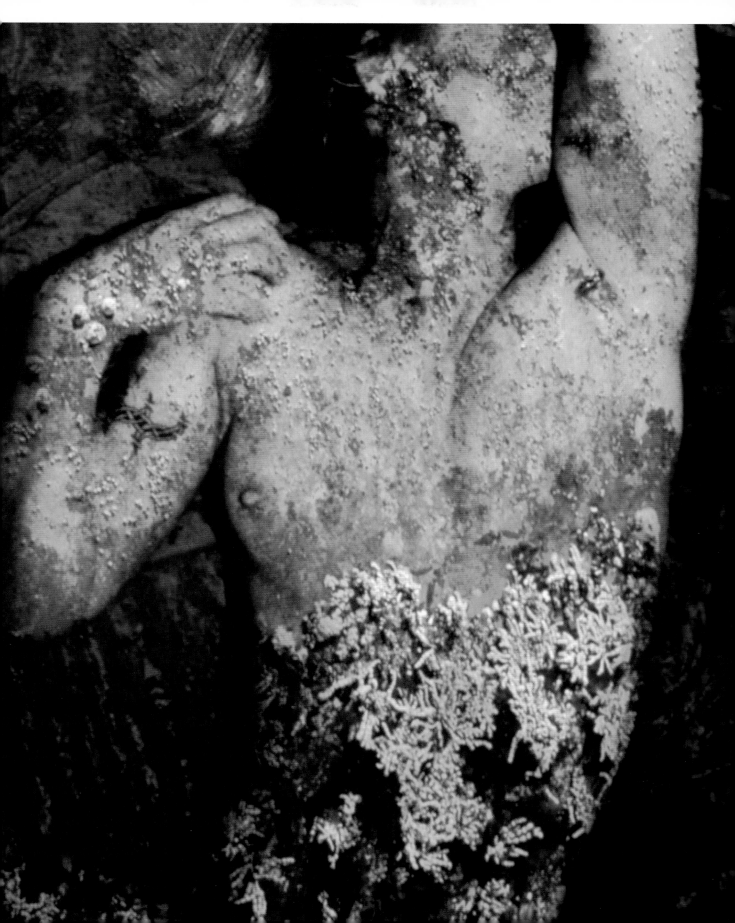

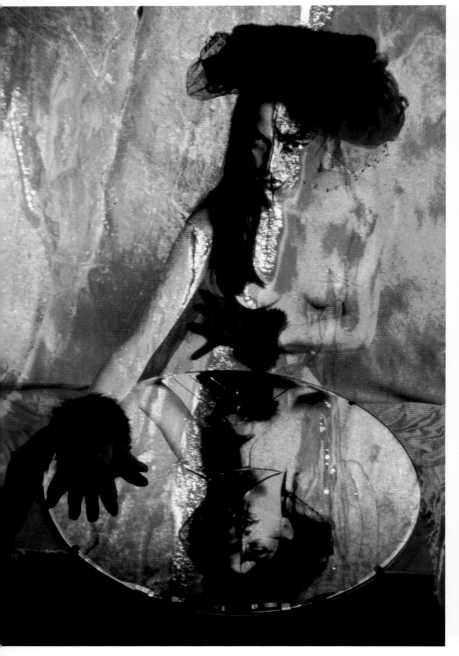

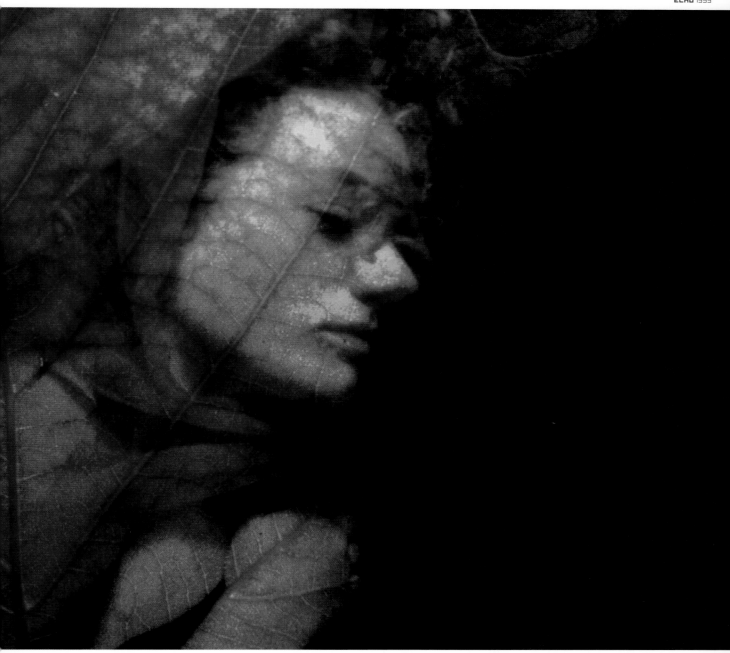

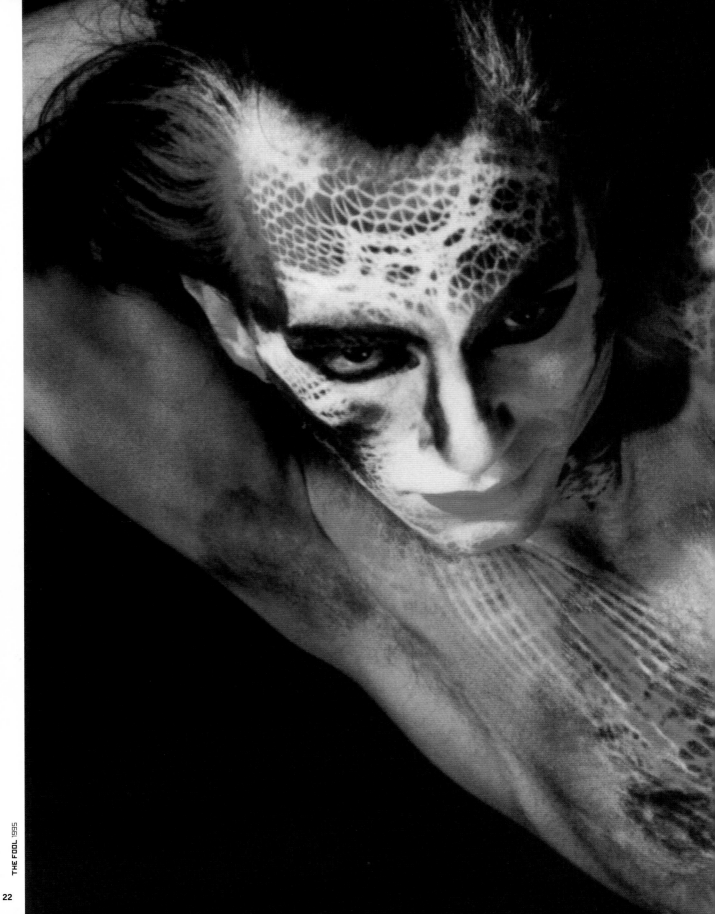

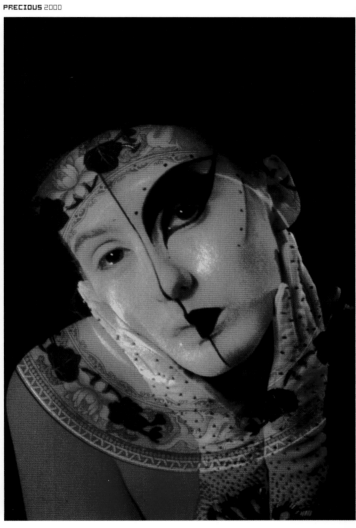

Fashion in the 20th century was progressively perceived through make-believe photographic styling and expression. The public was directed to view the work of contemporary designers reflected through the eye of the camera. Marcelo Benfield dusts down this weighty history by captivating the viewer with his sensitive synthetic image manipulation. His departure from realism is via a superb treatment of tone and colour, together with expressive compositional values. Reality becomes mirrored by photographic fiction as images employ visual references invoking their rich photographic heritage. Combining the technical perfection of Herb Ritts and the sleight of hand of Horst P. Horst, his fashion studies pry open preconceived notions and re-evaluate traditional concepts. At a time when most photographs are plagued with meaning, it is refreshing to take visual pleasure in these uncomplicated images – although simple photography, as here, is often a contradiction in terms. These images are as complex in their manufacture as the best in minimalist art.

MARCELO BENFIELD

ANGLO-ARGENTINIAN

SURREAL MOSQUE 2002

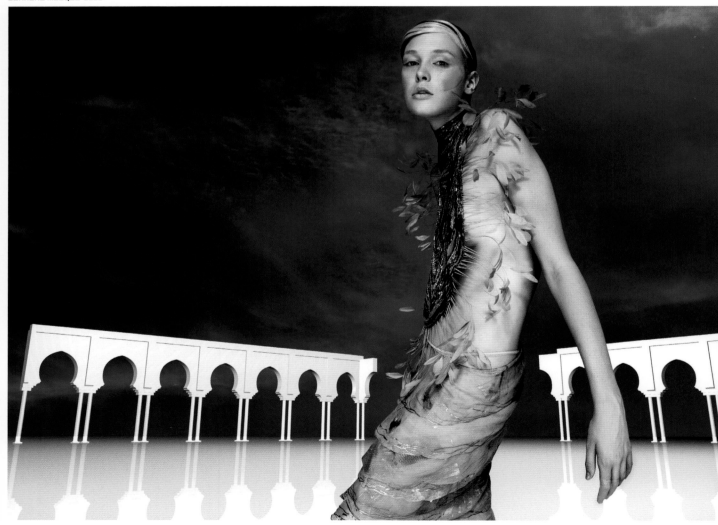

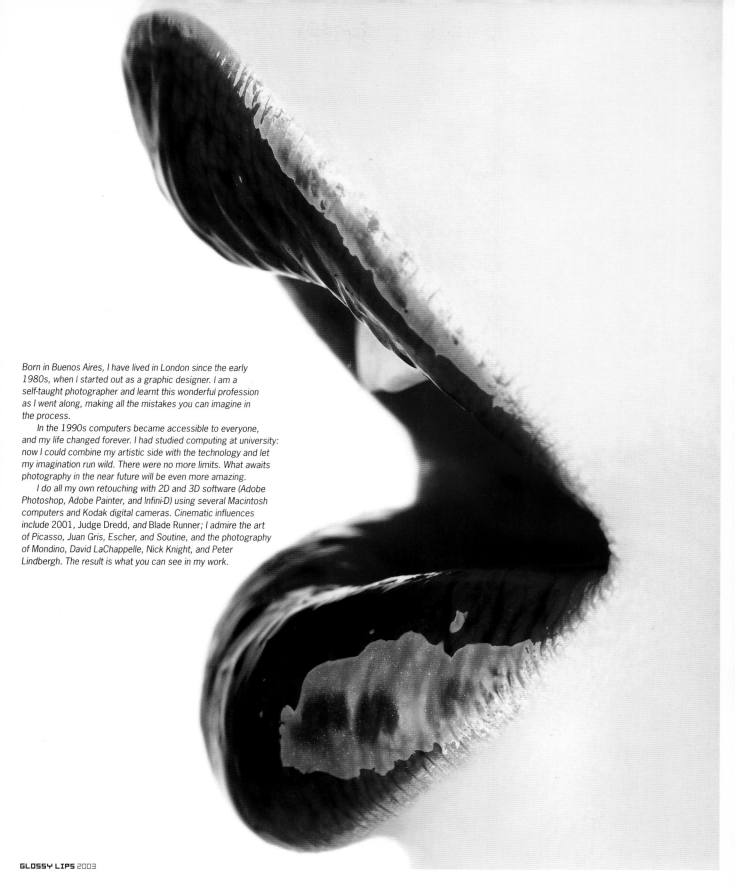

Born in Buenos Aires, I have lived in London since the early 1980s, when I started out as a graphic designer. I am a self-taught photographer and learnt this wonderful profession as I went along, making all the mistakes you can imagine in the process.

In the 1990s computers became accessible to everyone, and my life changed forever. I had studied computing at university: now I could combine my artistic side with the technology and let my imagination run wild. There were no more limits. What awaits photography in the near future will be even more amazing.

I do all my own retouching with 2D and 3D software (Adobe Photoshop, Adobe Painter, and Infini-D) using several Macintosh computers and Kodak digital cameras. Cinematic influences include 2001, Judge Dredd, and Blade Runner; I admire the art of Picasso, Juan Gris, Escher, and Soutine, and the photography of Mondino, David LaChappelle, Nick Knight, and Peter Lindbergh. The result is what you can see in my work.

GLOSSY LIPS 2003

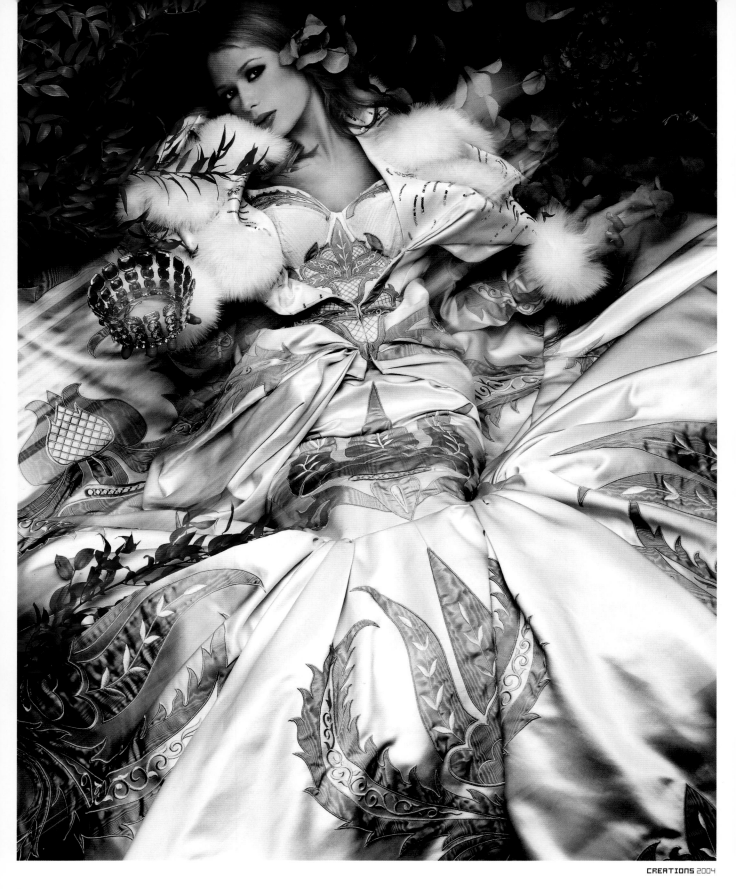

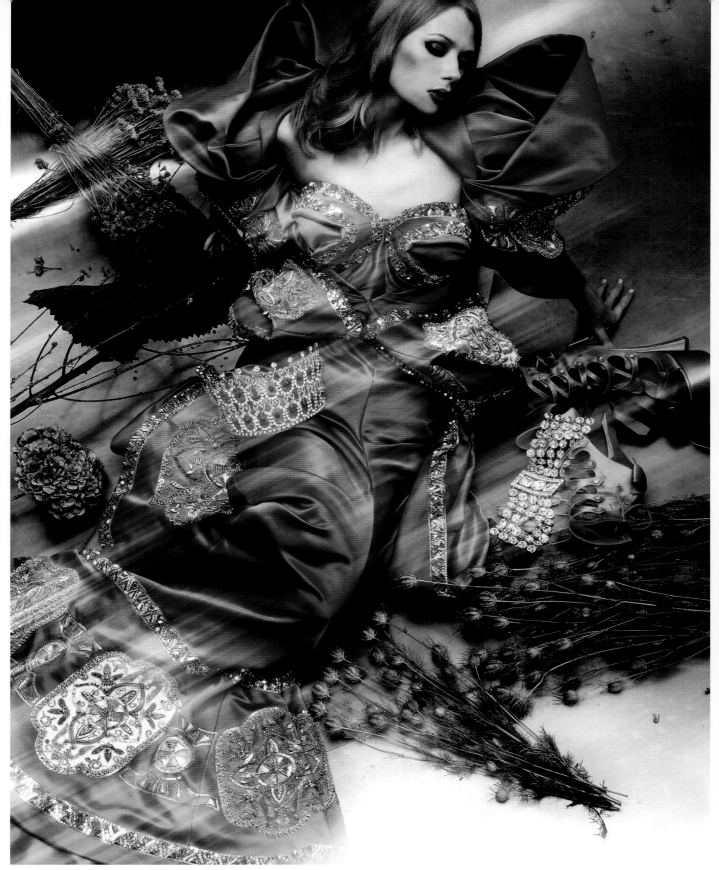

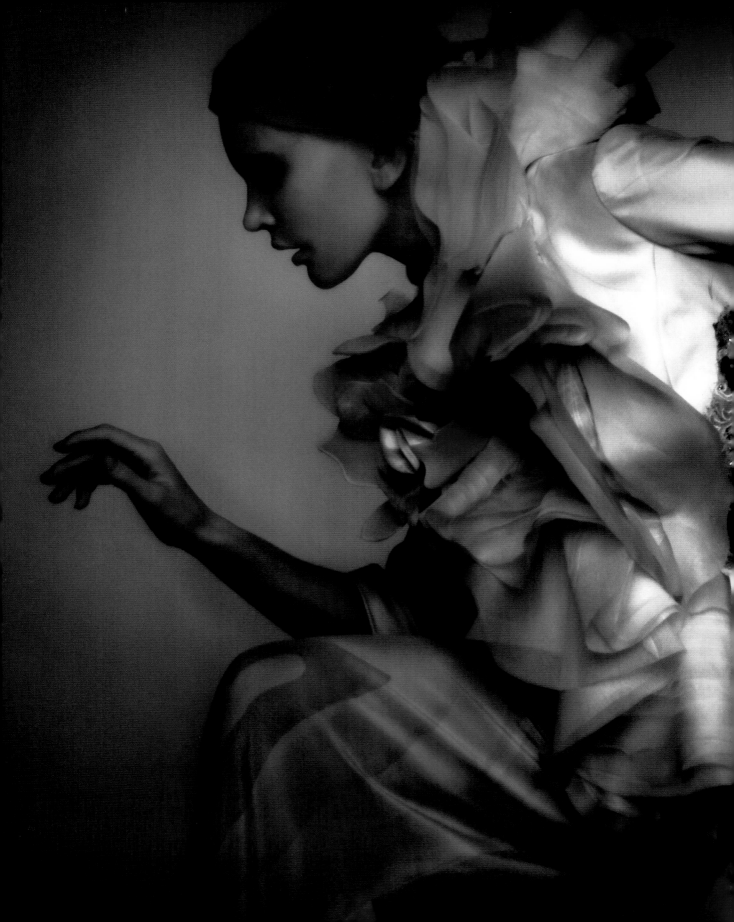

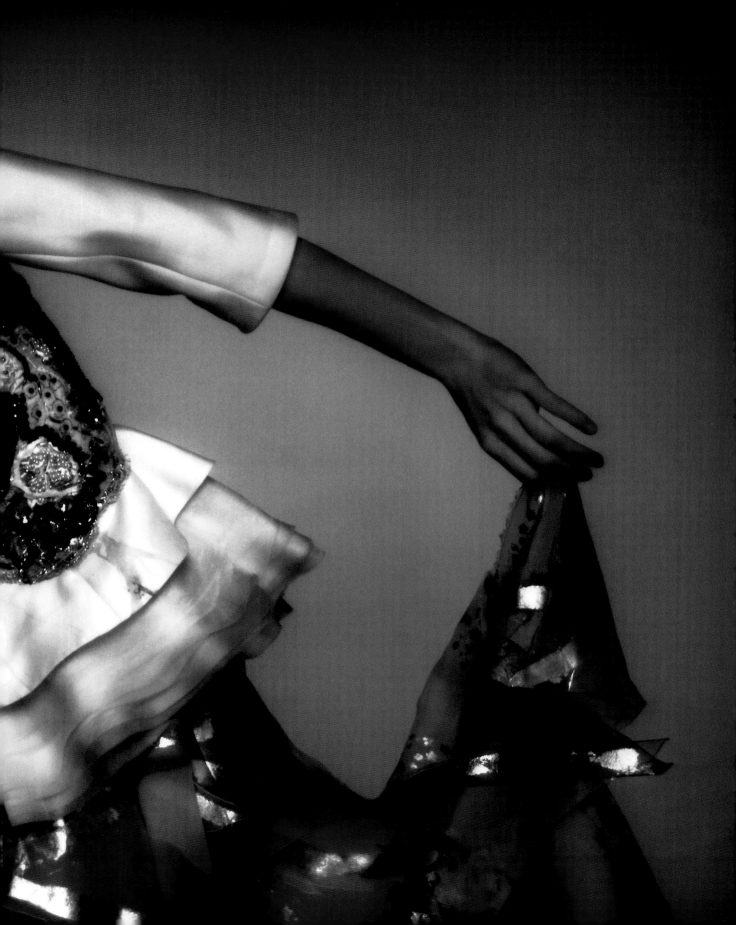

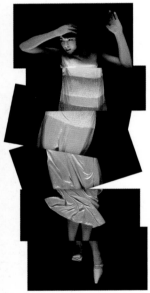

CONTACT: 2000

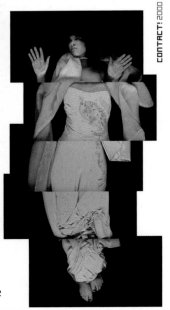

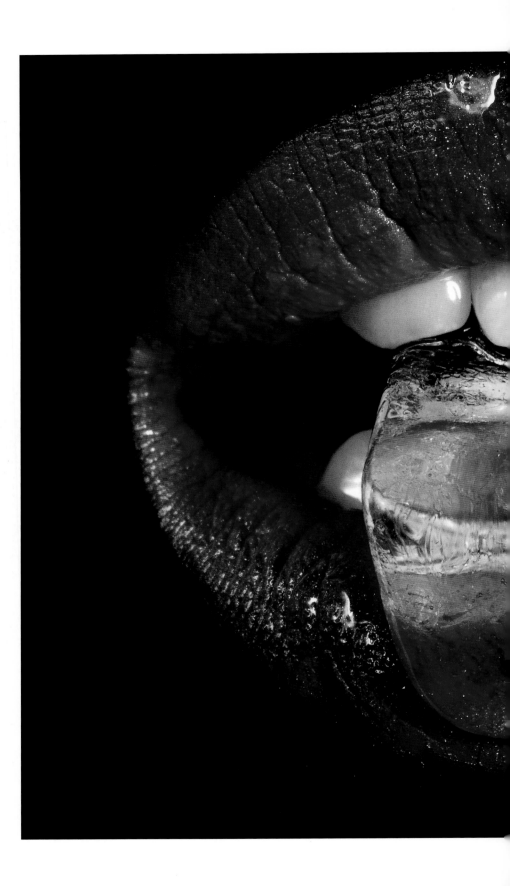

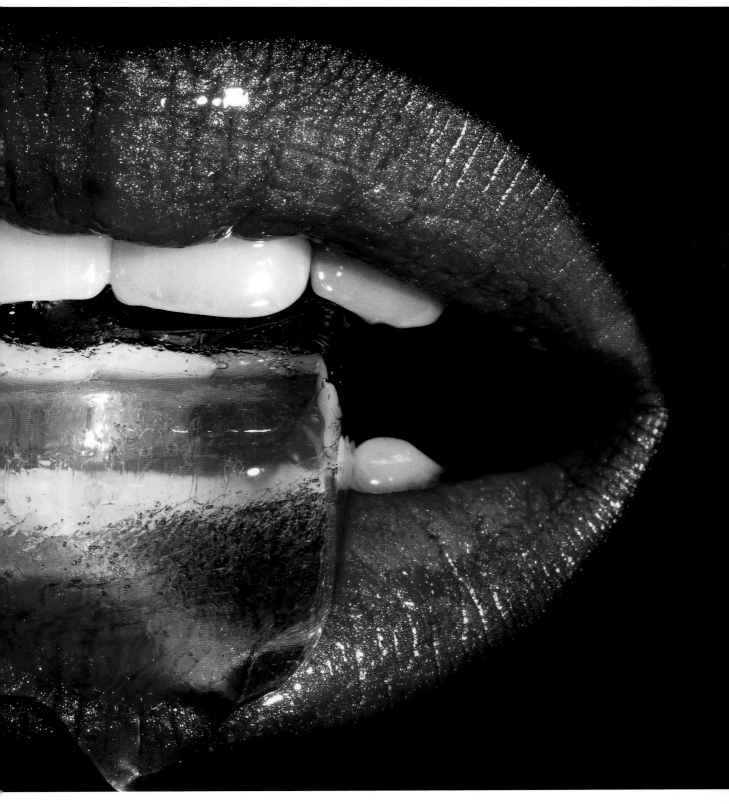

Steven Bingham's advocacy of the surreal makes the impossible seem real in his disorienting and haunting digital manipulations. Fantasy and reality merge in these photographs to form a single impression of the subconscious. These are hallucinatory dreams that challenge perceptions and require the viewer to stretch his or her mind and examine the visual certainty of the subject-matter. Everyday objects and settings are made strange by means of unusual or unexpected combinations and juxtapositions, operating in a similar manner to the dreamlike paintings of Salvador Dalí and René Magritte. These images also conjure up the surreal photographs that Angus McBean fabricated for *The Sketch* in the 1930s, and continued to elaborate in his famous London theatreland portraiture. Steven is sufficiently skilled in digital technique to run wild with the freedom of his imagination. The results spark off images of perplexing beauty and originality that pose more questions than they supply answers.

STEVEN BINGHAM

AMERICAN

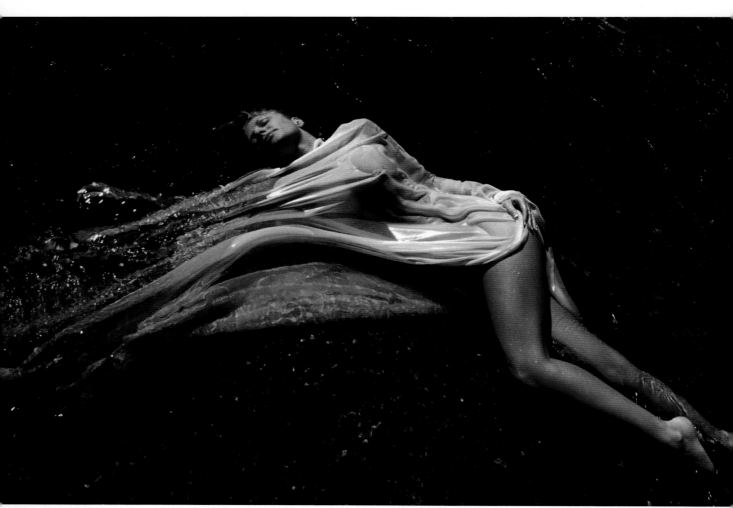

RIVER GODDESS 2003

Photography has been a marvellous trip for me. I can remember developing my first roll of film at the age of 11, in my mother's kitchen. The experience bordered on the mystical: I was hooked.

I went on to become a serious photographer. Not only did I shoot for a living, but I taught photography in college. Then a strange thing happened. After I retired I realised that, with the aid of a computer, I could now do anything that I could imagine. What a huge discovery!

As for my current photography, which I choose to call art, there seems to be very little that is not possible. The learning curve seems endless, but so do the rewards. I believe that art should be fun. It should be about making discoveries. Good photographs should have both motion and emotion. Motion of the eye is created by dynamic composition. The eye needs to want to wander over the picture, to make small discoveries. At the same time the mind must also have motion. To wonder. To approve, or disapprove. To be puzzled.

As a photographer and artist my priority is to please myself. I continue to make discoveries, have fun, and share with all who might be interested – for whatever reason. And so, my art is my joy.

VULTURE MINE REVISITED 2004

LADY IN BLUE 2004

ASPEN GROVE 2003

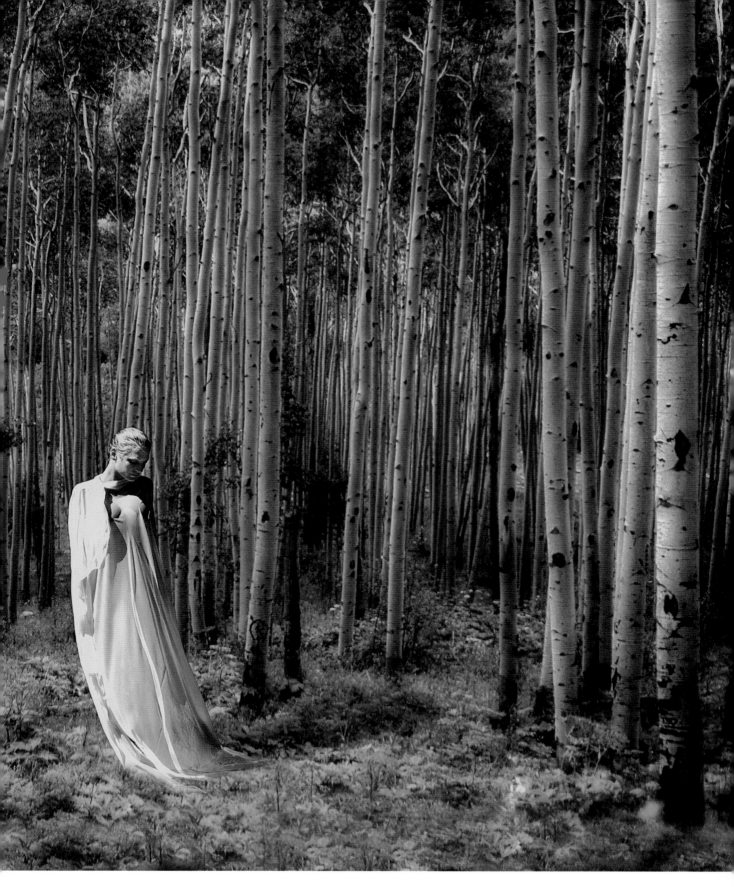

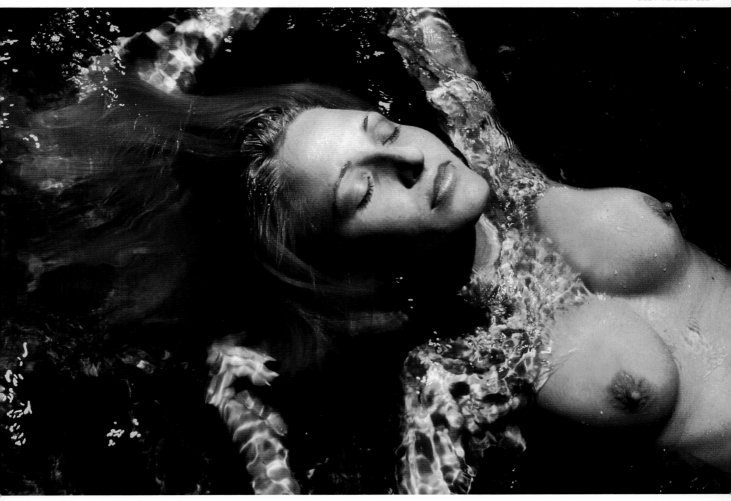

Barbara Cole captures the stillness of the moment. If photography is about trapping time, then her photographs are visual explorations of this theme, employing a skilful manipulation of light that also suggests the vulnerability of the model. Rarely do her subjects look directly towards the viewer: their faces are turned or hidden, sunk in reflection. Her delicately expressed images embrace the visual influence of Adolf de Meyer's early impressionistic photographs. Barbara is able to make the familiar completely unfamiliar. A romantic notion of freedom is perfectly matched to the restlessness of water in her decorative underwater parade: water releases these simple garments from the constricting architecture of the body and liberates the fabric into fluid layers that drape across the form with sinuous elegance. The use of shadow and light is masterly in the "land" series that references the Neo-Classical paintings of Lawrence Alma-Tadema and Frederic Leighton. Here the restricted earthy colour palette seems a legitimate foil for the models, garments, and faded surroundings.

BARBARA COLE

CANADIAN

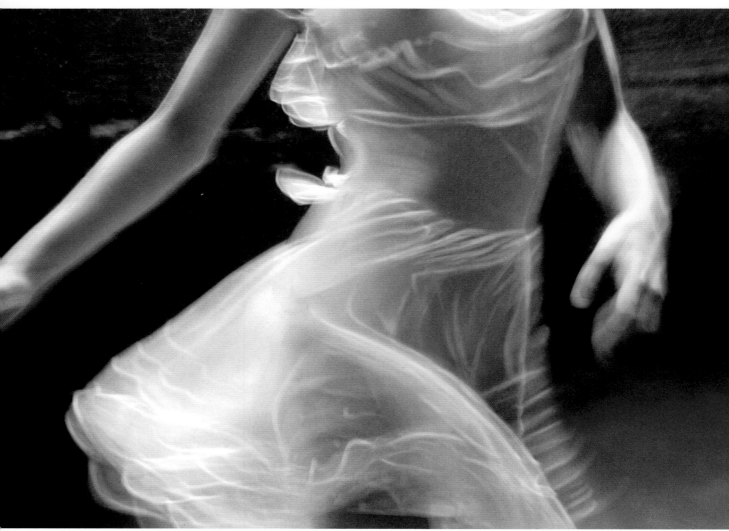

What I am doing today surprises nobody more than myself. I never thought of myself as an artist; I spent my time studying languages. But photography found me, captivated me, and ultimately saved me. I am absorbed by its endless possibilities.

I am a Canadian, born and bred in Toronto. I have seen many places, and my voyages have inspired what I do. Depression has been my biggest challenge: yet when I am in the midst of it, the images I create are often the most weightless and beautiful.

I am self-taught. A spell of modelling led to a career as a fashion editor, when I first encountered photography. I opened my own photographic studio and eventually directed television commercials, while making time for the personal work that informs everything I do.

Sarah Moon is by far my greatest photographic influence. I think her eye is original and brave and cutting-edge. The painter Lucian Freud is probably the second most important influence, who entered my life when I was experimenting with the SX-70 camera.

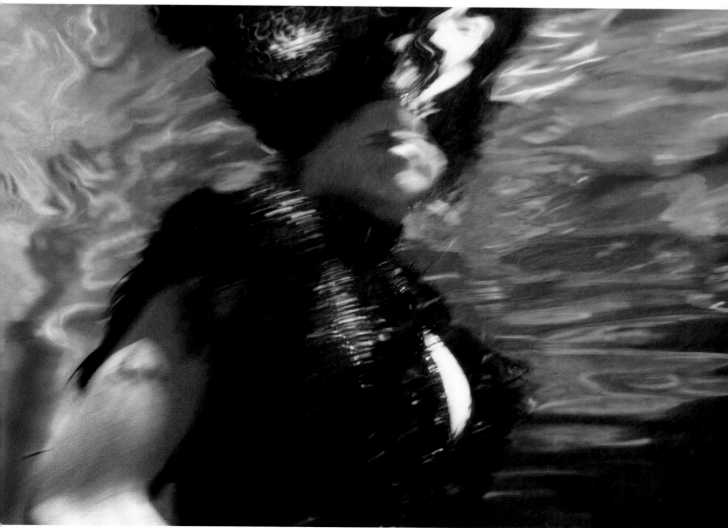

UNHINGED 2002 OVERLEAF LEGS 2004

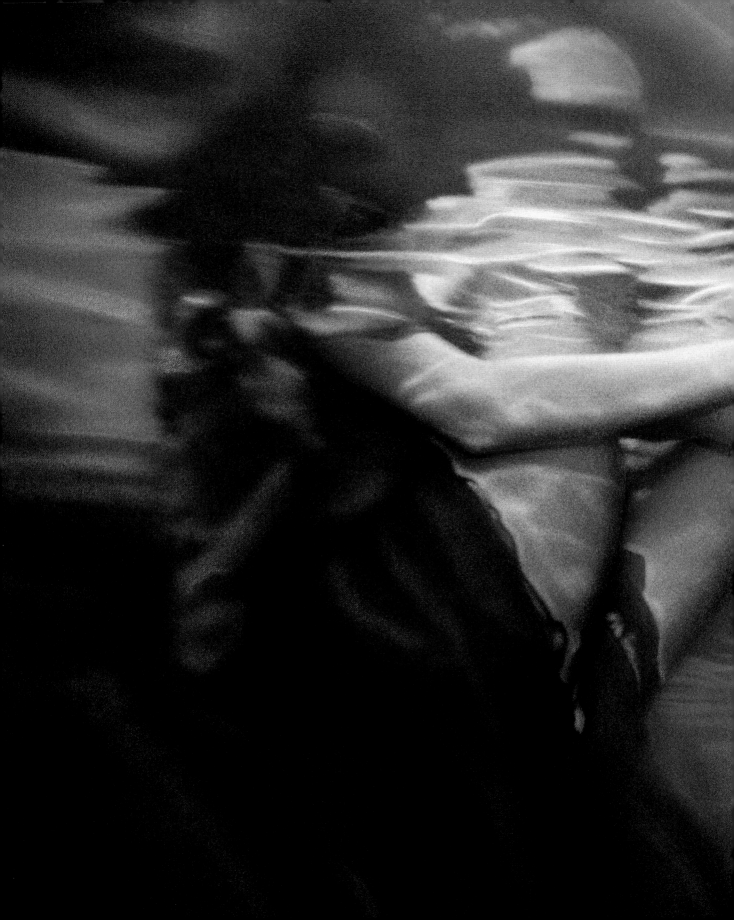

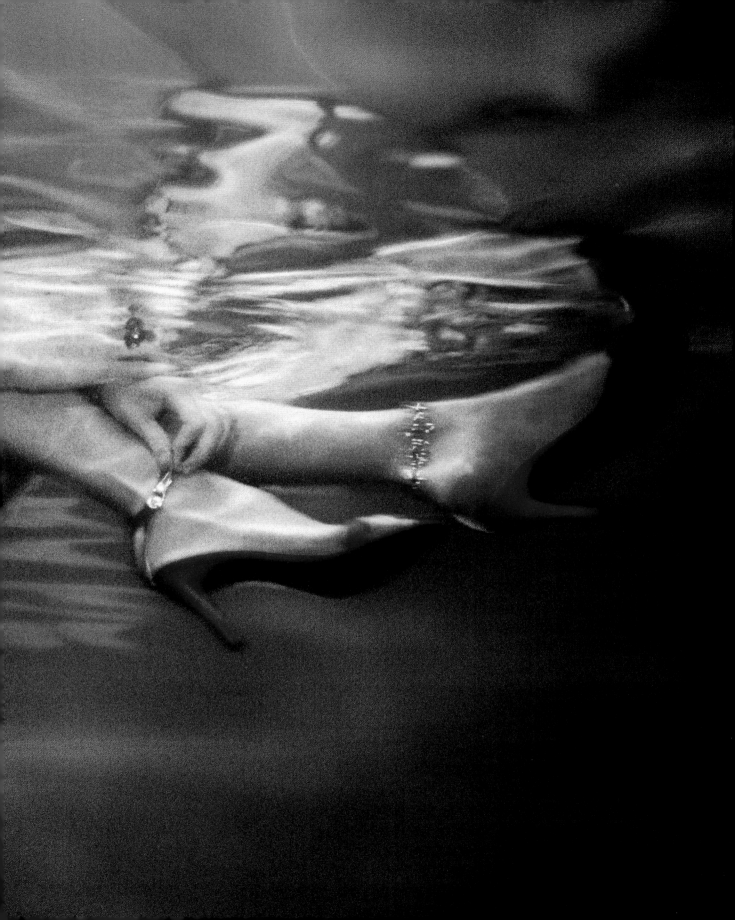

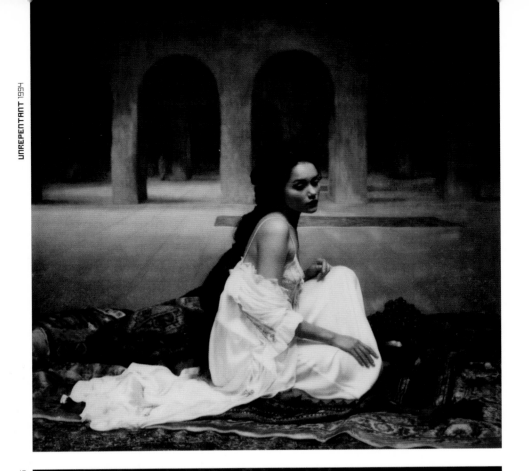

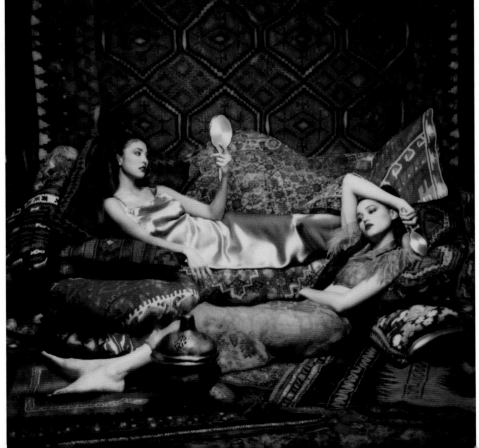

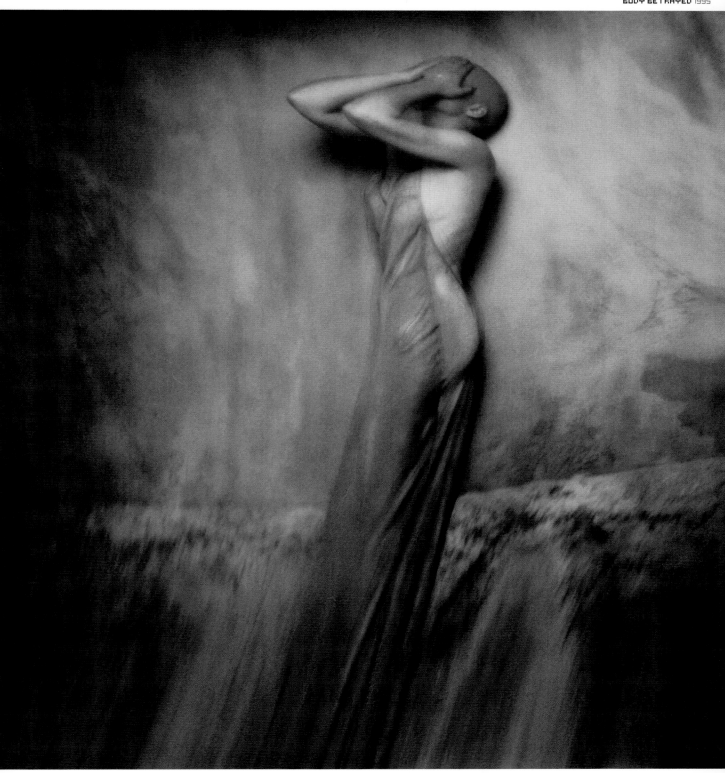

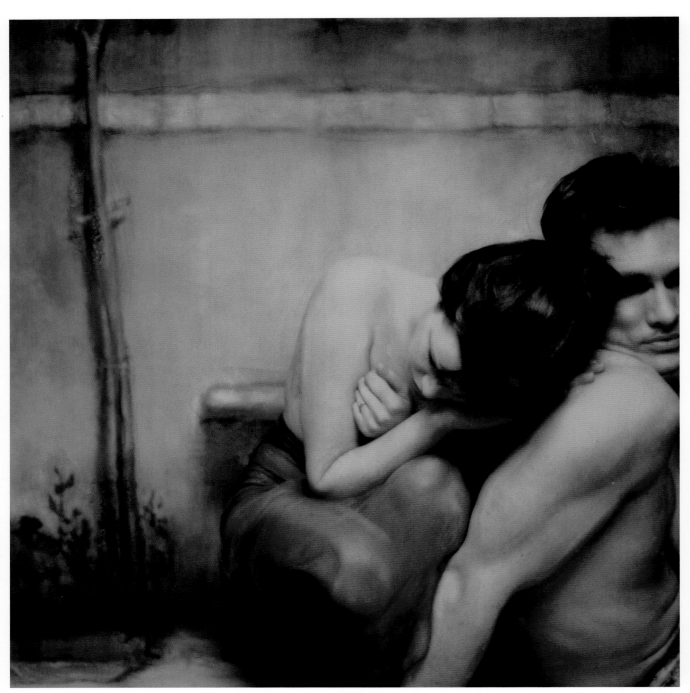

STONE LEDGE 1994

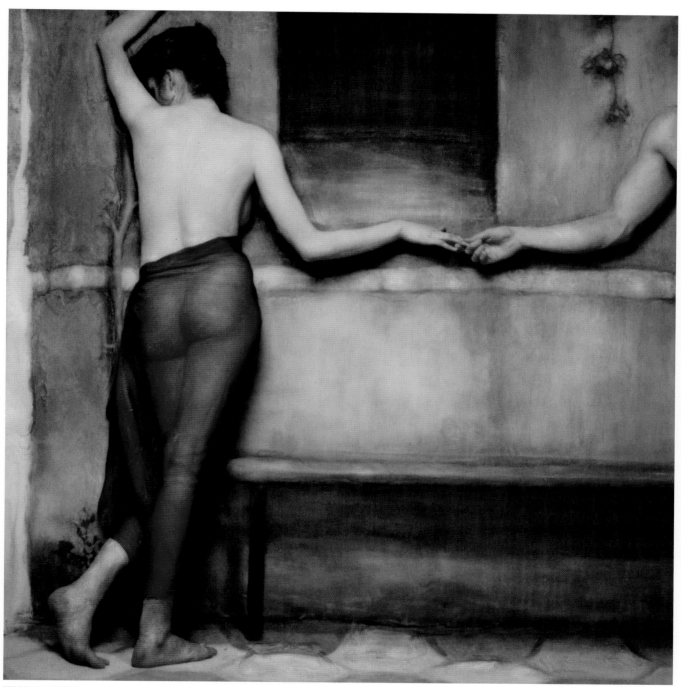

INDECISION 1994

Jason Jaroslav Cook's photographs transport the viewer into a wonderland of enhanced romanticism – worlds apart from the "in your face" style of most current fashion photography. He uses digital techniques to achieve a screening effect like that pioneered by Baron de Meyer at the turn of the 20th century and still referenced in the soft-focus studies of David Hamilton. Jason harmonizes a gentle world suspended in time, which recalls the elegant portraits of Thomas Gainsborough, the decorative poster art of Alphonse Mucha, and the sensual penmanship of David Downton's fashion illustrations. Jason prepares his figures for performance like the stage-managed tableaux of pioneering Victorian photographer Julia Margaret Cameron. Presented here, Jason's sophisticated models merge with their surroundings, absorbed within this imaginative décor in the elegant, ornamental style perfected by Cecil Beaton in his famous portraiture, and exuding a seductive intensity.

JASON JAROSLAV COOK

BRITISH

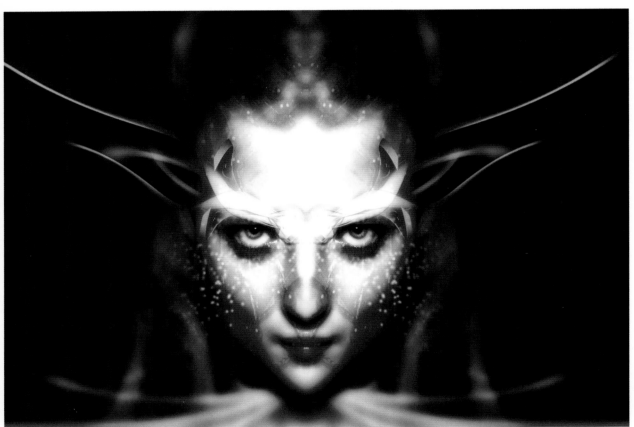

UNTITLED 2003

Based in London's Docklands, I have been a digital illustrator and pixel pusher for about eight years. I came from a photographic background, and after delving into various areas of design and photography I found my real passion – combining photography and illustration with computers. I divide my portfolio into three styles, each with its own name and identity.

Jacey is how I am best known: a commercial and very accessible style that focuses on 2D- and 3D-generated digital art. Flatliner consists of more traditional illustration methods with a contemporary edge. Jaroslav is my personal approach: this is an ongoing project, calling on my experiences with social documentary photography, design, and traditional illustration.

My influences range across all art media, including photographers Joel-Peter Witkin, Lee Friedlander, Don McCullin, and Anton Corbijn, and painter David Hockney, while it was Francis Ford Coppola's film Rumble Fish that pushed me in the direction of black-and-white photgraphy.

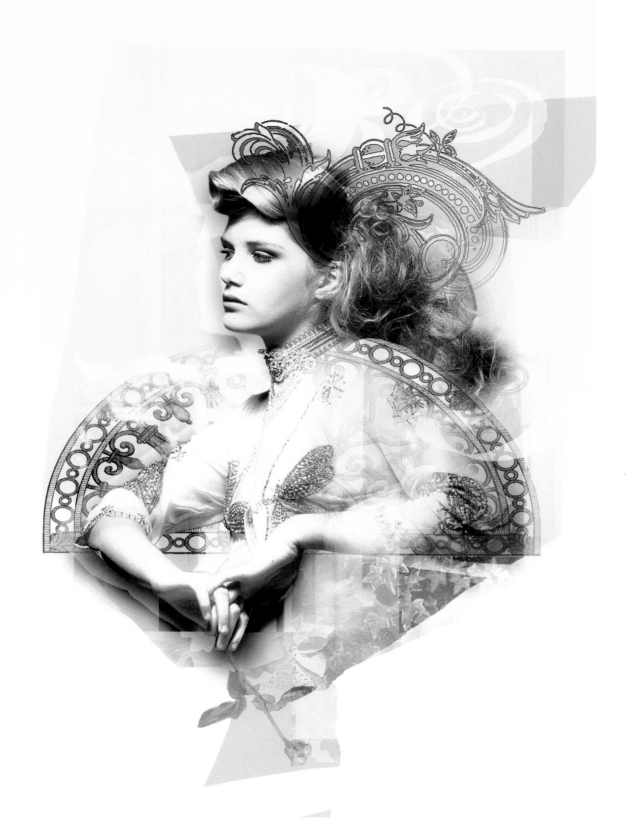

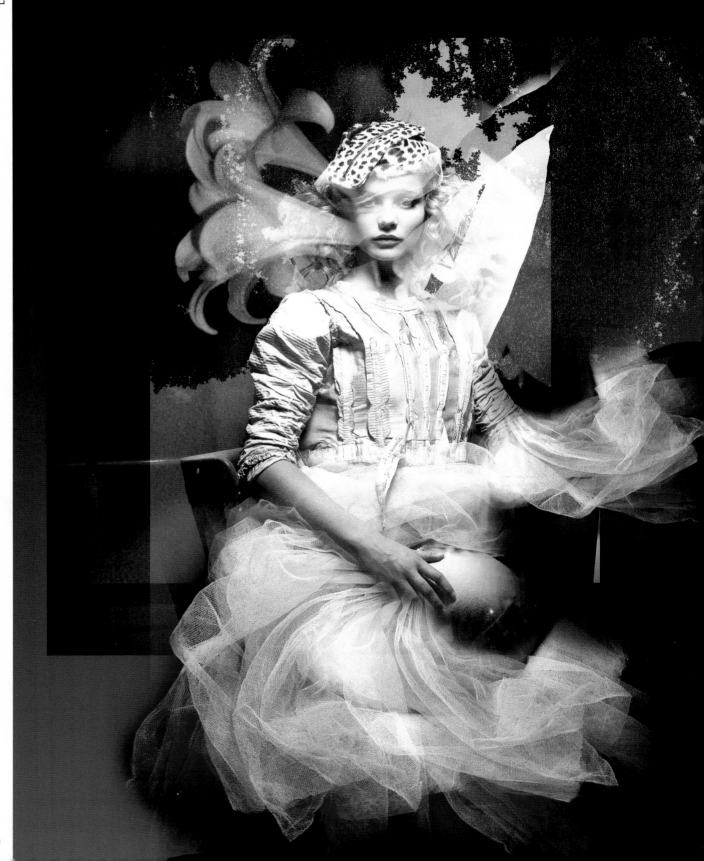

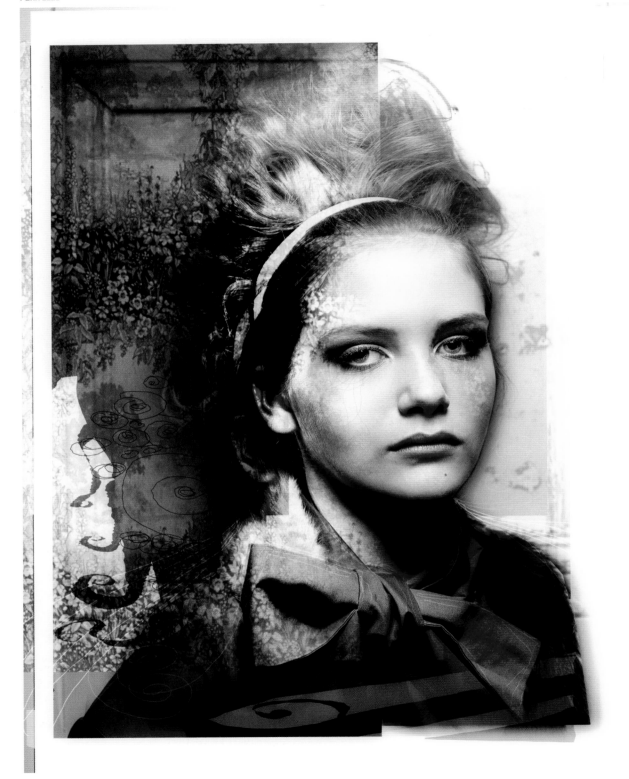

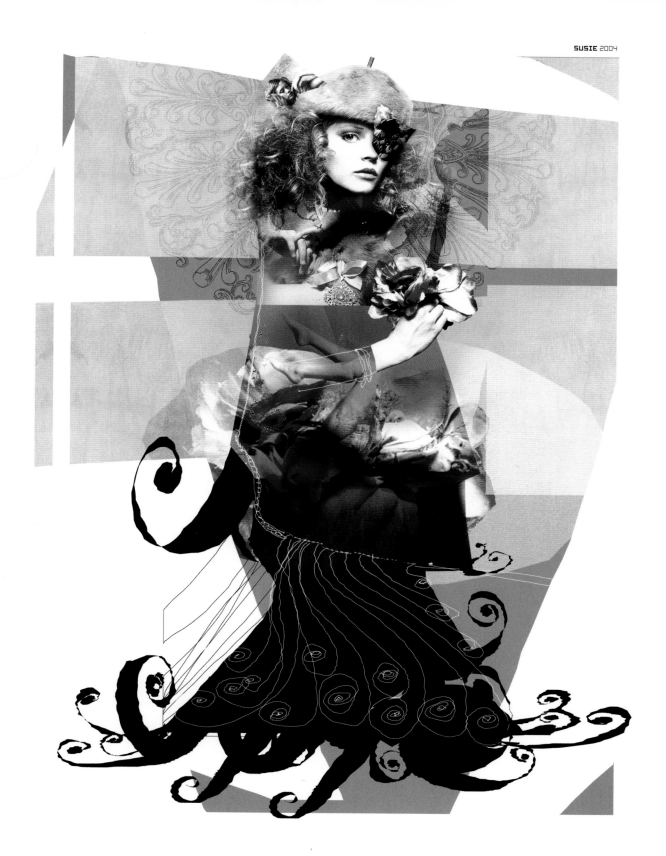

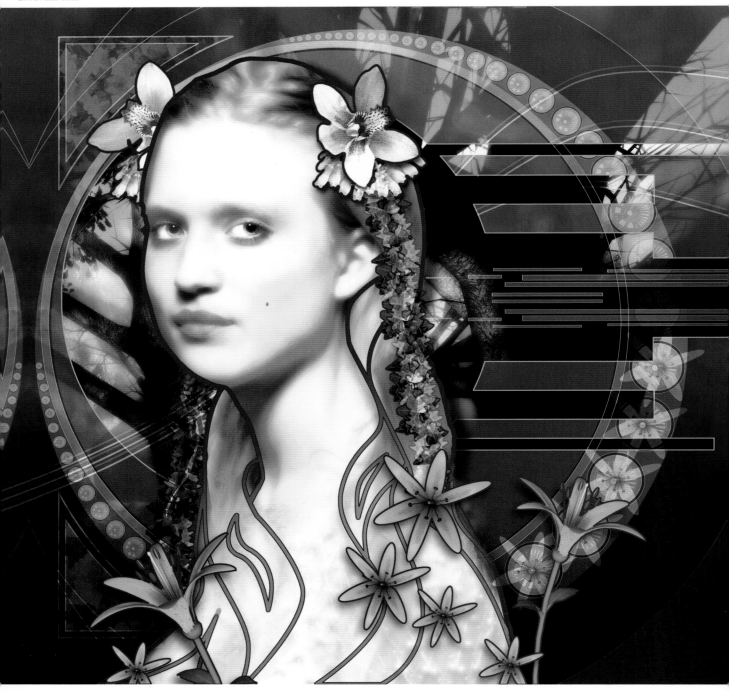

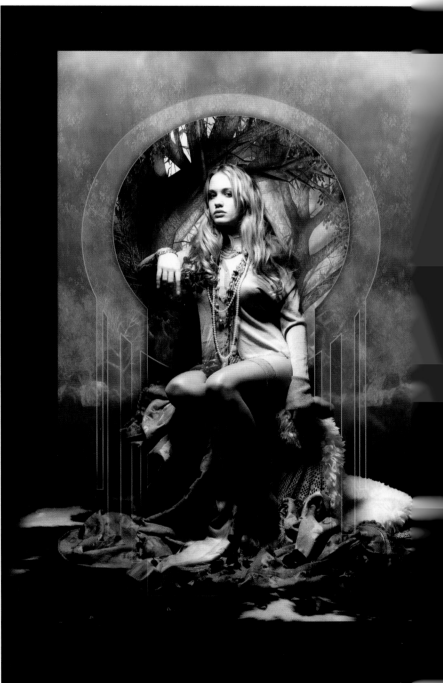

Disney's subjects are visually ensnared, gleaming like disco divas caught by flickering strobe lighting. There is a televisual look to the models that suggests that they could have stepped out of a pulsating music promo. Their dramatic posturing and distinctive costumes conjure up impressions of the heady, vibrant, larger-than-life spectacle of legendary New York nightclub Studio 54. Disney's group of photographs is a sequence of obstructions in time – a camera flash that adds permanence to each subject's Warholian 15 minutes of fame. The dynamic light-trails are reminiscent of Eric Staller's long-exposure experiments when attempting to draw with light in the 1970s. Disney's dizzying neon fireworks navigate around his static models like a *tour de force* techno art installation. The multilayered streaks of exploding colour and pattern charge the atmosphere with effervescence and excitement. Disney's digital manipulation is as stylishly fertile as the fashion editorials photographed and styled by Craig McDean and Alexander White in the late 1990s.

[ᴅɴAꜱAᴃ]

AMERICAN

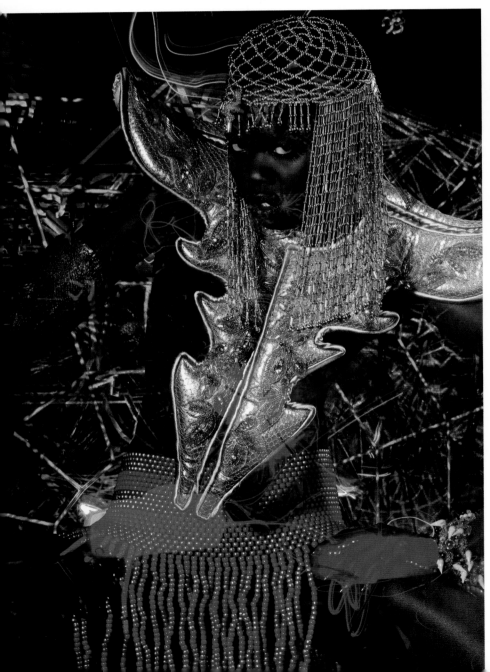

My name is [dNASAb], aka disneyNASAborg. I have a tremendous appreciation for a truly functional art form, steeped in lush history and tradition – the wearable arts: fashion. I am interested in perpetuating the creative aspects of the art form, but not commercial fashion photography, not hunting for clients, nor fashion photography as a career. But I am excited to create work in collaboration with true creative geniuses in the fashion field, designers whose passions reach far "outside the box," and who are at the forefront – leaders who set the standards, redefine the rules, and are absolutely avant-garde.

I consider myself a passionate and prolific New York artist, blurring the boundaries between media – especially painting and technology. I am focused on evolving my style and content in the pursuit of embedding myself into modern art history. I exhibit nationally and internationally.

I have a Bachelor of Fine Arts in painting, and have been experimenting with the implementation of the photographic process in my artistic toolset. Through an intensive experimentation with the photographic process, and a continued love affair with fashion, a unique hybrid has emerged that has led me to this point.

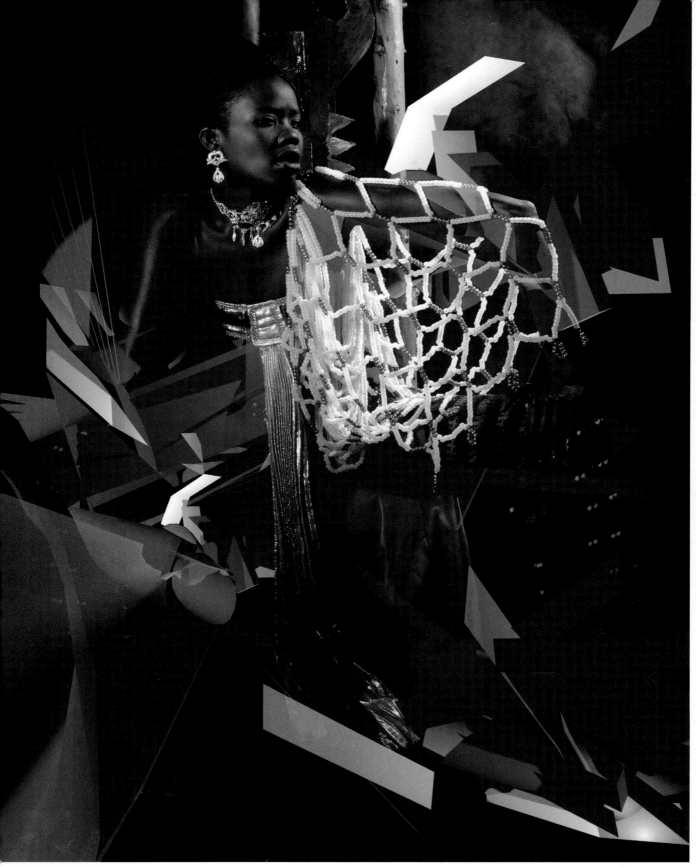

MIDNIGHT ISIS #3 2004

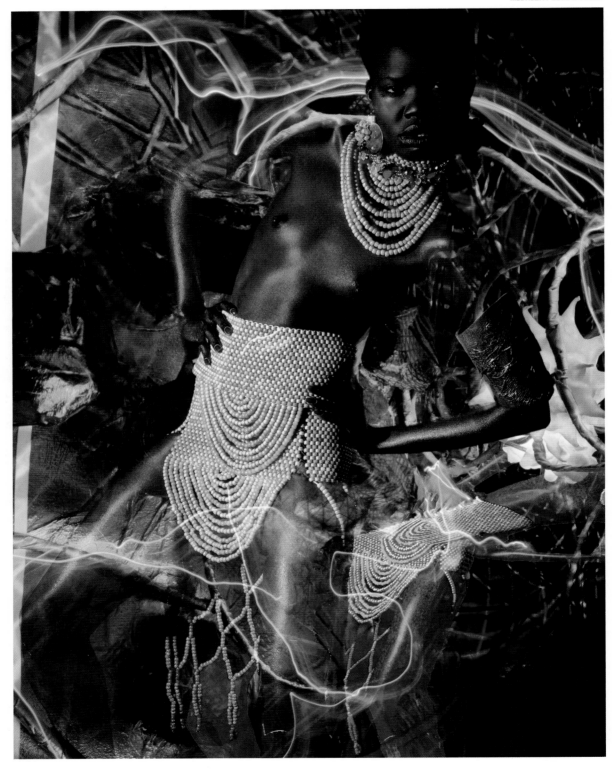

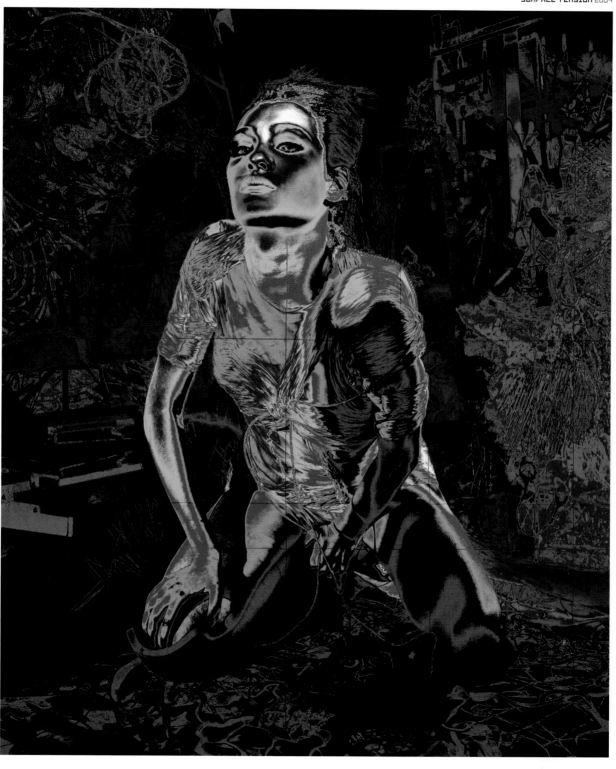

Amid the soft focus and layered styles of most digital enhancement, Andrey Efimov's modified photographs are all the more striking for their solid use of definite shape and harsh contrast. His pixels are fractured and regrouped not unlike the shards of iridescent glass that make up a classic Tiffany lampshade. There is none of the low-opacity filtering and over-working of the downloaded plug-in that impact all too frequently on most digital manipulations. Andrey fuses his "canvas" with pixels that repeatedly imitate an artist's brushstrokes with their saturated colour. These skilfully staged scenes take on a darkly-etched chiaroscuro that shows more than a cursory nod towards the management of shadows employed in most of Caravaggio's and Rembrandt's late paintings. Andrey proves himself to be a consummate pixel painter in these stylish studies that repeatedly stimulate the eye. His sitters often seem lost in contemplation, but when they blankly stare out at the viewer, their candour is all the more arresting.

ANDREY EFIMOV

RUSSIAN

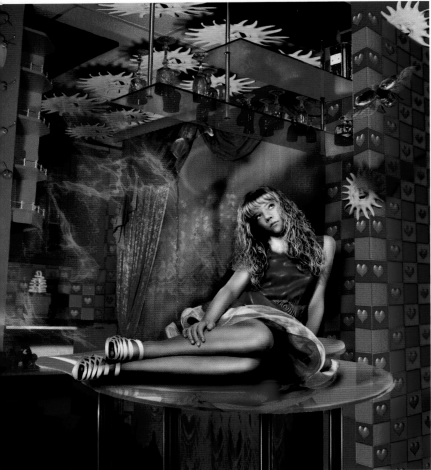

NIKA 2003

After completing my military service in the navy, I studied architecture and art at the Sverdlovsk (now Ekaterinburg) Architectural Institute in Russia. I then worked as a production designer in a film studio and participated in the creation of several films. I worked at Mosfilm (the Moscow film studio) and at the Sverdlovsk film studio.

After that I began to take advertising photographs and portraits, but this kind of photography was not enough for me, and I turned to digital processing. My favourite directors include David Cronenberg, Andrey Tarkovsky, Federico Fellini, and Luis Buñuel, among many others.

The most important part of creativity, I think, is to be able to disconnect one's brakes and to escape consciousness. The Russian fashion designer, Slava Zaitsev, has said that if you want to say something, you must not whisper – you must shout. In creative art any means is valid – the main thing is that the results are good. My favourite photographers are Helmut Newton, David LaChapelle, and Jeanloup Sieff for his refinement. I currently work as a freelance artist.

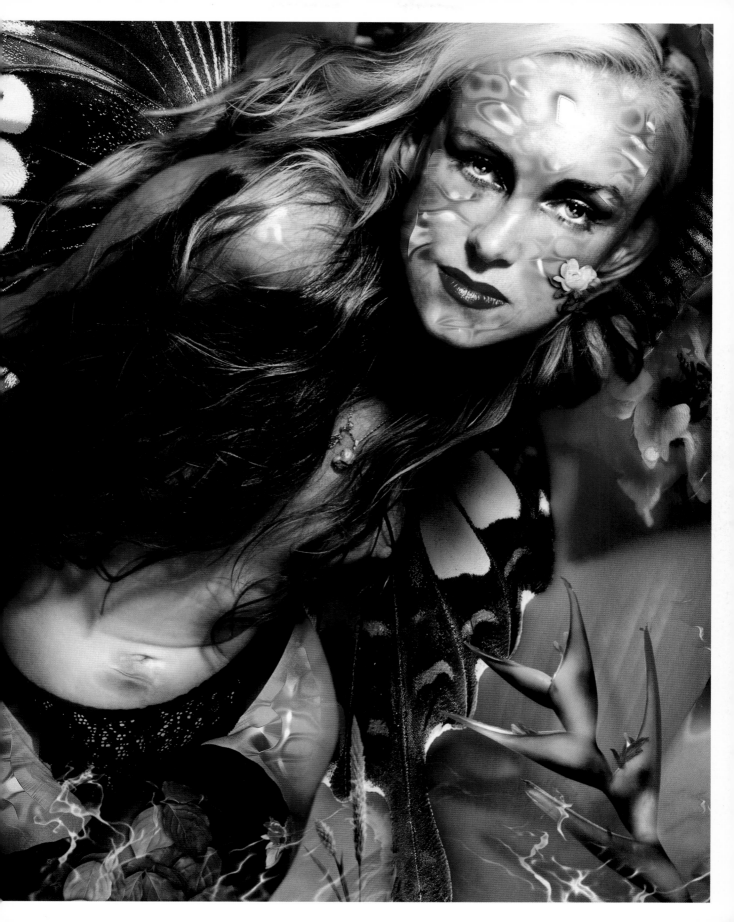

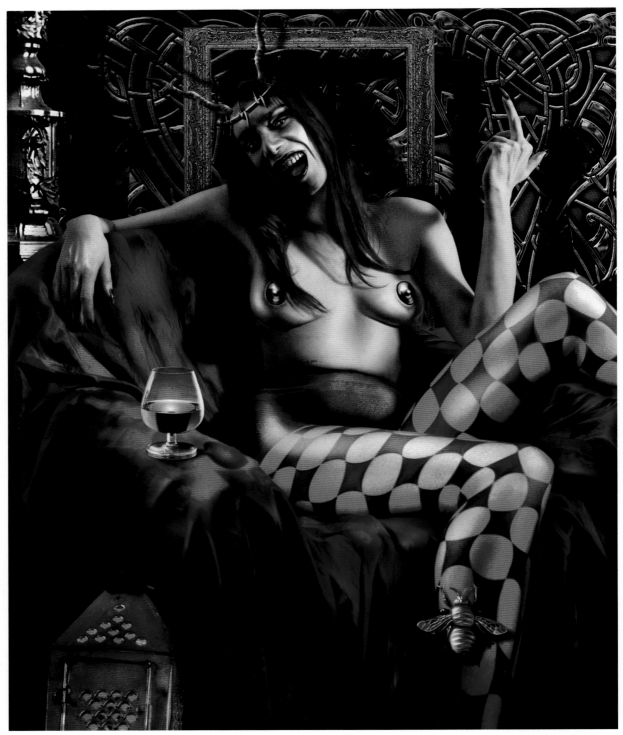

TATJANA MATUHINA 2003

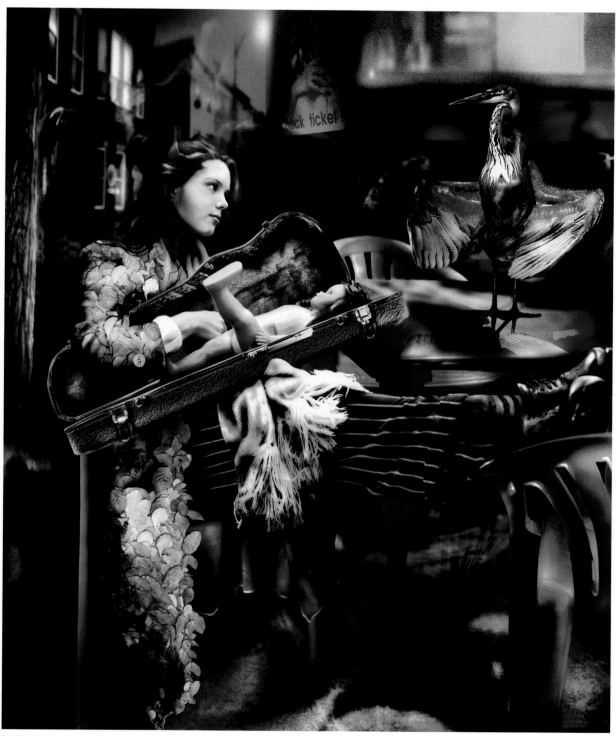

ELENA 2003

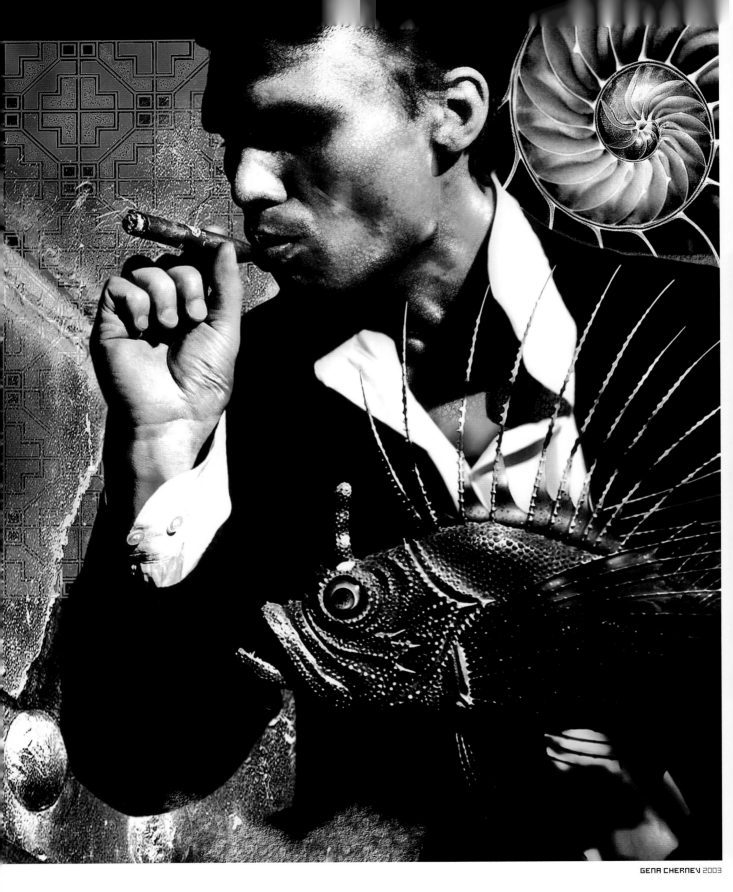

GENA CHERNEV 2003

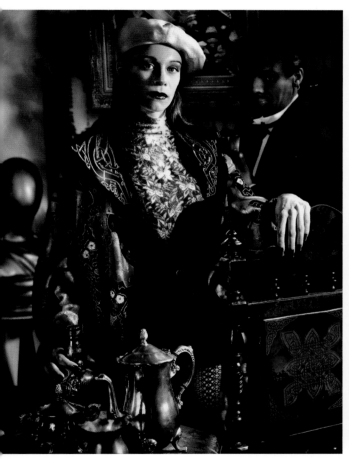

TATIANA MATUHINA 2003

TATIANA MATUHINA 2003

Eryk is a versatile photographer who mixes traditional techniques and digital trends, allowing him to give permanence to the ephemeral. He represents the transitionary breed of photographers who are walking away from their dark-rooms and running at speed with the digital capabilities of new software programs. Yet Eryk is not just a skilled showman, but a style supremo who works his images like a movie director. His output slips between the fantastical and the real in a fabricated digital dimension where all is not as it seems. These artificial montages, rigorous in their attention to detail, express the unexpected, often in bizarre feasts of style. Eryk's photography operates as a clever fusion of manipulated art, where the rational disbelief of the viewer is temporarily suspended, as happened with the Cottingley fairies – faked photographs that famously duped a gullible Victorian society. Eryk's celebrated style comes ready-wrapped for consumption, in the guise of an enhanced, hybrid art form that applies established values alongside new technologies.

ERYK

AUSTRALIAN

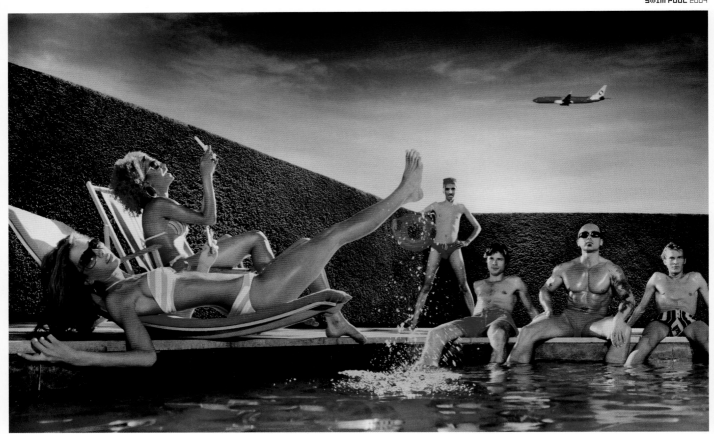

Raised under the Communist regime in Poland, I gained rich experience during my earlier life, including both the bitter and the sweet that life can offer. In challenging my predetermined path I often landed a bad-boy image.

I broke into photography through modelling and networking. Three months after taking my first photograph, I was hired as a photojournalist. Five years later I left Poland for Australia, knowing that Australia lacked photojournalist magazines such as Europe's Paris Match and Life; I survived through factory and building work, but after learning English returned to photography.

I learned advertising photography through trial and error, which led to some innovative, unconventional techniques. People often put a dividing line between art and commercial photography. I believe advertising photography transcends definition and is capable of being an art form.

A photograph does not speak, it does not smell, it makes no sound, it does not move. It is a 2D piece of paper. But a good photograph can do one if not all of the above.

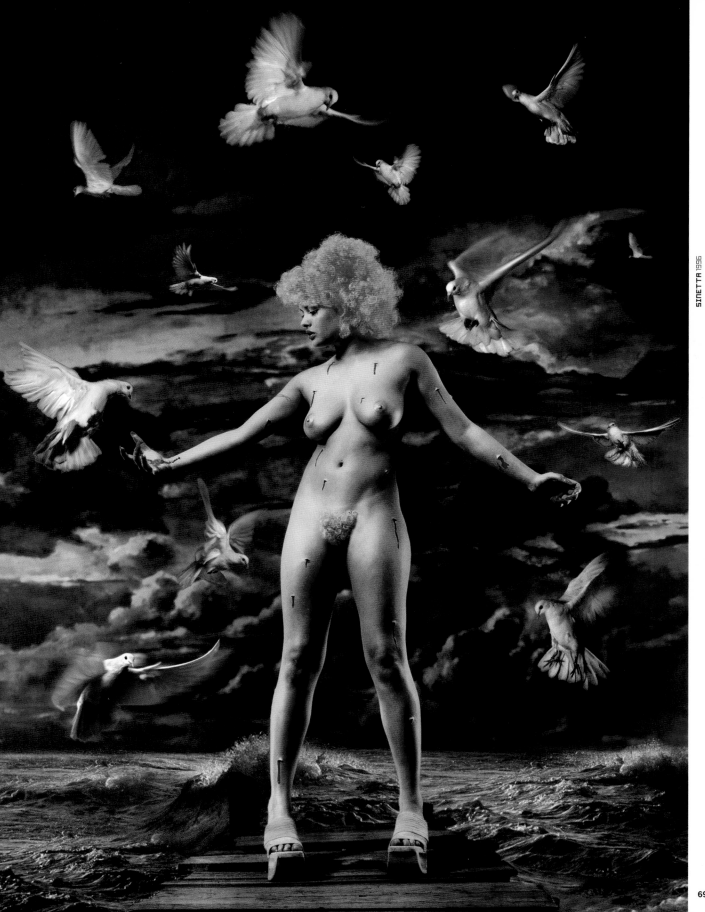

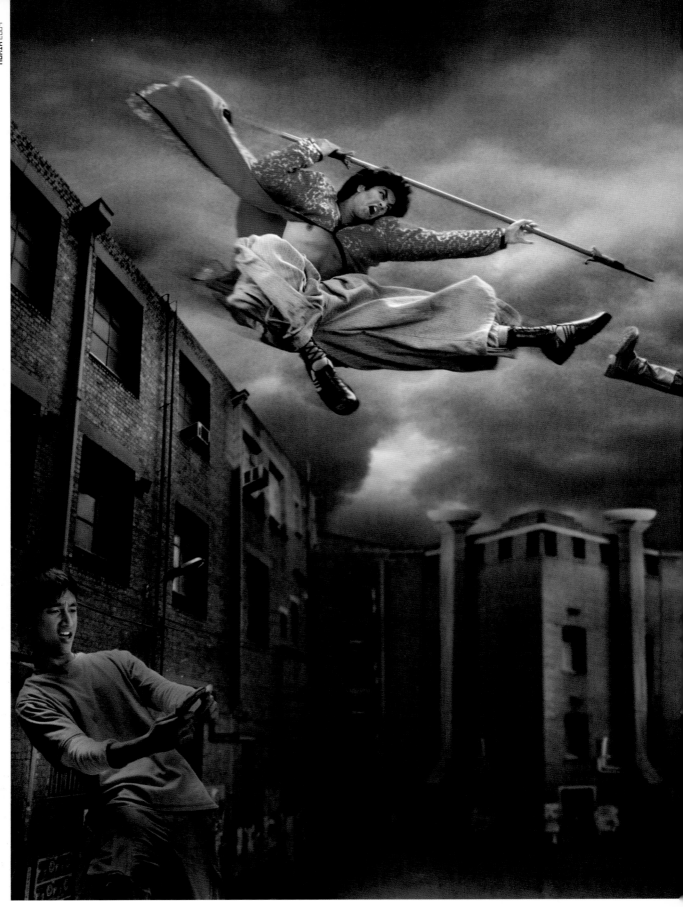

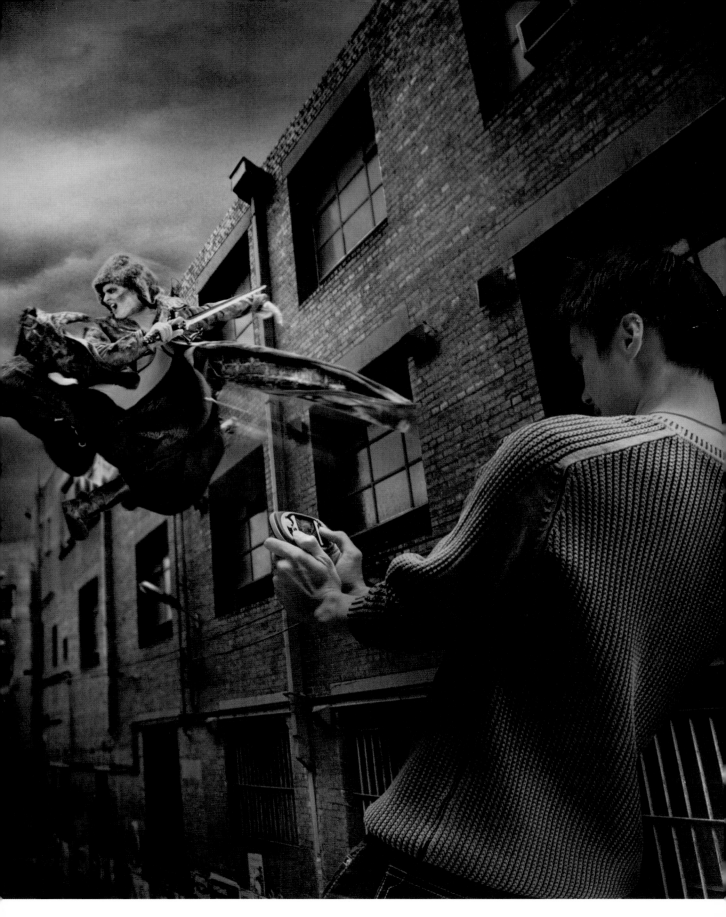

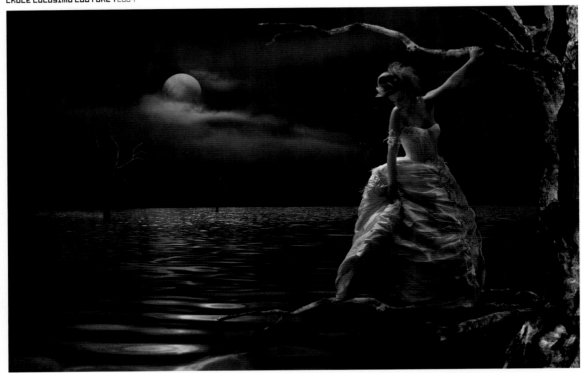

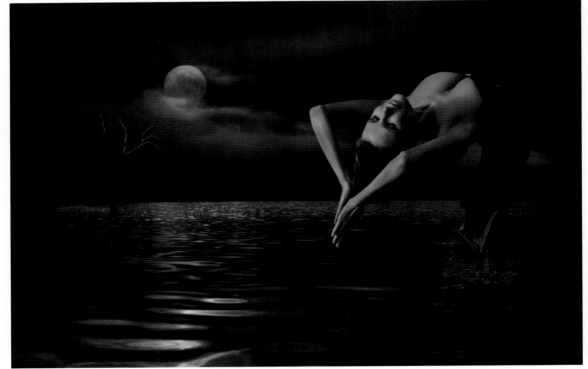

PLEASURE

There is a sexual frisson to much of Paul F.R. Hamilton's iconography that intentionally plays with an overtly homoerotic consciousness. Sensuality seems to run amok and there is a total embrace of aesthetic visual pleasure. His ghostlike figures are impressionistically conveyed with a grainy diffusion contrived to appear eroded by the passing of time. It is easy to discern a similarity with the faded photography of Deborah Turbeville. His manipulated images are attractively etched through diffuse and subtle chiaroscuro that obliterates the here-and-now. By clever use of a smudged colour palette, Paul bottles the same shadowy sexual aroma that Javier Vallhonrat captures in his blurred fashion shots. The camera's customary concentration on clothes is replaced by patinas of alluringly coloured skin texture. Rarely do Paul's sitters engage directly with the viewer: the figure is often subject to extreme cropping within the frame, like many of Robert Mapplethorpe's models, and reduced to an exposed torso. They offer a glimpse of something that is off-limits to the viewer.

PAUL F.R. HAMILTON

BRITISH

HURT 2003

My grandfather and his brothers were world-famous professors when I came along: they'd each invented new disciplines in which to be experts. So I knew that was possible; it seemed a bit daunting, but better than working for someone else.

The formula seems to be to doggedly pursue your bliss, get to the edge of the known and go beyond it, question everything, and spend a lot of time battling personal demons. The archetype of the hero quest, the never-ending story.

My lifelong passions have been art, magic, technology and beautiful boys. I've gradually found ways to combine them; but I've spent a lot of time living in a homeless hostel to achieve these alchemical effects, and have acquired some battle scars.

All my pictures are made with amateur equipment and no budget. I'm basically self-taught, which I'd recommend. Schools are factories in the big countries. A basic secret of creativity is to get your mind and internal censor out of the way and trust your instincts.

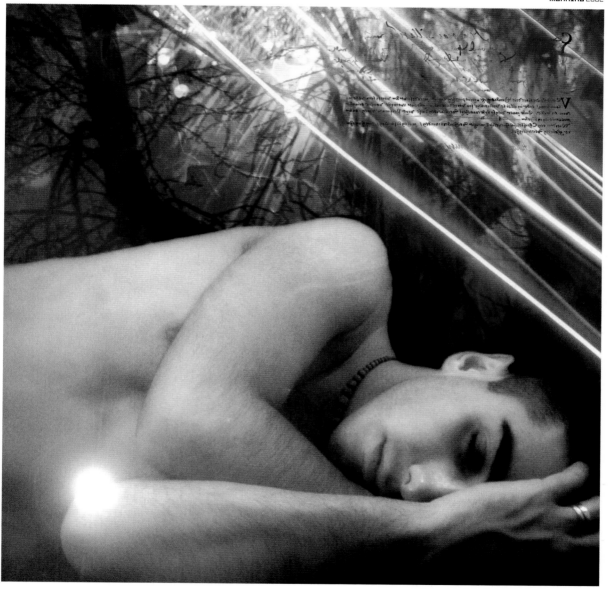

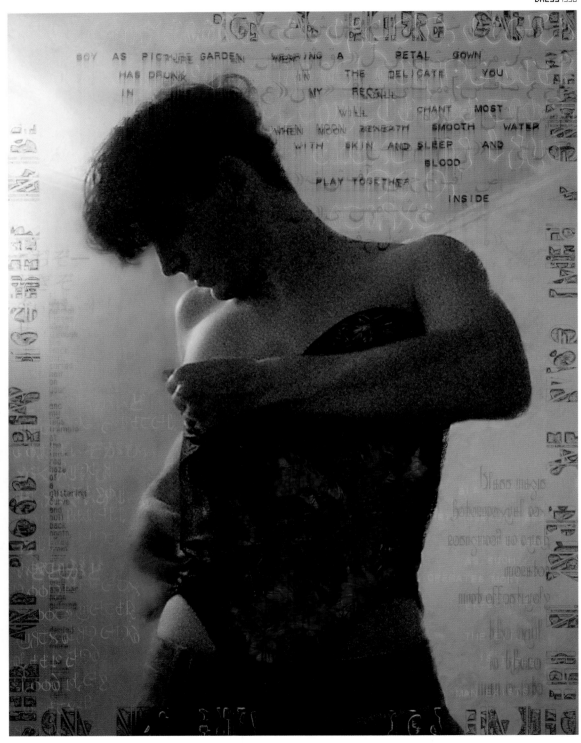

BOY AS PICTURE GARDEN WEARING A PETAL GOWN
HAS DRUNK IN THE DELICATE YOU
IN MY RECALL
WILL CHANT MOST
WHEN MOON BENEATH SMOOTH WATER
WITH SKIN AND SLEEP AND
BLOOD
PLAY TOGETHER
INSIDE

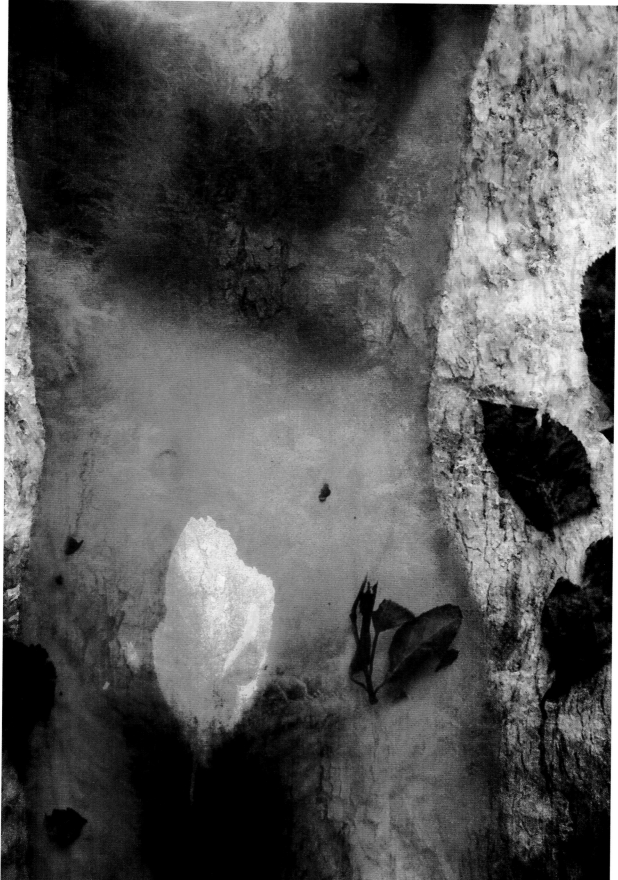

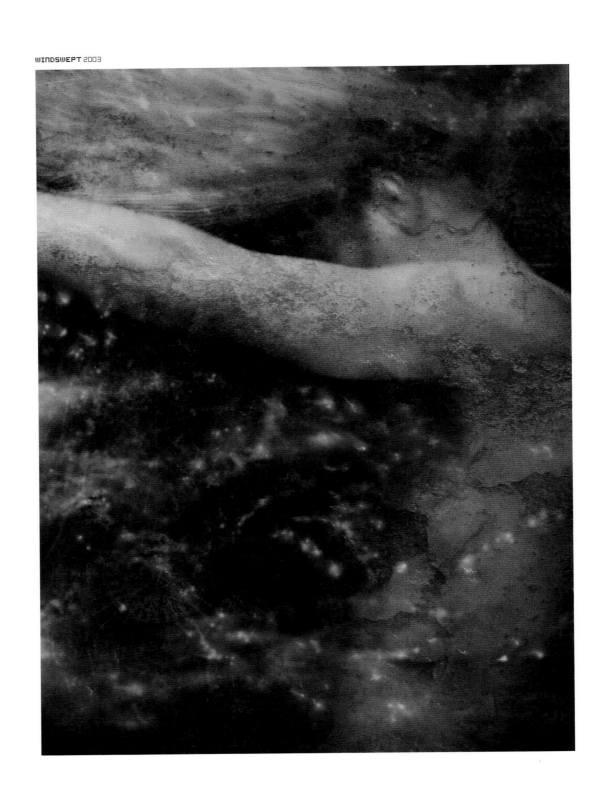

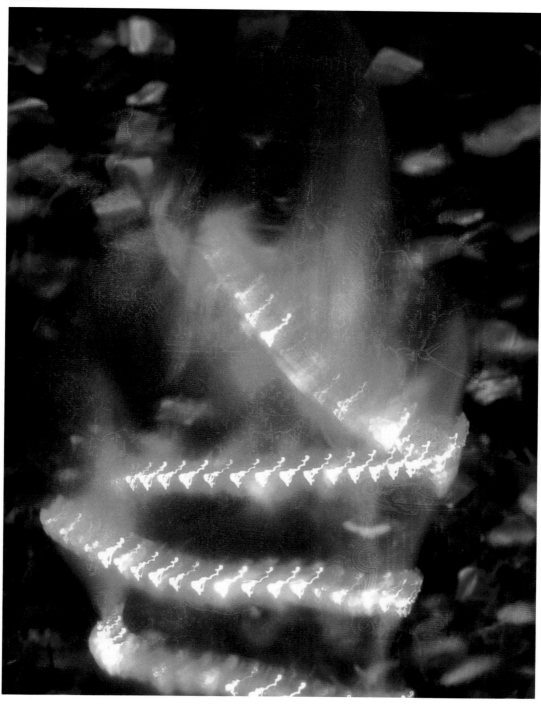

Fashion photography now has the ability to bridge the gap between the real world and the imaginary by playing with the issues of modern life with an ambiguous symbolism. *Another Magazine* and *Dazed & Confused* are crammed with photographic spreads using brutal images that are the opposite of traditionally glamorous fashion spreads. Here, Tim Hansen's images reinvent documentary photography and make forceful, disturbing statements. Strongly emotive, Tim's work is open to interpretation. These photographs raise questions about the values and conventions of traditional fashion photography. Sequential transformation is key: each photograph is viewed as part of a progression rather than an individual print. Tim's pictures challenge the viewer to participate, to intrude into the personal space of the subjects, much like the voyeuristic photography of Nan Goldin. The reinvention of the flower-bearing suitor takes on the metaphor of Edgar Allen Poe's "Red Death", while a bandaged face shows the ravages of war and pestilence in a painful visual allegory.

TIM HANSEN

SWEDISH

BECOME ABSORBED 2004

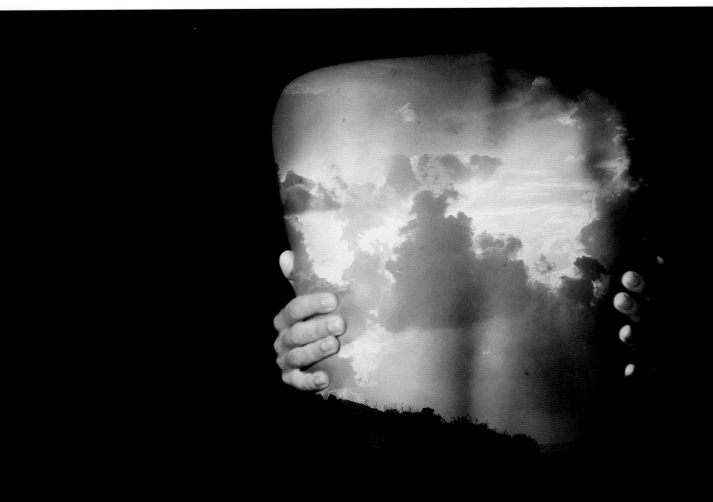

Born in a small Swedish town, I was an only child and developed a great imagination. In school I spent lessons daydreaming and drawing.

I've been drawing my whole life, and when I got hold of Photoshop I started to use the computer as a complement to pen and ink. I also had a big interest in photography and when the digital SLR cameras came out I could combine my photographic interest with my ideas from my drawings.

Making my images is necessary for my survival: it's something that needs to come out. Drawing, graffiti, photography, and manipulation have all been my way to escape the real world for a moment.

My images almost always come to me instantly, like lightning. Often an image comes to me before I go to sleep and I have to write it down in my sketchbook otherwise it will be gone. When I'm working I try to stay as close to the original idea as I can, but sometimes the image takes over and I'll end up with some artwork that doesn't look like the original idea.

My inspiration comes from everywhere: everywhere I go I look at the environment with my eyes like a viewfinder. I have many influences, from Edvard Munch and David LaChapelle to Japanese horror movies, video games, and everything in between.

THEY CAN'T HEAR ME 2004

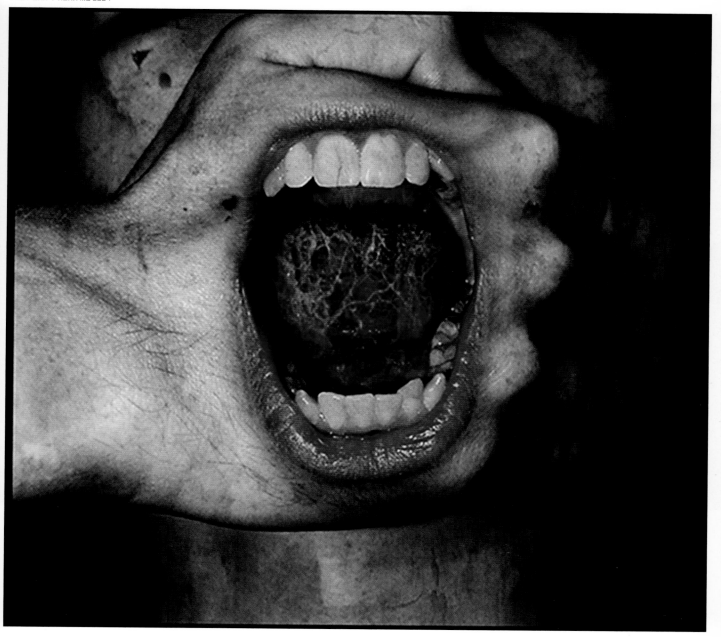

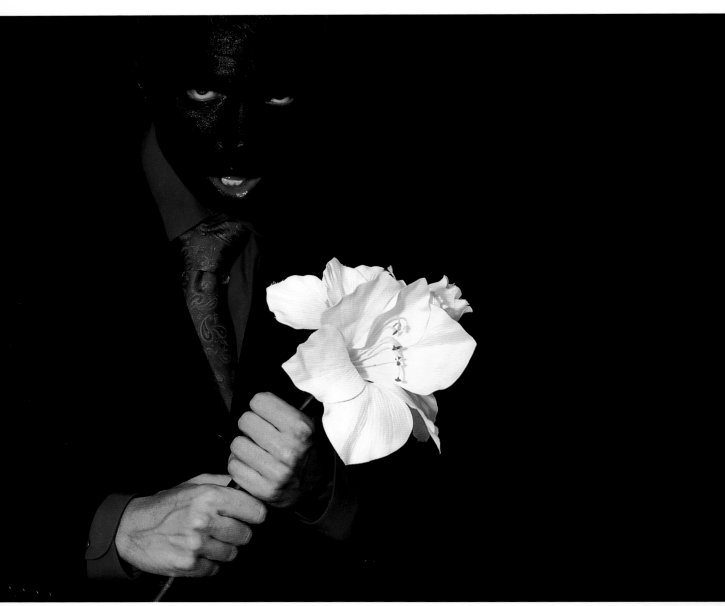

FLOWERMAN LOVE 2004

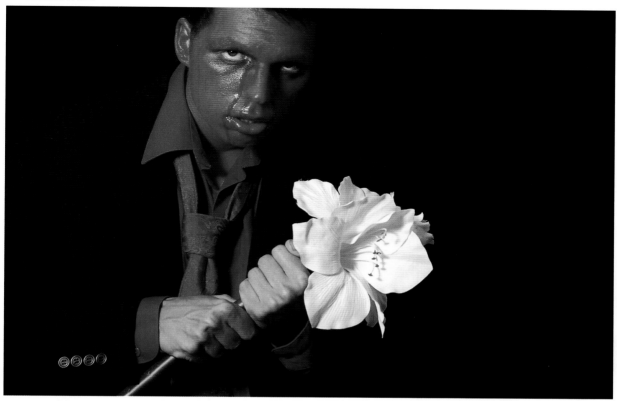

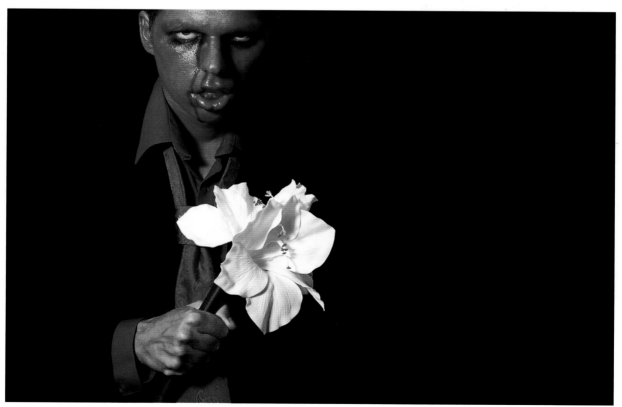

FLOWERMAN HATE 2004

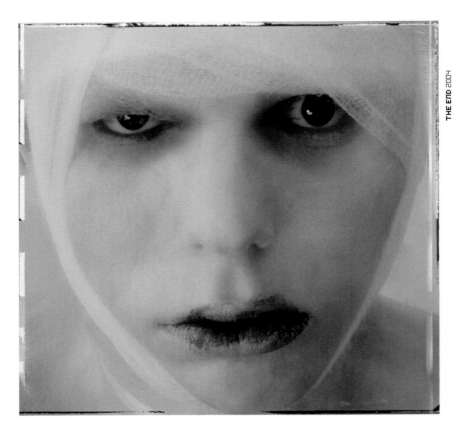

THE END 2004

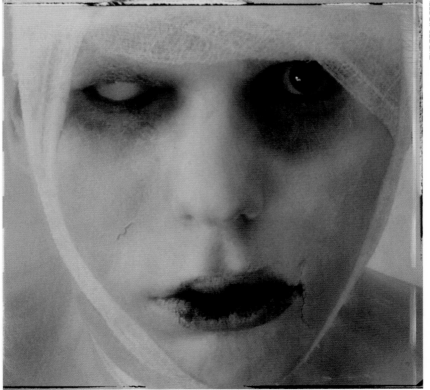

THE END #2 2004

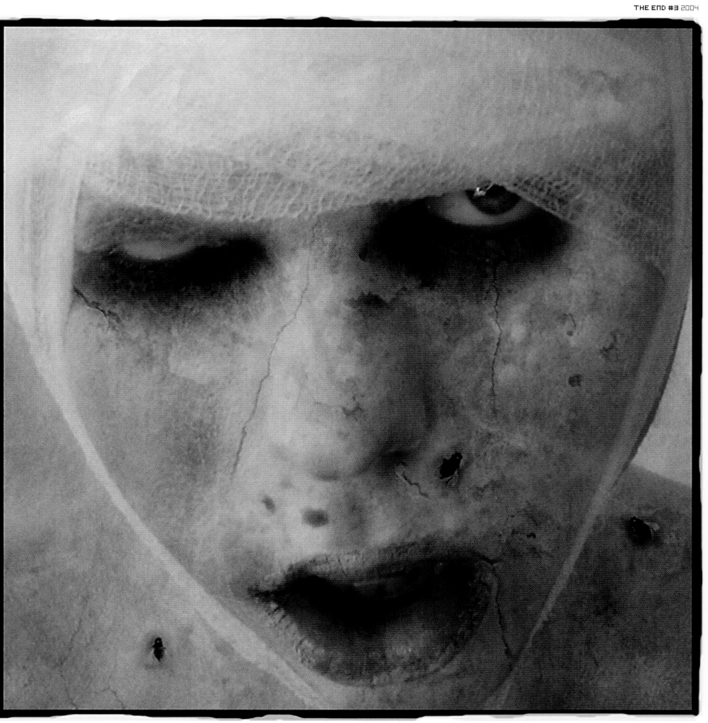

Andrew Hart's fertile imagination proves itself in the versatility of expression found throughout his photographic assignments. The narrative to his fashion spreads is always a strong and recognizable feature, whether echoing Francis Bacon for a menswear story, or borrowing a nightmarish quality from Tim Burton's films in his fantastical womenswear images. However, in both stories, Andrew brings into play his own personal vision. There is none of the disturbing violence that is dominant in Bacon's oeuvre; here a much gentler distortion is allowed to blur the features and hands of the model, subtle enough to allow the cut and silhouette of the garments still to register. The empty black backgrounds reiterate the stillness and isolation that is similarly a characteristic of Bacon's paintings. There is a more light-hearted, cinematic approach to the monotone Halloween sequence, which incorporates Tim Burton comic-book overtones in its framing and depiction of the model. The layering of photographed and drawn is skilfully achieved and accentuates the other-worldliness of the images.

ANDREW HART

AMERICAN

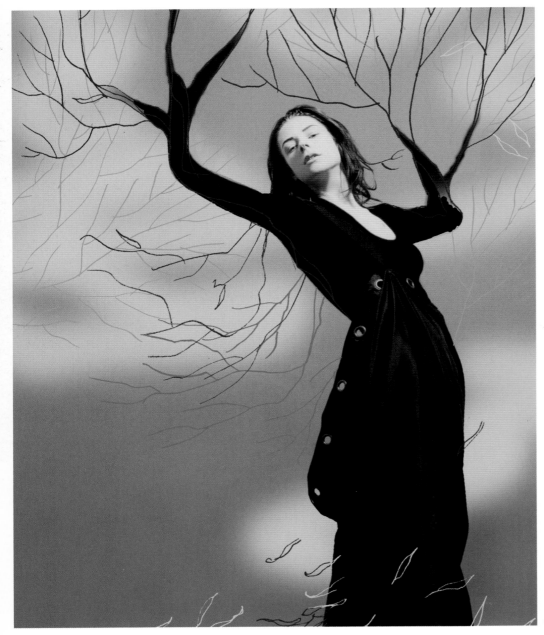

TREE 2002

It wasn't until my last year in college that I decided I wanted to be a fashion photographer; up until then I had been studying fine art. A class I took with Paul Jasmin showed me that fashion photography could be very creative and inspirational. At this time Harper's Bazaar was relaunched, with Liz Telberis as editor-in-chief and Fabien Baron as creative director, and I realized I wanted to do work of the quality that the magazine was showcasing – amazing layouts by David Sims, Mario Sorrenti, Craig McDean, and Mario Testino.

In 1996 I moved from Los Angeles to New York, and discovered that there are few moments when a photographer is given creative freedom. I was labelled "conceptual" and "avant-garde" by many people. And, luckily, that is what a few of them were seeking.

Technically and creatively, my biggest influence has been Irving Penn. Other influences are Michael Roberts, Helmut Newton, any band I listened to in high school and college, numerous cartoons, Pee-wee's Playhouse, and tons of flotsam and jetsam.

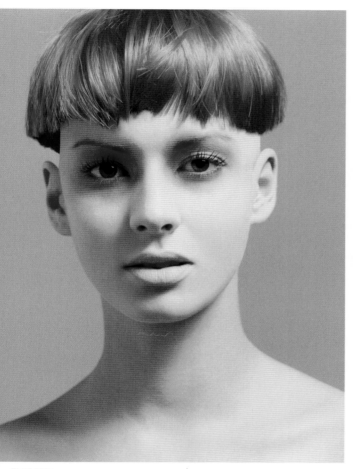

BLUE 2004

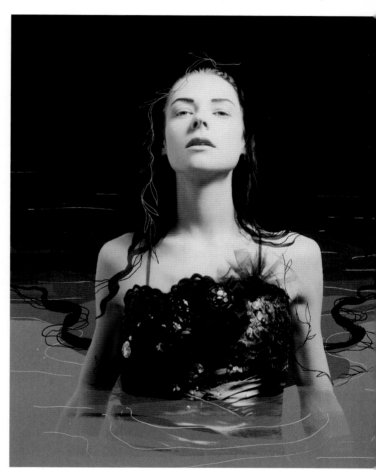

LAKE LADY 2002

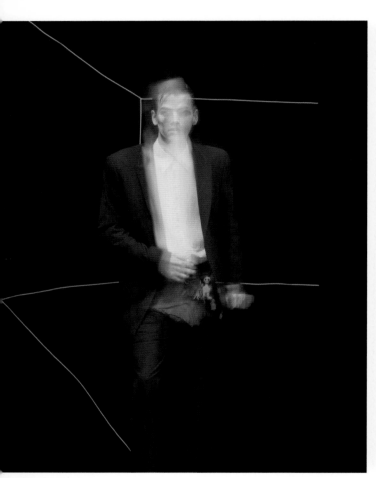

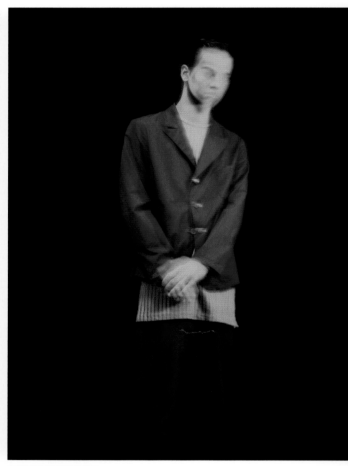

FRANCIS BACON 1 2001

FRANCIS BACON 2 2001

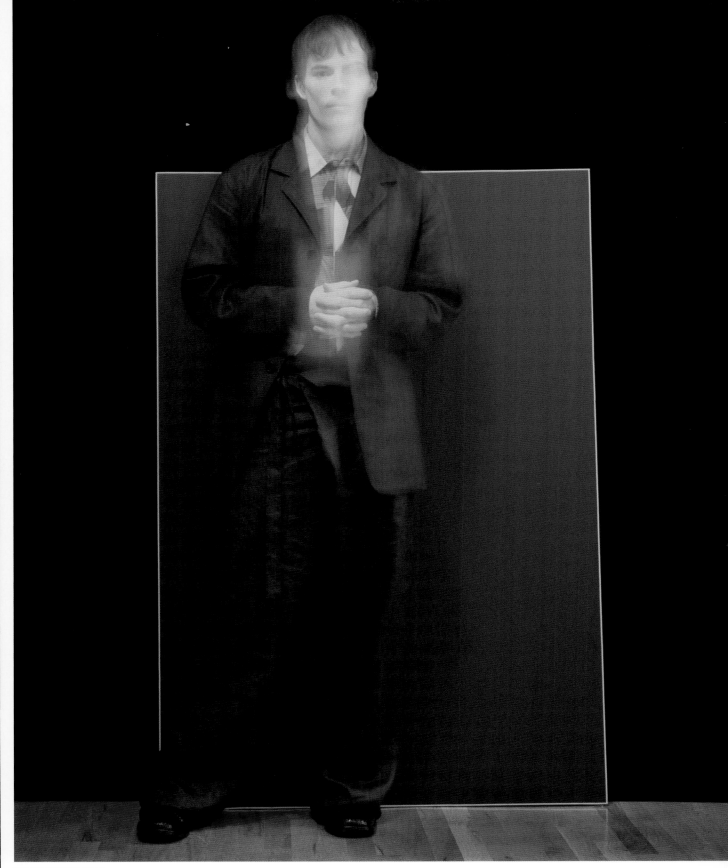

FRANCIS BACON 3 2001

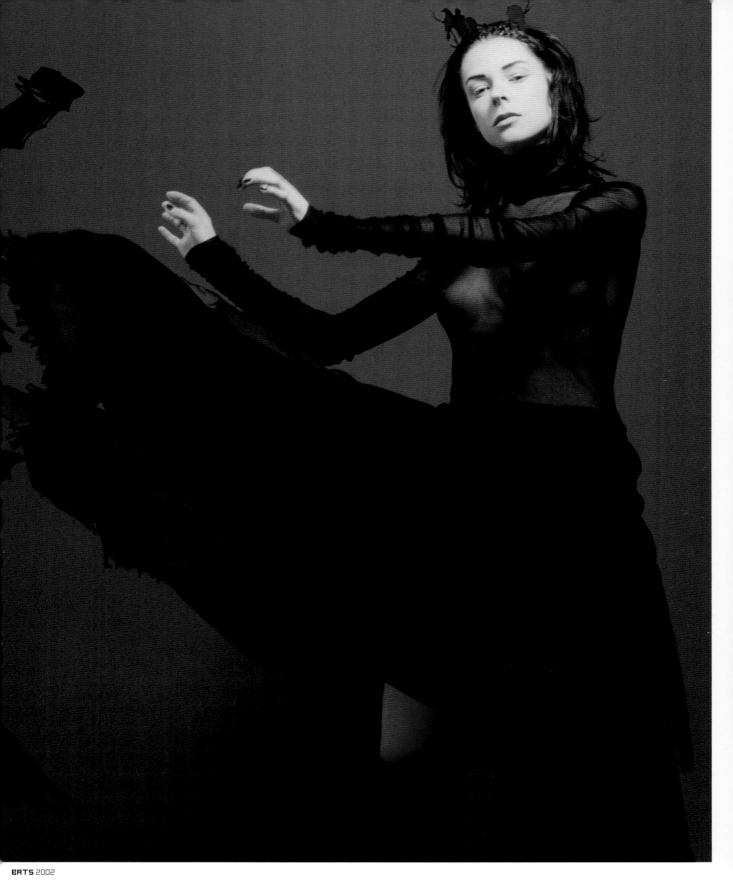

Sarah Howell's images succeed as puzzling visual anagrams that freely relish the current creative media platform open to artists. These images clearly support the maxim that "it's not what you see, it's the way that you see it" as computer and camera merge to form a patchwork of captivating photo-similes. Sarah is not afraid to raid the past. The decadence of Aubrey Beardsley's unique style is here synthesized with the irony found in Allen Jones's Pop art iconography. These mixed photographic and drawn montages dice with the same unknown that Hungarian Constructivist, László Moholy-Nagy, experimented with while teaching at the Bauhaus School of Art and Design during the 1920s. Sarah's technical manipulation achieves similar novel images of aesthetic abstraction. Her nonconformist approach to conventional glamour is treated subversively, like the DIY persuasions inherent in punk. Ultimately the viewer is left speculating at this unguessed subculture, questioning the ambiguity of the imagery while enjoying its clever intricacy.

SARAH HOWELL

AUSTRALIAN

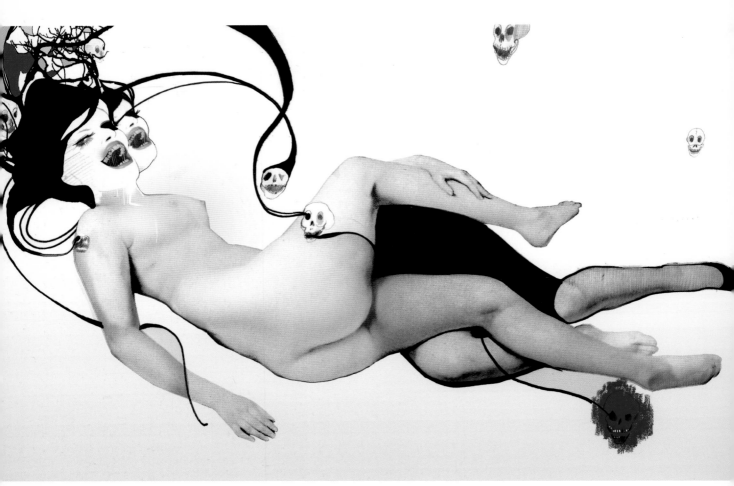

SMILING LADY 2004

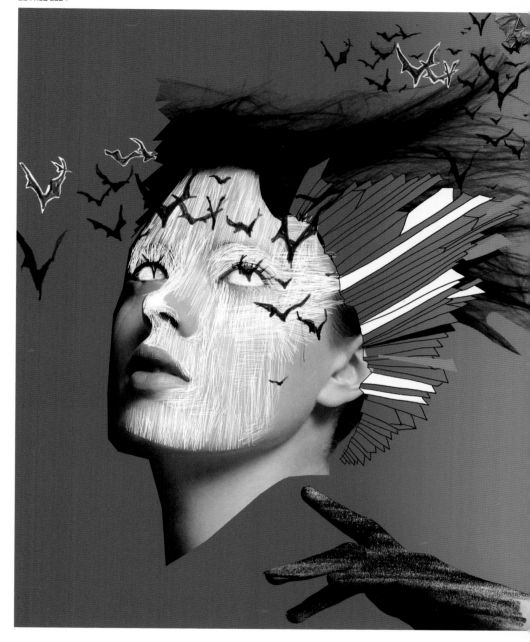

I have been painting and drawing since I can remember, but it wasn't until I moved to London from my home town of Sydney about seven years ago that I started realizing the potential of Photoshop in my work. Years ago I thought that computers and art didn't mix, it was somehow cheating (an idea that perhaps is a remnant from my strict academic background of life drawing and fine art) – until I discovered that the computer can be such an amazing tool in mixed media work.

I start with a collaboration, say with a photographer, and build a team to create a studio shot. I then scan this, layering collage, drawing, paint: anything that creates the textured final work. I get excited by the idea of an image being so full of different techniques that it becomes arresting and complex, yet beautiful. It is important to me, crucial, that my artwork is somehow precious and alluring, even in a disturbing way.

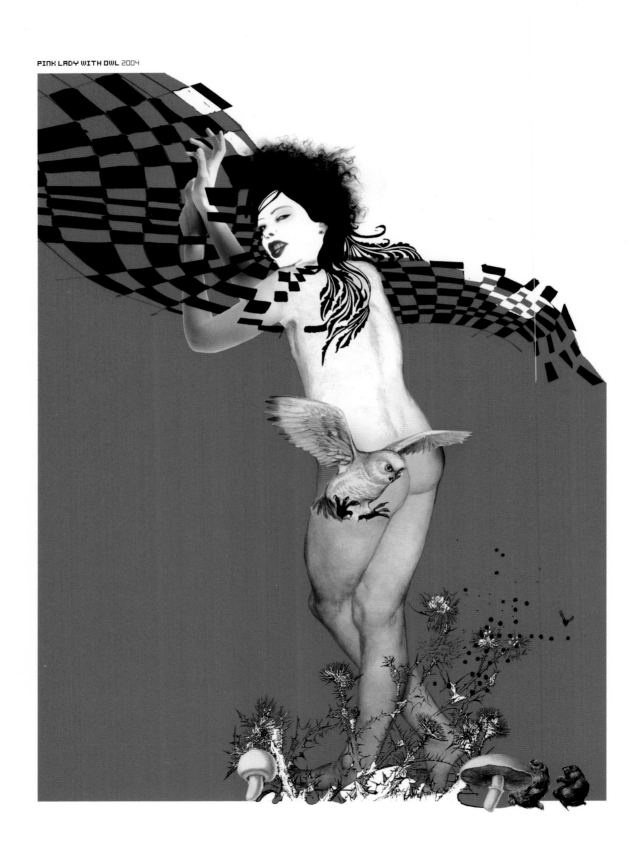

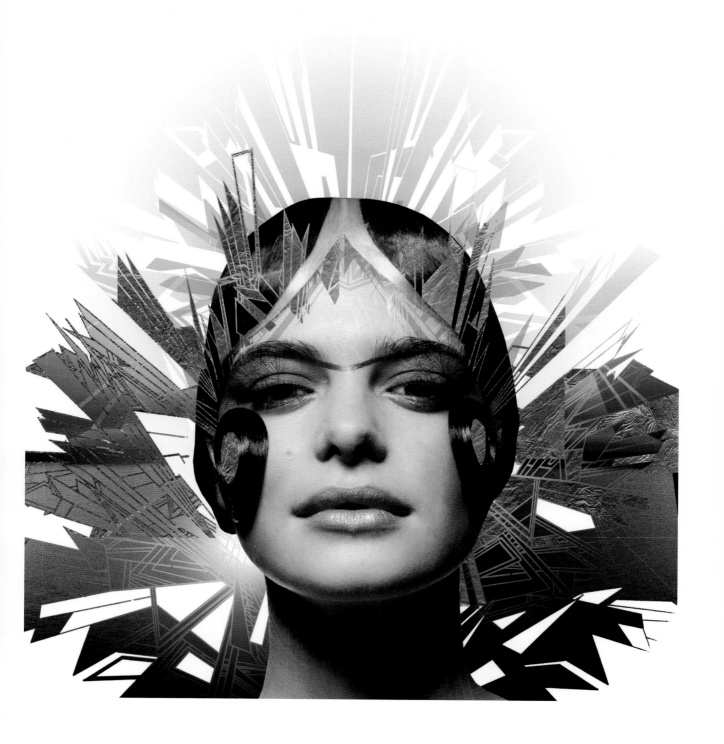

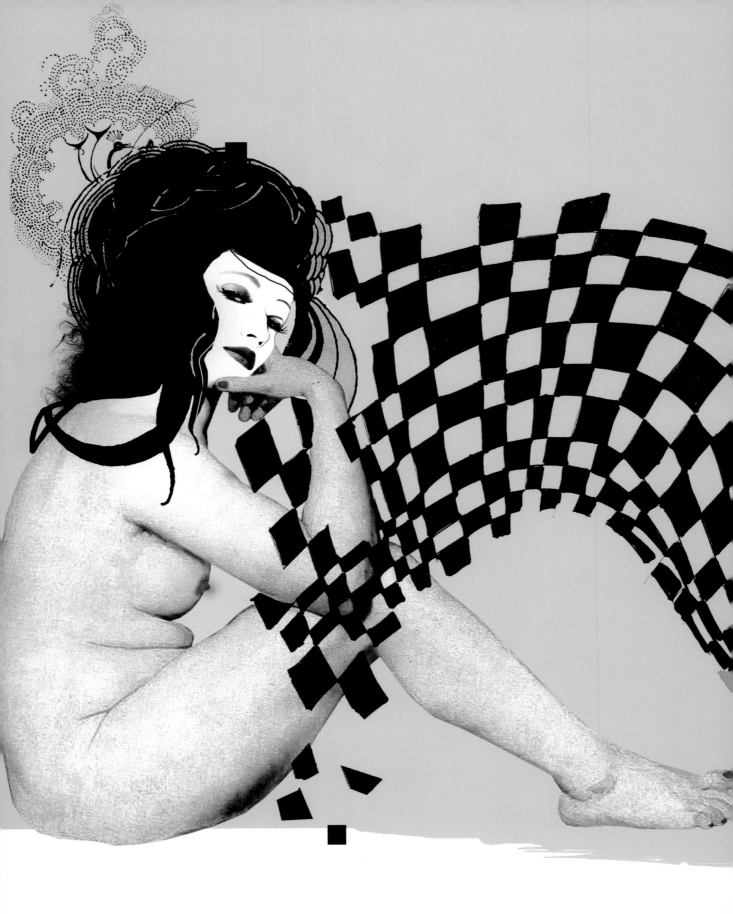

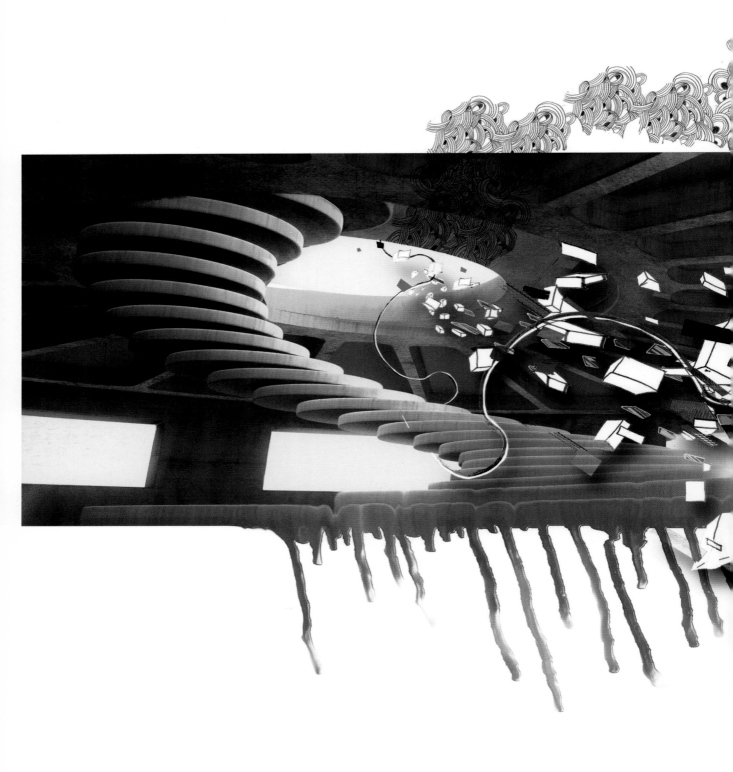

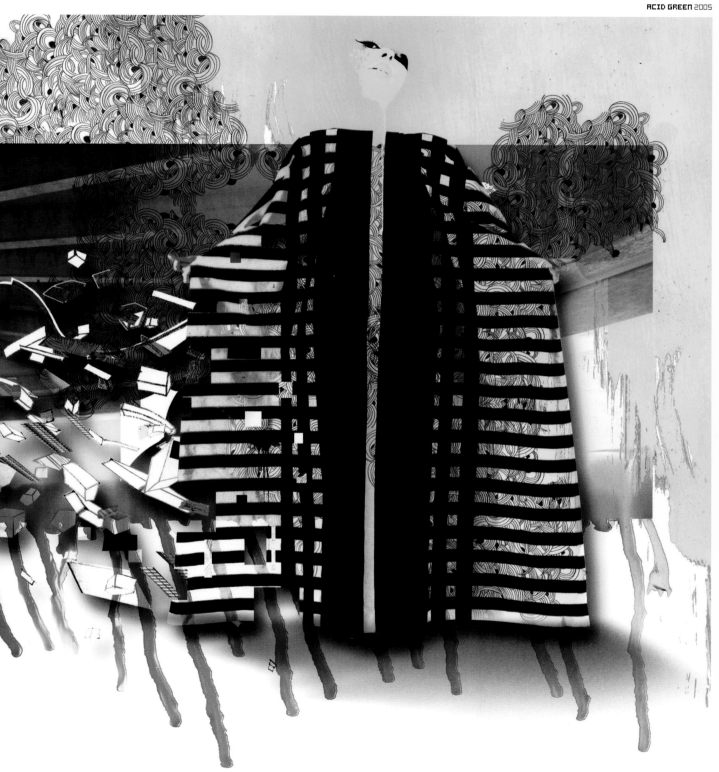

Resonating with a heady fusion of the dark art of H.R. Giger and the surrealism of Salvador Dalí, Francesco D'Isa's extreme explorations of digital transformation draw also upon a wealth of other artistic movements, from the statuesque and Classical to the sensual line of Art Nouveau and beyond. In this way Francesco evokes the past to provide commentary on the present. The sexual ambiguity of the image is all the more disturbing in its hyperrealist detail, which both alienates and attracts the viewer. There are noticeable echoes of the "physical prodigies" from Joel-Peter Witkin's controversial photographic oeuvre. Francesco's transmutation of the female form explores the journey from birth to death, with the metaphor of fossilized bone a constant reference to organic beauty even in decomposition. The aesthetic qualities of the female nude are linked here to the simple sculptural images that Imogen Cunningham photographed during the 1930s and '40s. The possibilities of digital media are shown at their most creative in Francesco's technically superb manipulations.

FRANCESCO D'ISA

ITALIAN

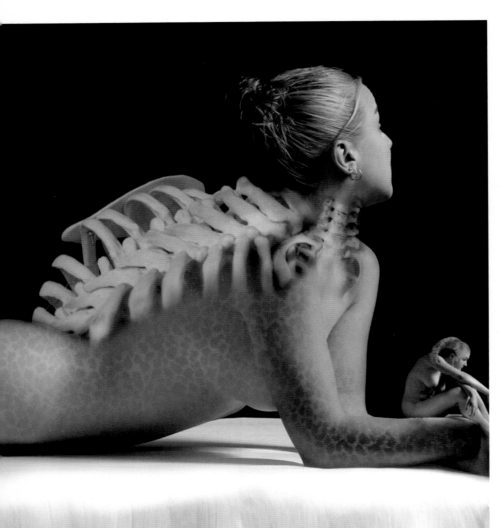

I was born in 1980 in Florence, Italy, and I studied philosophy at the University of Florence. I'm self-taught as an artist: my fascination with visual imagery has propelled me into mastering the required skills. I have published most of my digital and traditional artworks in the Italian art and literature magazine Mostro, but also in other magazines, both in Italy and abroad. I'm not a fashion photographer (I'm not a photographer at all) – fashion imagery, along with contemporary and historical art tradition, is the backdrop for my imagination.

My work has a very modern appearance but in fact it has its foundation in a wide array of traditions. It is the particular techniques I use, digital media in combination with photography, that are responsible for the modern feel of my work. But if you take a closer look you will recognize the Classical poses of the figures, no matter how deformed they are.

I love things in the very moment of their birth, when they get their definition. When horror meets beauty, horror and beauty are defining each other. I try to catch this particular moment using mostly the human (female) form. An image must catch attention but also teach a type of contemplation. There are too many images in the modern world and we're not able to really watch them.

DOUBLE LABYRINTH 2003

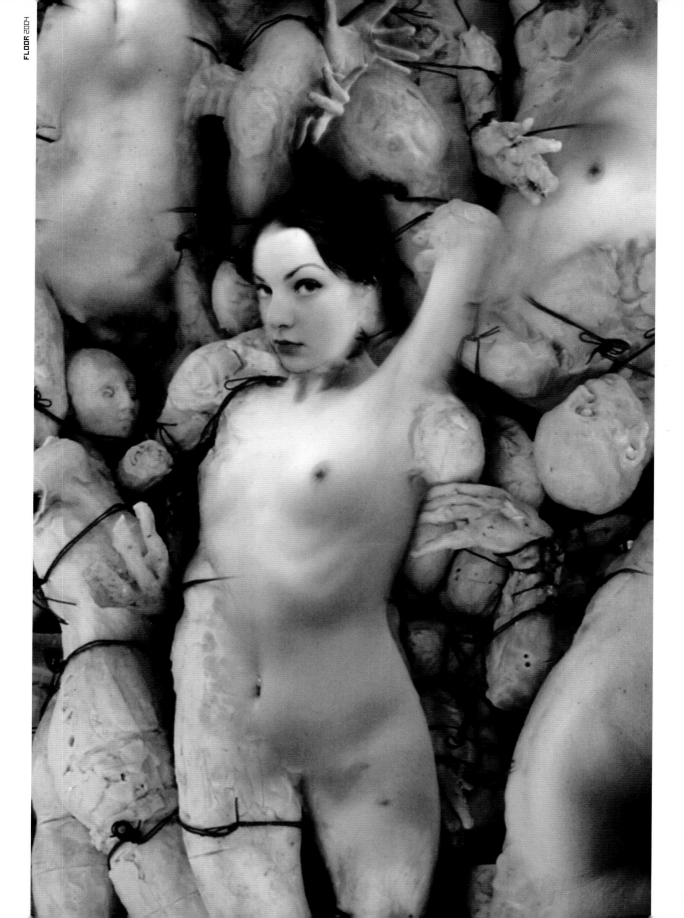

LIVING DECORATION 2003

SCEPTIC WILL EMBRACE SOMETHING 2002

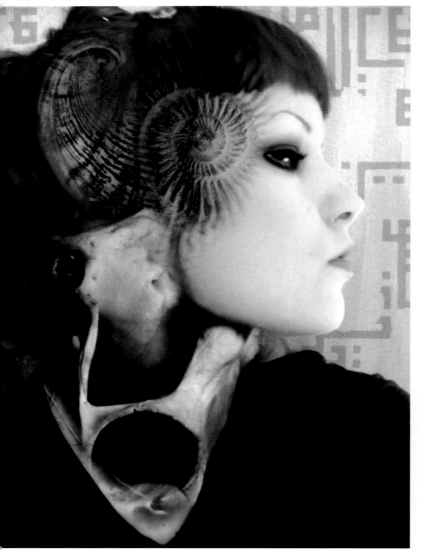

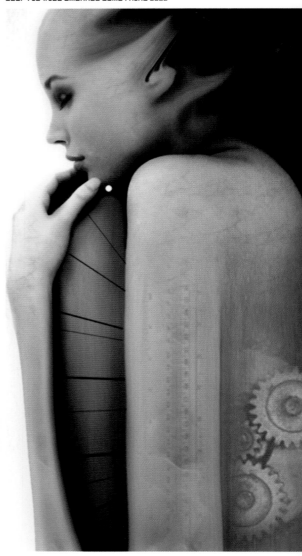

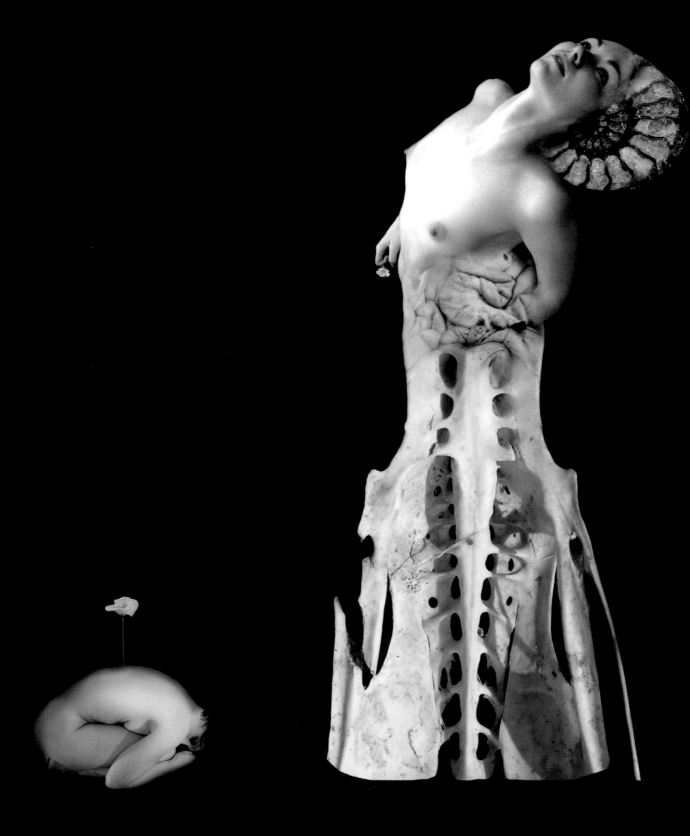

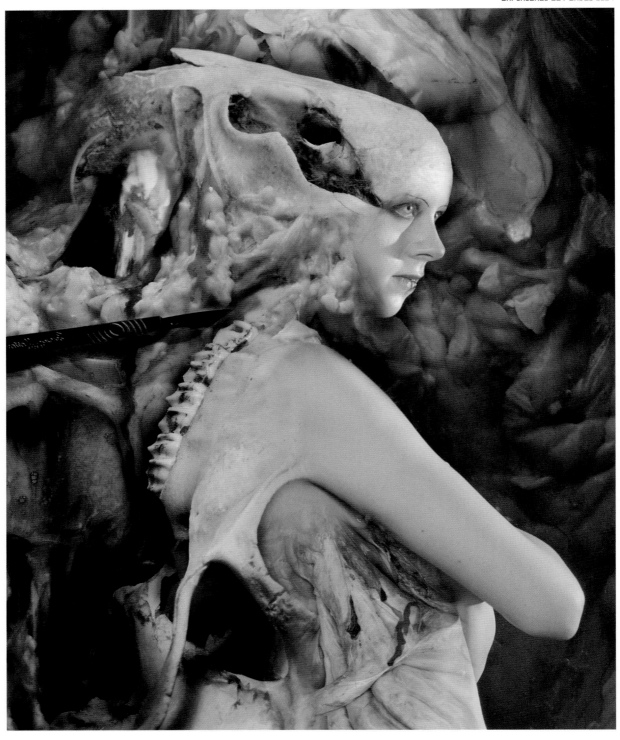

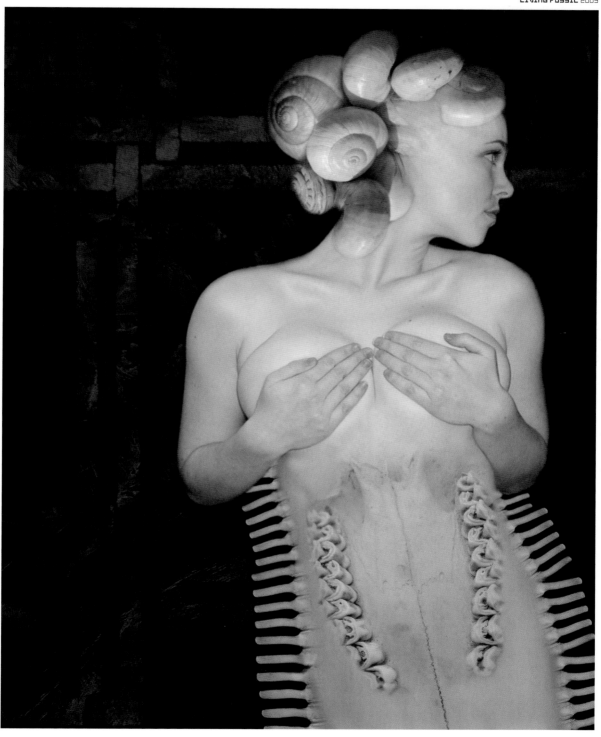

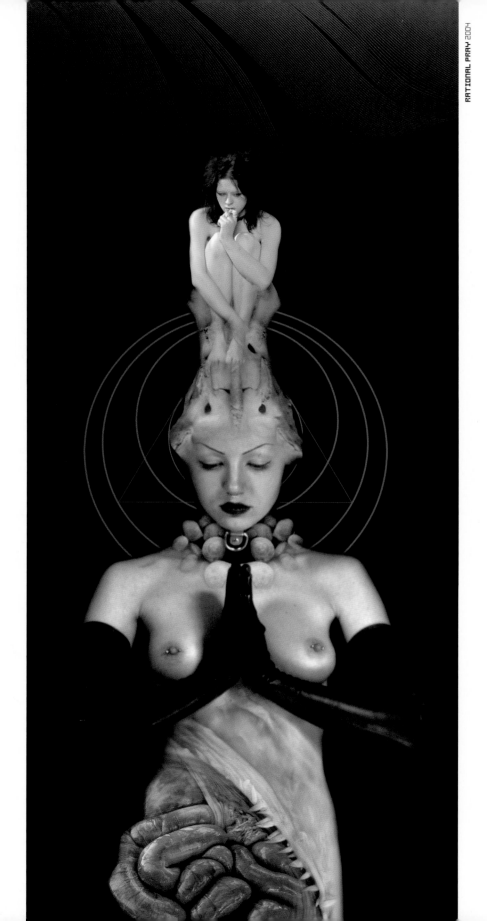

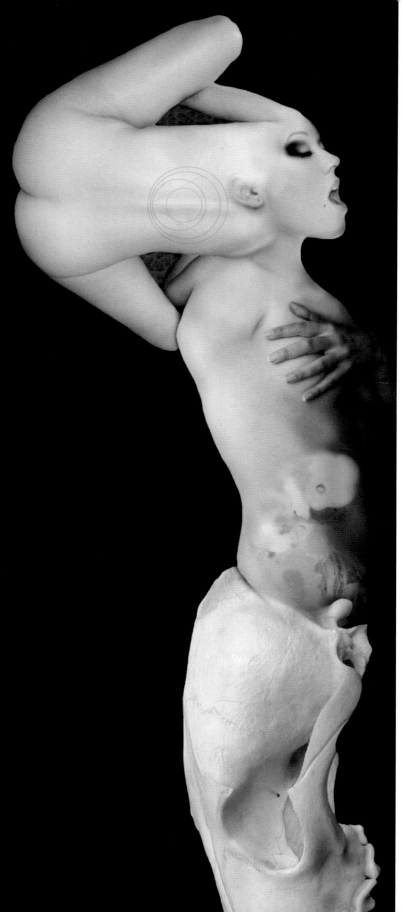

Sebastien Jarnot's outstanding digital images combine the realistic storytelling moments of tabloid sports journalism with the "Zap! Pow!" energy trails of pulp comics. The accelerated gestures of the figures carry the crucial twist, the unexpected variation that raises them above the stereotypes of most sports-related photography. Sebastien presents a 21st-century mirror that reflects the revelatory photo-sequences of athletes that Eadweard Muybridge caught with his experimental fast-shutter cameras in the 19th century. The dynamism of each action is evoked with tremendous visual impact, according with the Futurist concern to symbolize movement through lines of force. Networks of whooshing lines replace limbs that escape out of the frame. Sebastien unleashes all the power and drama (if not the visceral impact) associated with Nick Knight and Simon Foxton's "War" images for *Big* magazine. Captured from unusual angles, the participants speed off the page, leaving the viewer exhausted by the ride.

SEBASTIEN JARNOT

FRENCH

FIT SUPPORT TANK
GYM CAPRI

KICK-BOXING 2002

My parents ran a bar in a small French town. I used to draw all the time and the bar was the perfect place to observe people and behaviour.

As with a lot of draughtsman, my schooling was a failure. I spent a year in an advertising school; I learnt a lot but this wasn't what I wanted to do. I then spent three years at Brassart Graphic Art School in Tours, and after graduating I worked as a graphic designer in various small agencies. In 1998 I took my chances with freelance illustration.

I think I keep a lot of my childhood in my current work. I seldom have a precise plan or vision before starting a drawing: I start and pay attention to possibilities, harmony, and accident. I'm obsessed by fixed images and feel very close to photographers who have a way of capturing fleeting things, such as Richard Avedon, Peter Lindbergh, Mary Ellen Mark, and Larry Clark. In my images I'd rather play with sensuality, hidden messages, and abstraction than simply reproduce something or feel obliged to give a clear message.

I don't like barriers between styles. I admire the work of designers such as Raymond Pettibon, Aya Takano, Robert Crumb, and Paul Davis. I have many and varied influences from music, painting, movies… all of these are mixed together, which comes out in my drawings.

TRAINING TANK
BUDO PANT

KARATE 2002

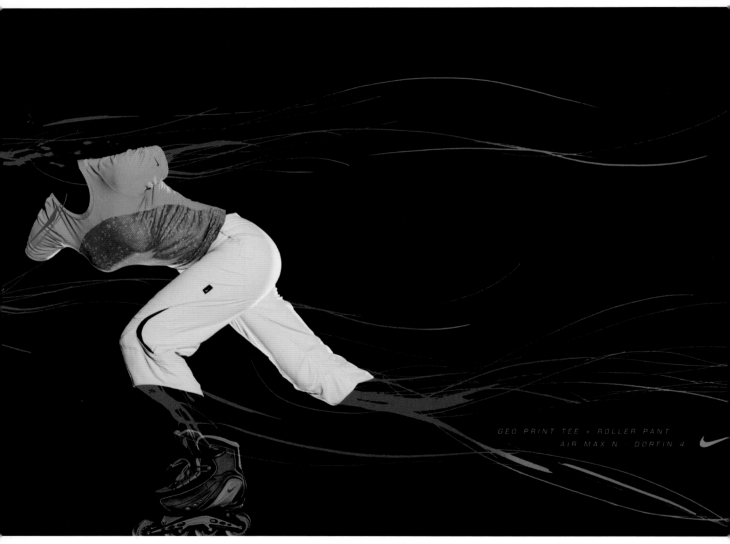

GEO PRINT TEE + ROLLER PANT
AIR MAX N · DORFIN 4

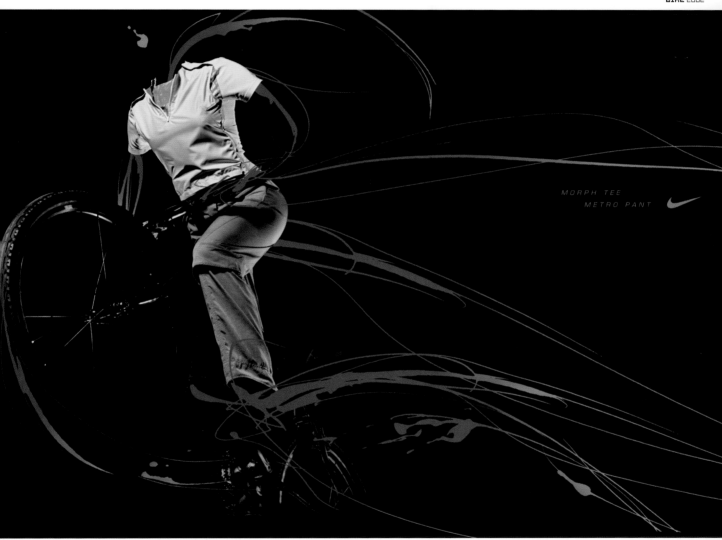

MORPH TEE
METRO PANT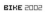

NERU TANK
KARATI CAPRI

DRIVING JACKET
FOUNDATION PANT

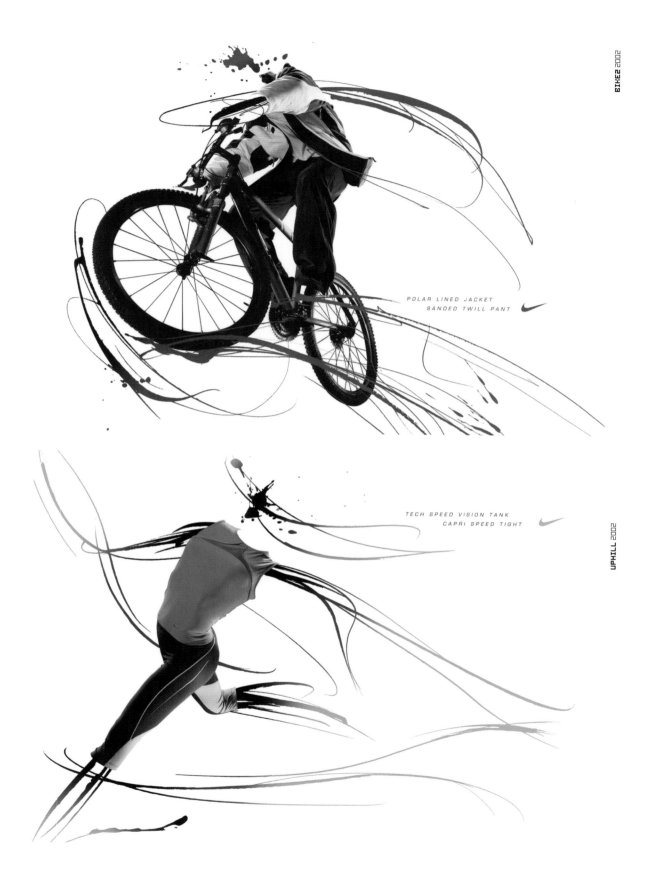

POLAR LINED JACKET
SANDED TWILL PANT

TECH SPEED VISION TANK
CAPRI SPEED TIGHT

With his intricately structured kaleidoscopic images, Monèt Kittrell revels in a love of creative anarchy. In his multilayered photographs he accepts the human body purely as another surface to decorate and embroider with ostentatious colour and pattern. Whether in the pulsating outline of the flexing model or in the uniform criss-cross basket-woven body, his imagination produces increasingly weird and wonderful imagery. These compositions give more than a passing nod towards the Surrealist photographer Man Ray, who pioneered the technique of photographic montage in the 1920s and '30s. The viewer is transported by the hallucinatory manifestations of Monèt's digitally enhanced photographs; menaced by the disquieting viewpoint and heightened perspective of the blue-hued "devel", who fills the frame like a genie emerging from a bottle. Monèt's concern is not that of the objective camera lens, recording and setting down reality; his motivation is that of a dream-catcher, articulating the unknown through his manipulated photographic art.

MONÈT KITTRELL

AMERICAN

SPLASH 2002

BLUE DEVEL 2003

MORNING DEW 2001

I feel that where I come from is unimportant: my focus is on where I'm going. I will disclose this about my background: it was the extreme of every emotion. And this meant that I developed a very surreal imagination. My eyes are like camera lenses, every blink a snapshot. Out of this I form images in my imagination.

I am enlightened by the work of Helmut Newton, Henri Cartier-Bresson, Gordon Parks, Nick Knight, Nan Golden, and Robert Mapplethorpe, and am captivated by their style and sophistication in making photography an art. I desire to be noted as a modern-day influence for future generations, presenting an avant-garde style as a photographer. The importance of photography in my life and what it means to me are beyond words.

The basis of my photography is the montage of fashion, style, and futurism. When my work is viewed by the public it is my intent to move the viewer. Whether art is good or bad is not as relevant as the fact that the viewer is moved, emotions stirred. Being able to share my artwork is my personal utopia.

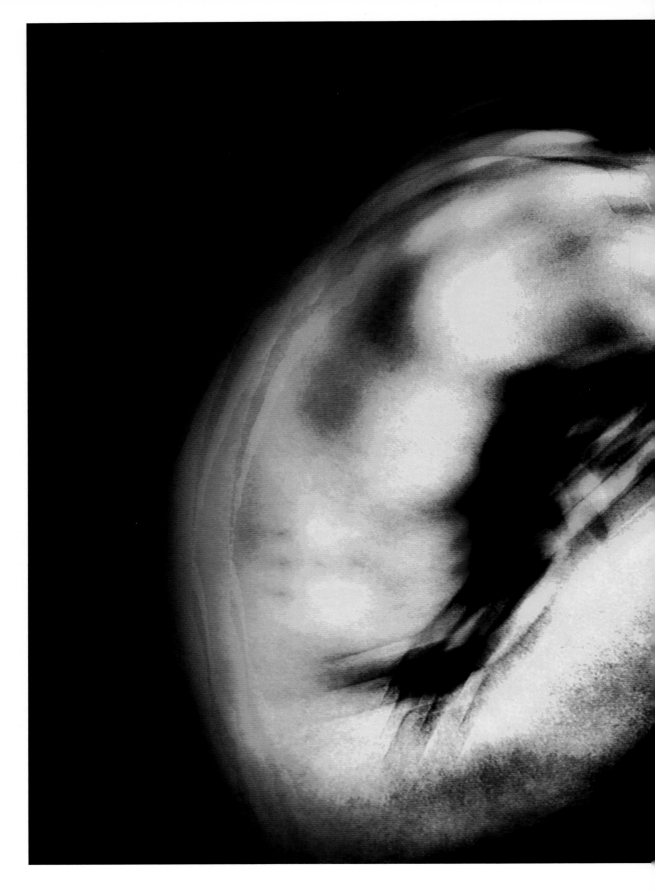

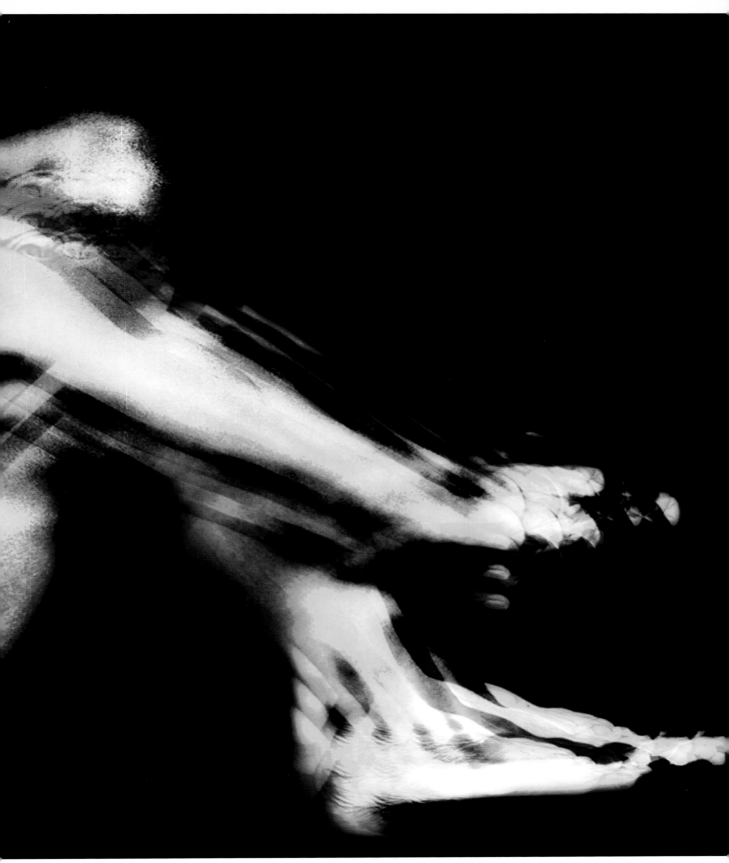

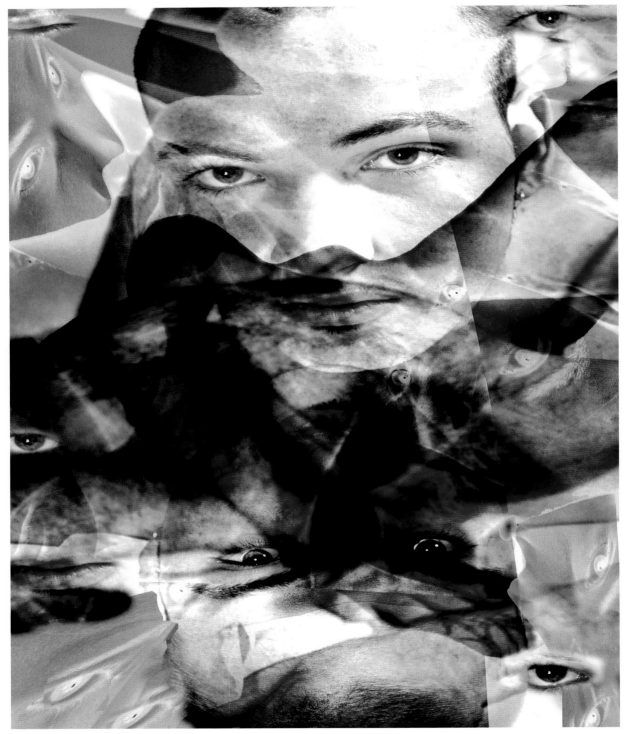

ICU 2004

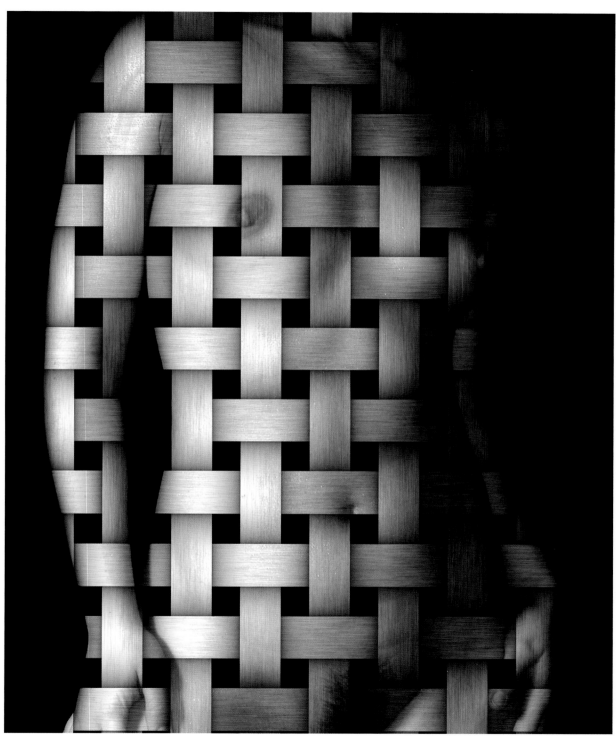

BASKET 2003

Jo Lance displays a breadth of vision that allows him to fabricate, digitally, artificial worlds of sensual sophistication and unsettling beauty. Delighting in the ambiguity of visual form, he metamorphoses his subjects into dreamlike apparitions. Reiterating the sanitized futuristic worlds envisioned in the 1960s by fashion designers André Courrèges and Paco Rabanne, Jo peoples his synthetic landscape with engineered imitations that could have been beamed up from the set of George Lucas's seminal science-fiction movie *THX 1138*. These mutated androids are superlative photographic accomplishments, the legacy of Futurism clear in their convincingly rendered appearance. They bear a resemblance to the futuristic, robotic *mécanique* fantasies of fashion photographer Serge Lutens in the late 1980s. In contrast, the peacock pedigree of the feathered female suggests the product of some mad scientist's misuse of bioengineering that could easily have escaped from the pages of H.G. Wells's *Island of Dr. Moreau*.

JO LANCE

MEXICAN

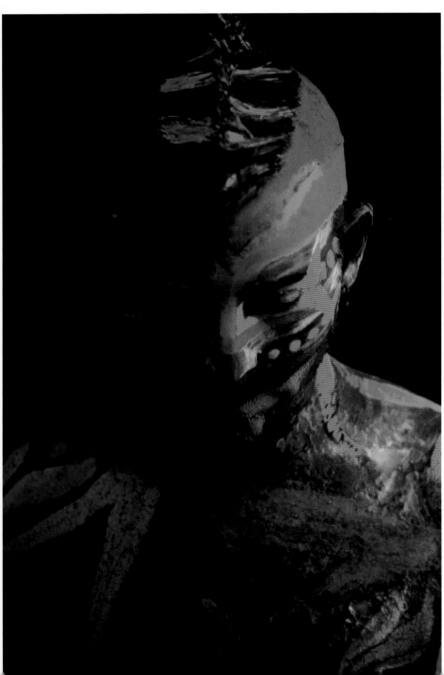

It was my calling to take photographs…

I was raised in a small town in Arizona, with part of each year spent on a small farm in California. This is where I feel my creativity started to take off: being bored, I had to do something. At the age of eight I decided to take photos of all my friends in school. I was already telling them how to pose and what to wear and how to do their hair – and who knew that I would grow up to do the same thing but get paid for it?

I went to New York at the age of 21, and two years later found myself working in Hollywood doing commercial work. Every time I tried to be creative with more artistic styles of image I would be turned down. So I decided to visit other parts of the world and see where people liked my work best. The years of travelling and the influence of different countries helped me develop my own style further.

I now live in New York in Times Square and work with many magazines and celebrities.

INTRAXIS 2002

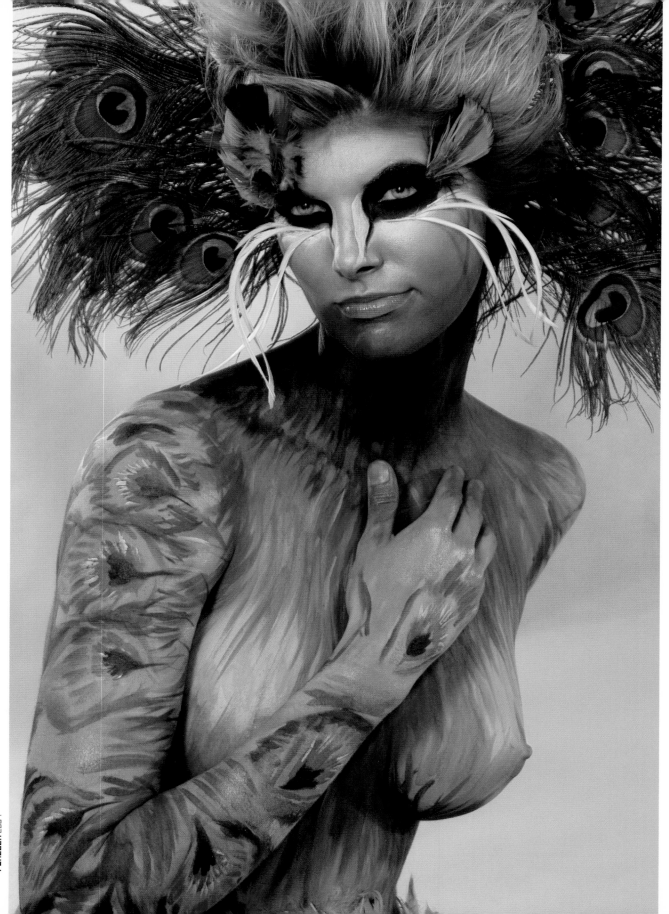

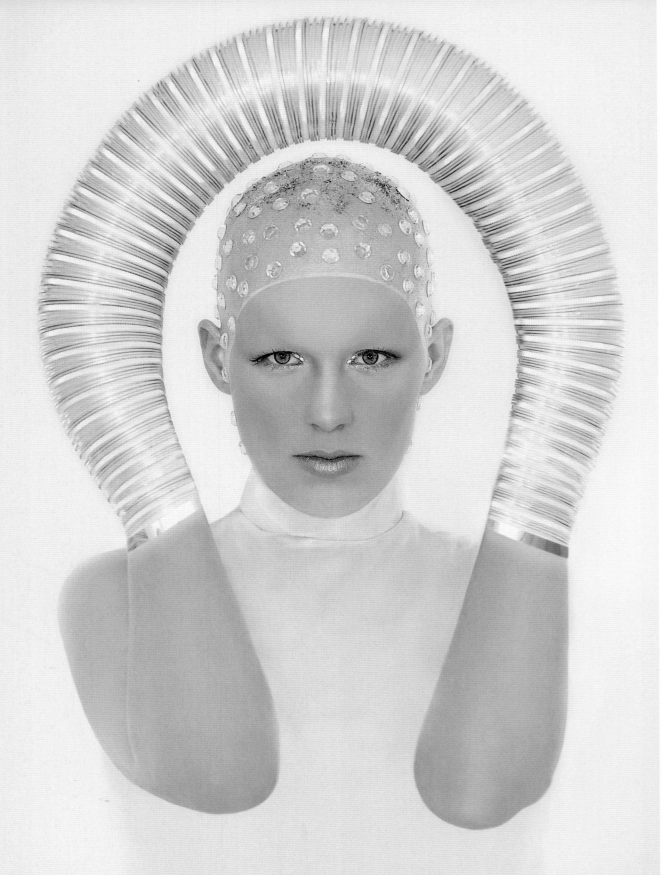

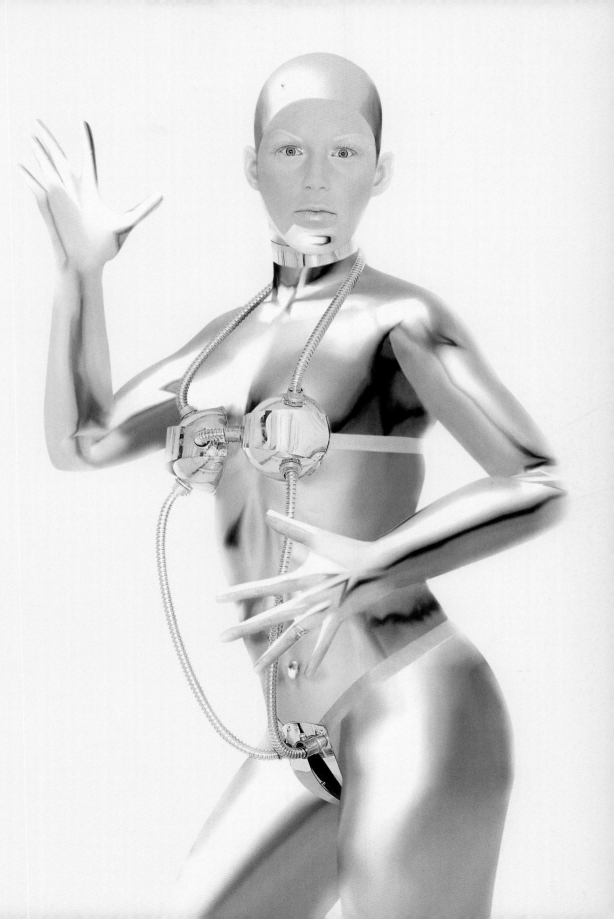

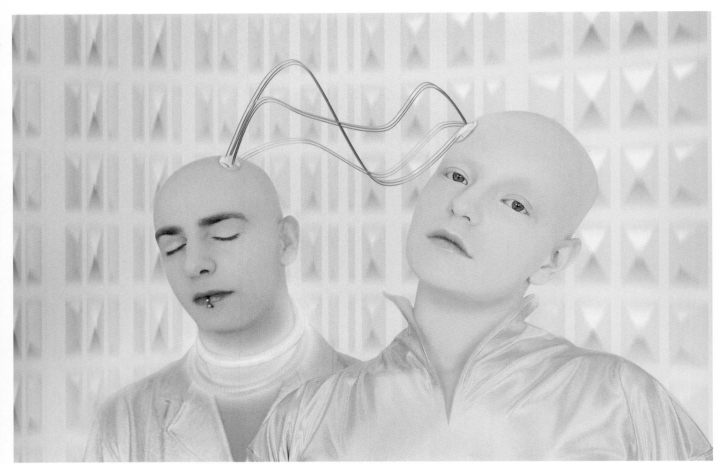

SPACE DIGITAL VISION 2003

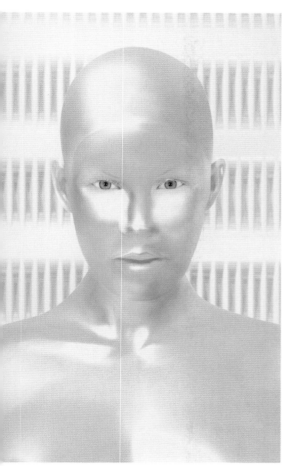

SPACE DIGITAL VISION 2003

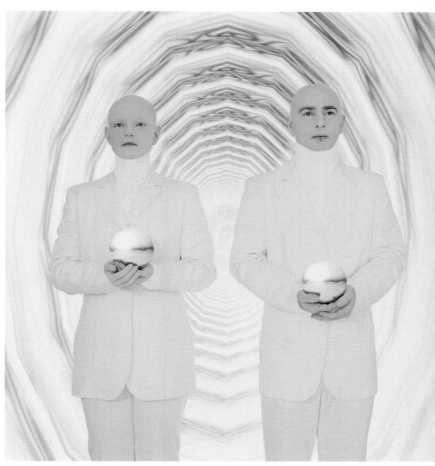

SPACE DIGITAL VISION 2003

Seemingly conjured out of some dim and distant past, Catherine McIntyre's photographs reveal themselves like an archaeological unveiling. These beautifully crafted portraits attest to her consummate skill as a powerful magician of the enhanced photographic impression. Her subjects are framed with theatrical flare – although these are not big production numbers; rather they are more intimate in their interpretative style. There is little reality behind these illusions. Yet Catherine's digital artistry allows her to call up images of women that, although they never existed, somehow have the semblance of faded memories. In this they have a dreamlike affinity with the wistful photography of Sarah Moon. The textures within each photograph are meticulously fashioned. Ultimately everything is finely dusted by subtle layering and further disguised by reduced opacity. In their own way her photographs share a similarity with the conceptual artist Cindy Sherman's "History Portraits" of the 1990s, both playfully constructing an imaginary portraiture.

CATHERINE MCINTYRE

BRITISH

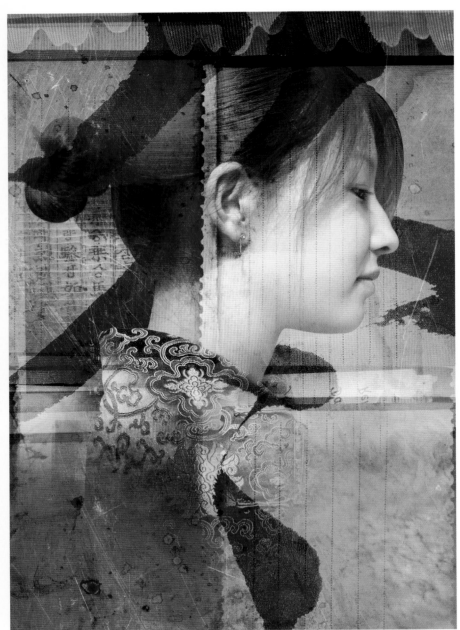

Born in England, I now live in Scotland, surrounded by landscape, skies, and wildlife. I spend a lot of time walking with my two greyhounds and a camera. The subtle colours and textures of such lovely surroundings feed into my work.

My favourite fashion imagery is atmospheric, giving a sense of the feel of the textiles, the movement and mood of the clothes. The influence of Herb Ritts has been vital; I aim for something of his directness and clarity. The organic, evolutionary aspects of Javier Vallhonrat's work are also an inspiration. Each piece, though, develops a life of its own, absorbing influences and then moving off somewhere new.

I am self-taught, and before I used a computer I was convinced that you couldn't achieve any kind of subtlety with one; then I tried Photoshop. My love of collage made it a perfect fit. My initial belief that nothing emotional could happen without physical creation was overturned. The fact that my images are fantastical – ideas becoming visible – perfectly suits a medium that allows creation somewhere between the two: between pure thought and the physical result.

JAPANESE WINTER 2004

THE SEVENTH DAUGHTER 2004

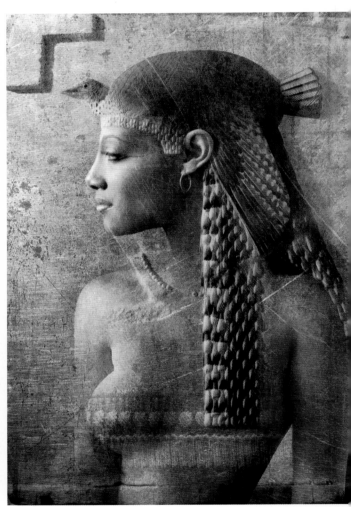

NEPHTHYS 2004

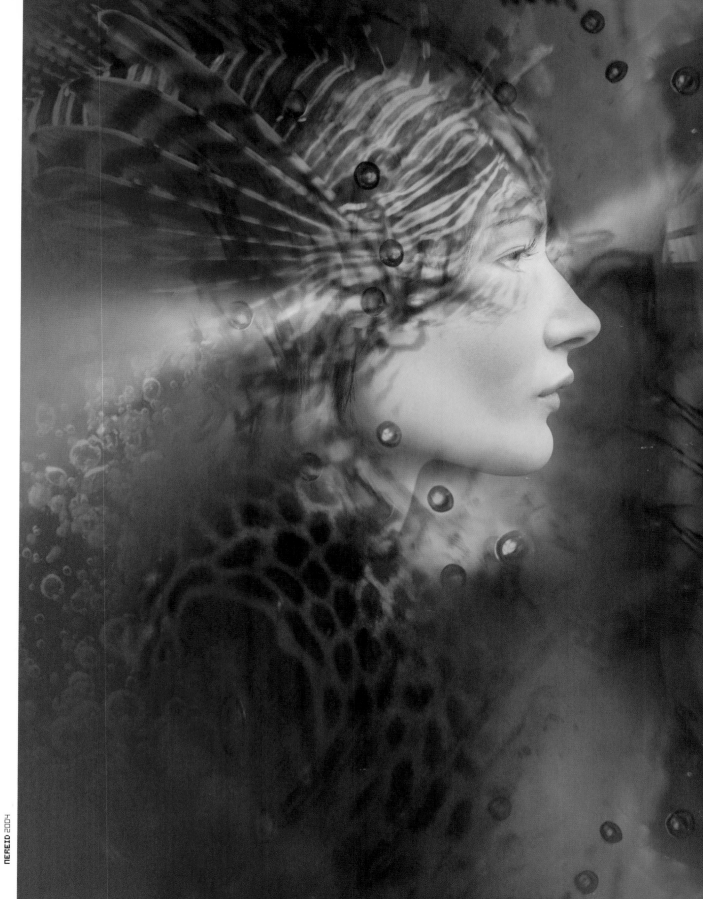

Christos Magganas's muse is a native cultural past that conjures up images of heroic dimensions; a similar regard for antiquity fuelled the Classicism of Victorian artist Frederic Leighton. Christos's application follows in the wake of Horst P. Horst, who was himself inspired by Classical paintings and sculpture in his fashion photography of the 1930s and '40s. Christos brings the myths up to date in his expressively articulated digital photographs that revel in a post-modern freedom. These 21st-century "gods and goddesses" brazenly adopt the mask of celebrity in the manner of a Herb Ritts portrait or a Warhol screen-print. Christos's animated dreamscapes conjure up similar lost civilizations to those evoked by Rommert Boonstra in the 1980s in his staged photographic images. Christos eloquently mixes motion graphics with image manipulation and 3D graphics to create fantastical photographic hybrids of stunning originality and beauty. The films of Peter Greenaway enjoy the same manipulation of multilayered and invented imagery that seems to repackage the past for the present.

CHRISTOS MAGGANAS

GREEK

DIMITRA/BIRTH 1999

I was born in 1972 in Greece, where I started my education. I then moved to London and continued my studies in design, finally getting a Master of Arts degree in Communication Design at Central Saint Martin's.

All my work derives from photographs and printmaking material that is put together digitally, plus 3D models that are custom-made for each image. All these are combined and manipulated digitally in order to produce the final artwork.

I am trying to bring together, through a variety of media, different methods of representing the body; to comment on aspects of identity and appearance in relation to gender, race, nationality, sexuality, and technology. There is much debate within the electronic arts at present about the role of the body in a digital era: I have done work about cloning, genetics, and "cyborgs". I am fascinated by genetic engineering and the so-called post-human body.

I am also interested in the Greek tradition of using stories, narrative, and myths. There is a poetry in the language of Greek myths and music that is an expression of an aspect of myself, which is difficult to express in any other way. Also I like to create implied narratives within my images. My work, therefore, often takes the form of a staged event.

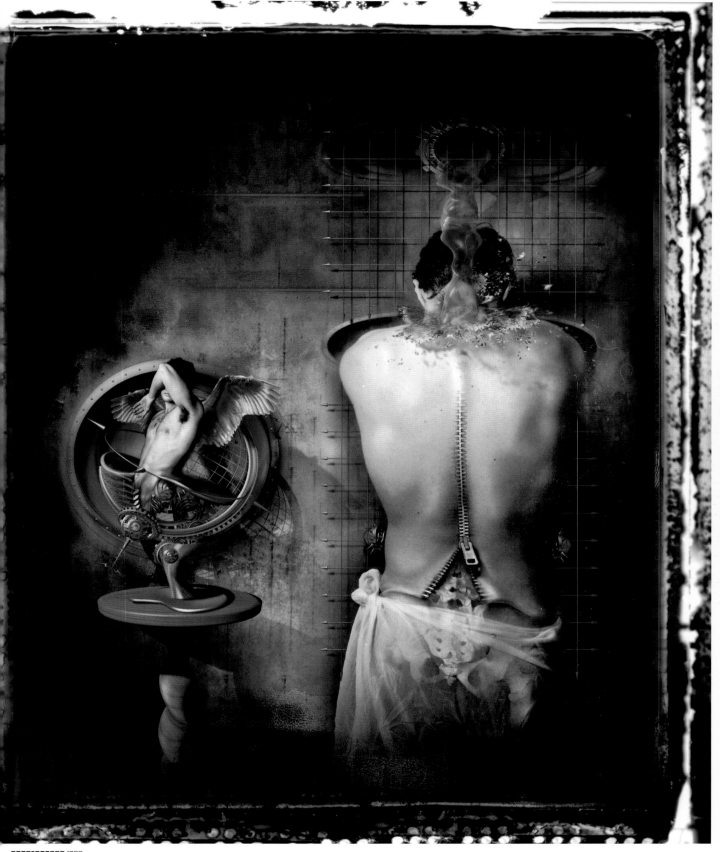

RENAISSANCE 1998

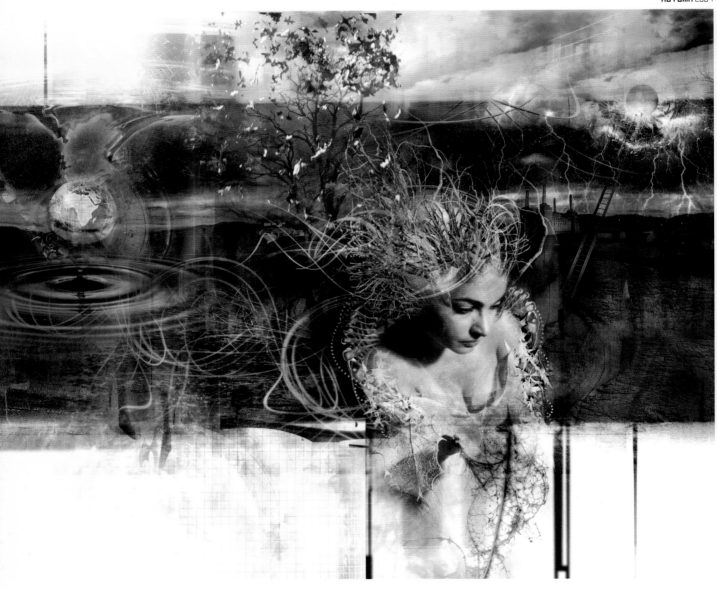

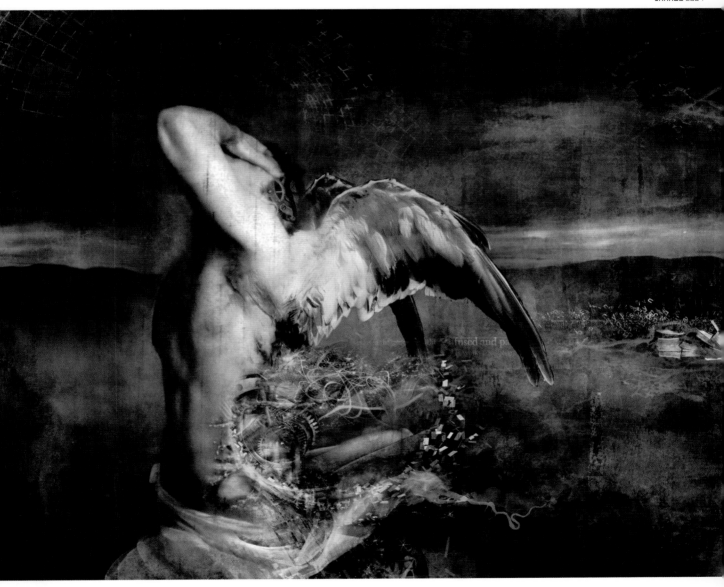

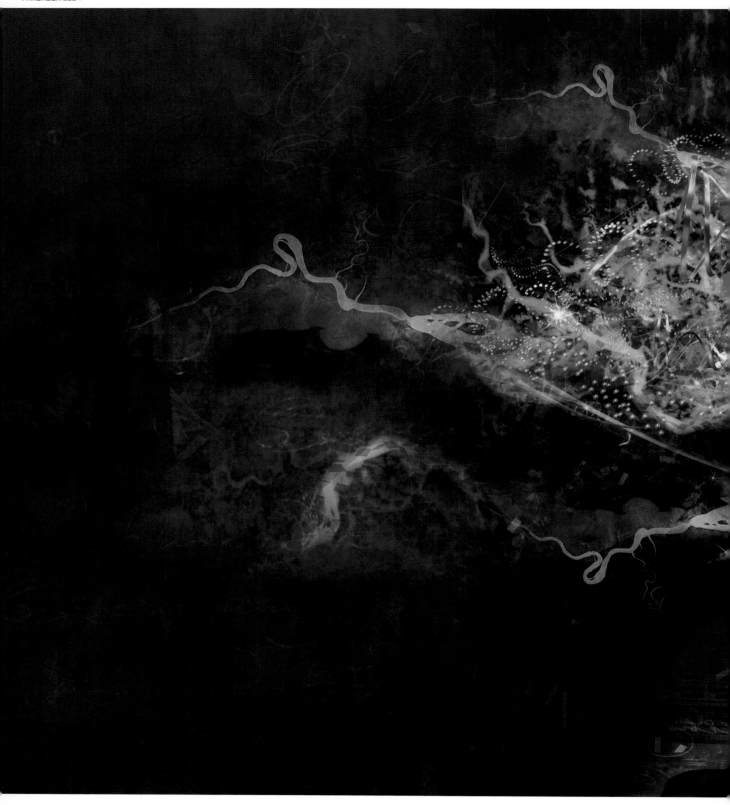

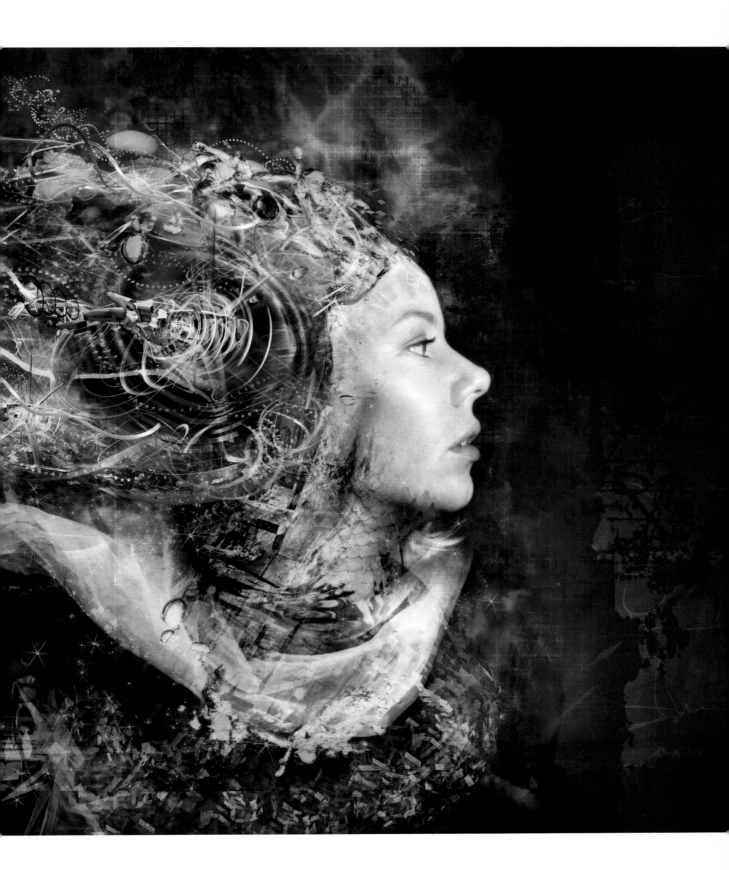

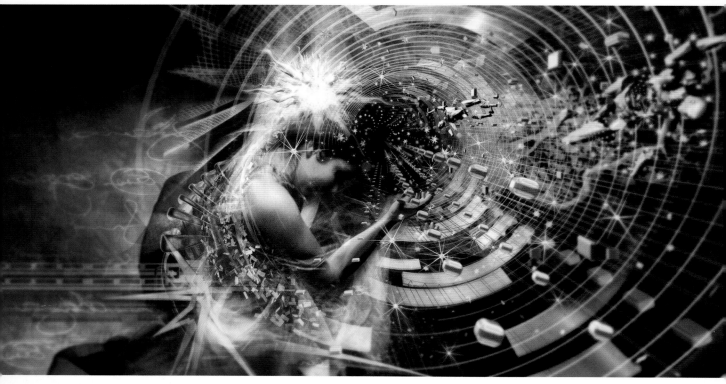

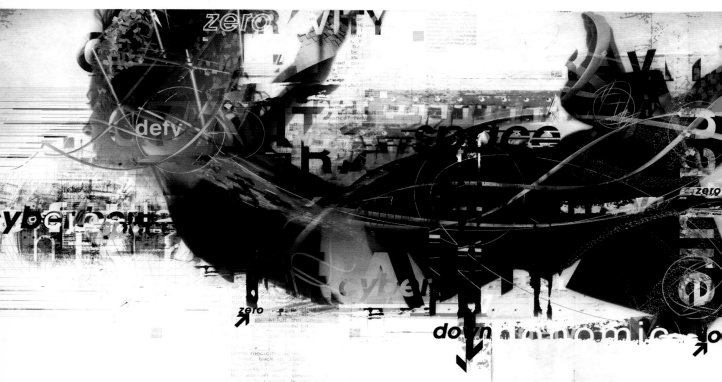

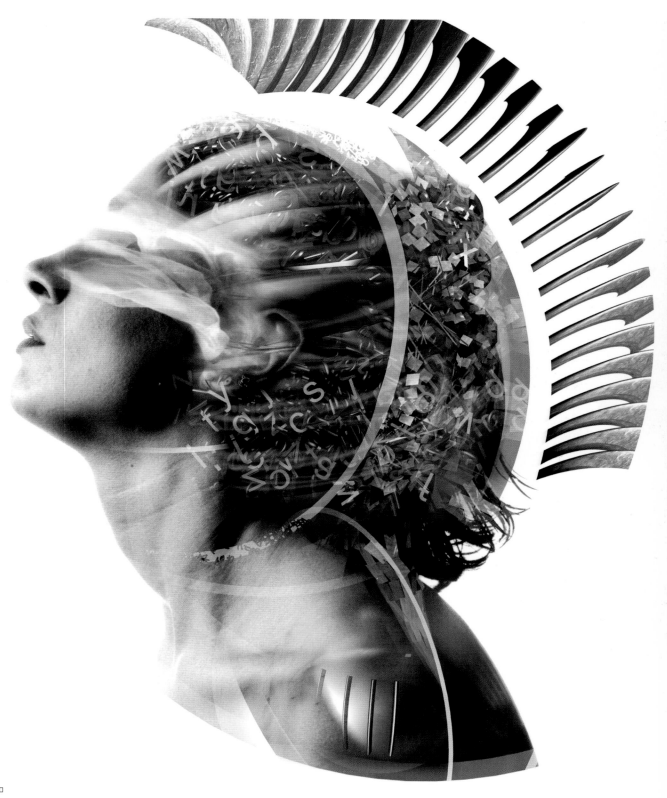

Adhering to the maxim that many hands make light work, the cooperative of Me Company whip up their version of the digital light fantastic by a singular collision of animated teamwork and vibrant artwork. Functioning like a latter-day version of the Magnum Photos agency that pooled together a team of international photographers after the Second World War, the members of Me Company relish the versatility of their own combined techniques, which adds to the distinctiveness of the output. Presented as a visual paradox, the commonplace is ambitiously reinvented through a sequence of narrative essays that captivate the viewer by their dazzling invention and digital effects. They challenge authentic camera reportage with their montages of make-believe images, a theme that runs like a leitmotif throughout all their creative output. By means of continual experimentation, they exploit a variety of styles and techniques that characterize and distinguish their work, ensuring its freshness and preventing it from falling into a repetitive house style.

ME COMPANY

VARIOUS

BJORK AS SELMA 1 2000

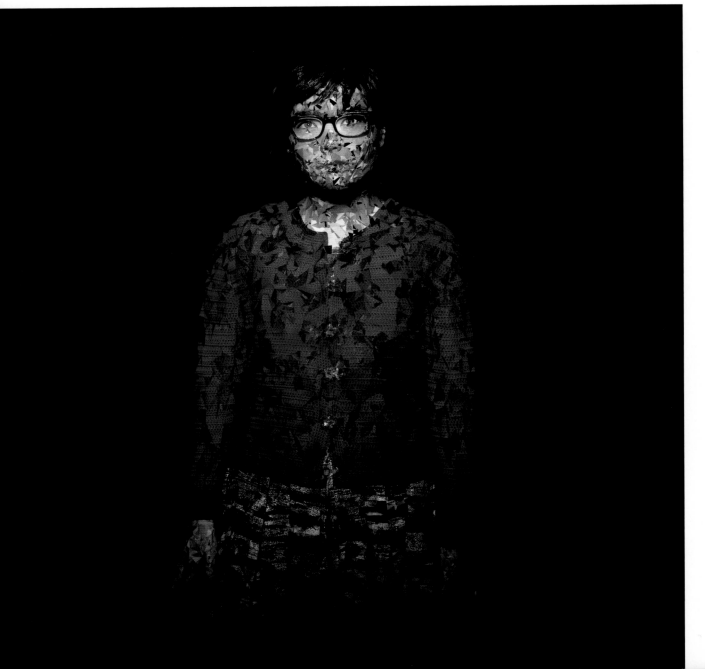

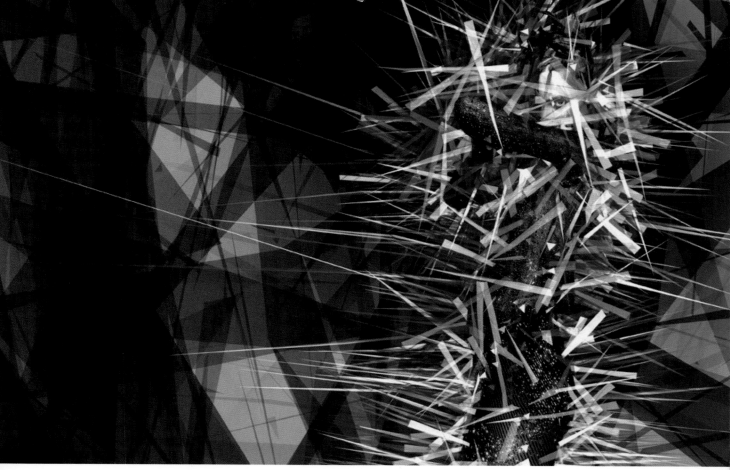

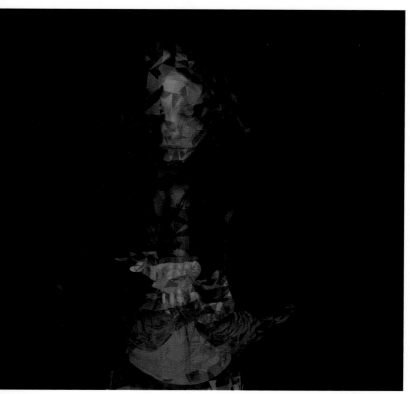

We are not an I, we are a we. Me Company is Paul, Jess, Rebecca, Ross, and Jamie. We come from various places around the globe and reside in London. We share a passion for all things modern and many things not modern at all – John Singer Sargent, J.C. Leyendecker, Naum Gabo, Victor Vasarely, Santiago Calatrava, Lebbeus Woods, André Bloc, Oscar Niemeyer, Greg Lynn, to namecheck a very few.

Our approach is based on being serious about having fun. Our work is intense and we enjoy strong relationships with our clients. They are companies who want to communicate modern ideas and powerful emotions to their customers. We work for a very wide range of people and companies, from artists such as Björk through to multinational corporations such as L'Oréal, Lancôme and British Telecom, and magazines such as Numero, Numero Homme, Gloss, and Big.

We always want to work for people who share our enthusiasm for new and innovative techniques. We are fortunate in that we have clients who are excited by our ways of thinking: in our own words, "A manifesto of metamedia and a gospel of untruth."

PANDORA 4 1999

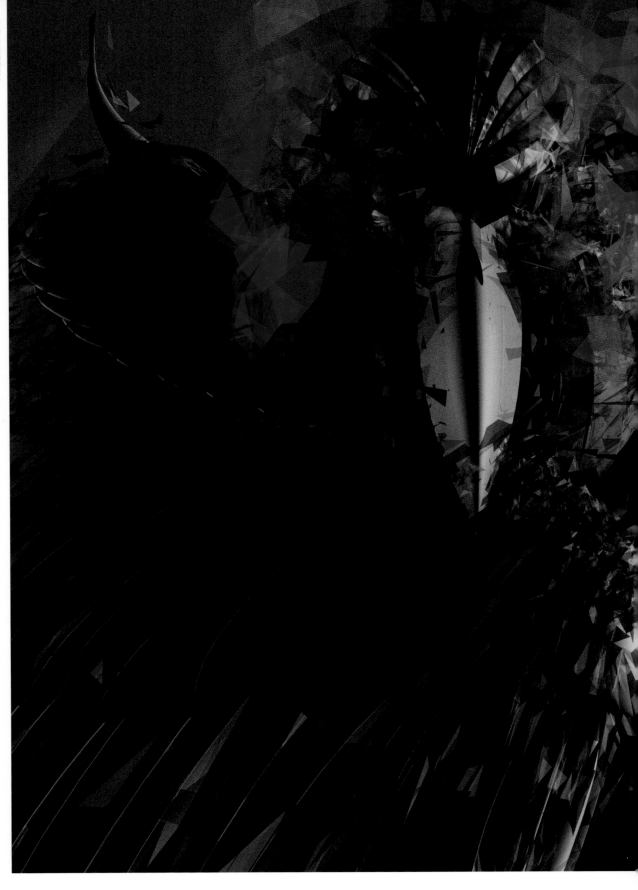

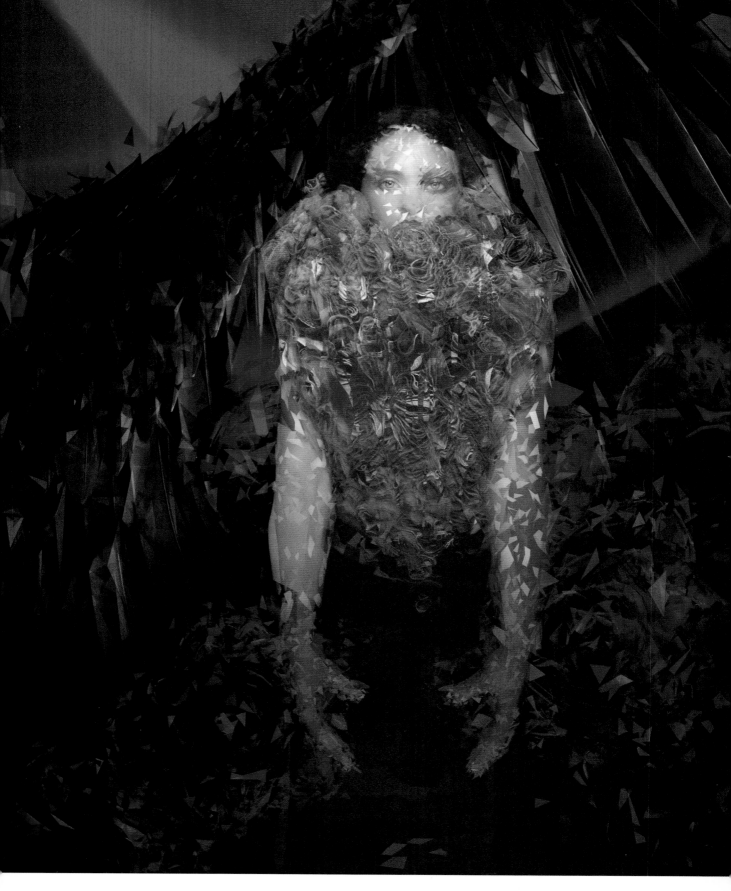

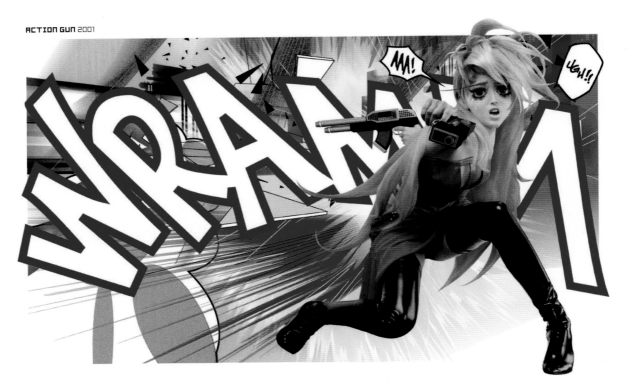

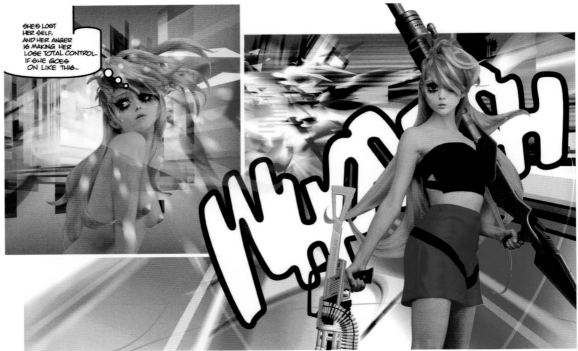

BIG GUN 2001

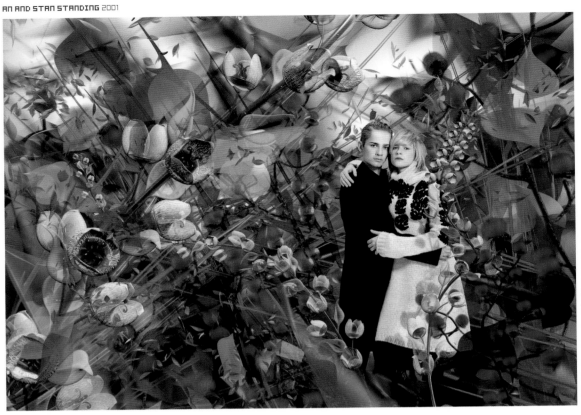

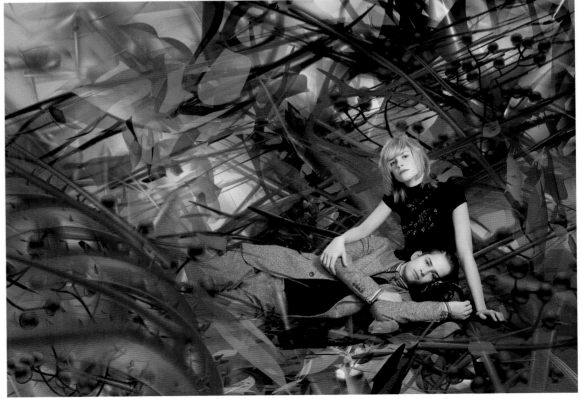

AN AND STAN LAYING 2001

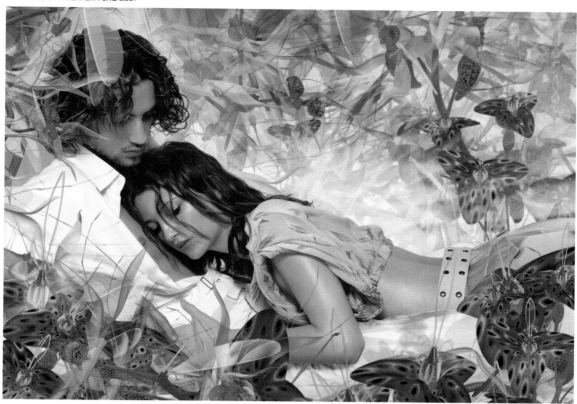

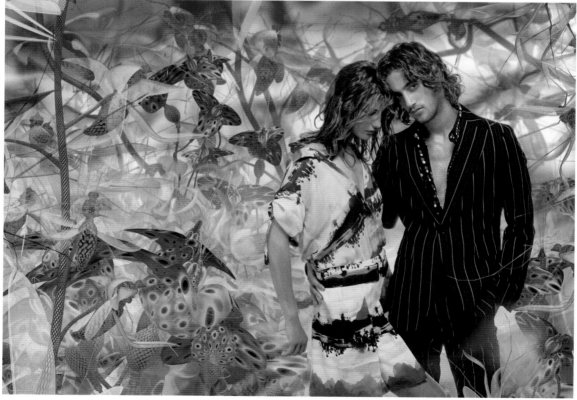

NOOT AND MATHEW STANDING 2001

These snapshots of urban life transcend the mundane through the clever articulation of genuine photographic reference and pixellated abstractions in the same frame. The mixture of the captured and the drawn offers a digital re-enactment of the experimental photographs of Lillian Bassman for *Harper's Bazaar* in the late 1940s, when she applied sweeps of painted colour over black-and-white printed images. Here the pictures are constructed, almost like screen-printing, by building up layers and texture. They offer a unique approach to expressing the here-and-now, which has become the Melegari trademark. Like the urban graphic illustrator Tim Marrs, they take their reference from street culture, giving a glimpse of today's society as recognizable and current as the reportage photographs of the 1930s and '40s were to readers of *Time-Life* magazine. Jacqui and Carl's view remains as unemotionally objective as that of Finnish reportage photographer, Markus Jokela, who singled out the ordinariness of life in the 1990s.

J. PAULL MELEGARI

BRITISH

Jacqui is English through and through and Carl was born of Italian parentage in North Wales. We met at art college in Bristol and have been together ever since. Jacqui went on to a career in graphics, while Carl became a freelance illustrator. It made sense to join forces and work together when digital illustration came into vogue. With Carl's love of fine art, photography and illustration, and Jacqui's technical graphics background and growing fascination with illustration, "J. Paull Melegari" finally emerged, fusing all these components.

The photographic element in our work evolved from Carl's interest in street fashion and today's urban lifestyle. The technical process of our work, inspired by our love of collage, involves the scanning in of photography reportage material along with line-work produced in the studio. The combination of media that we apply to our work is manipulated in Photoshop to create a dreamy, surreal effect. Among our influences are the lithography and screen-print work of artists Larry Rivers, Richard Smith, and Tim Mara. Our photographic influences include Henri Cartier-Bresson, Marc Ribound, René Burri, and Raymond Moore.

SMASH—N—GRAB 2004

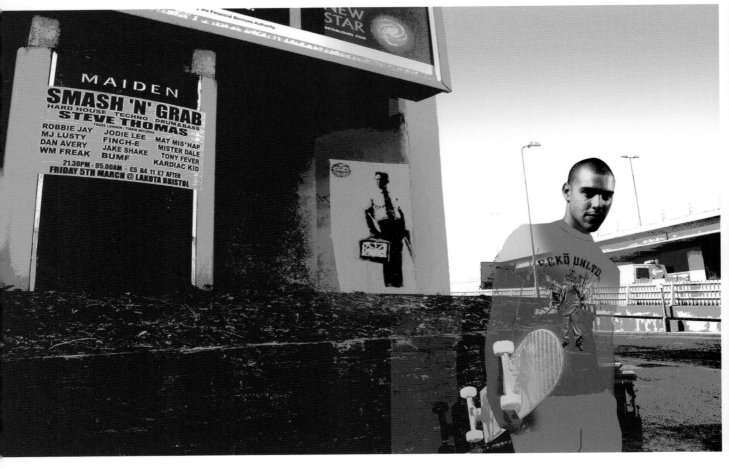

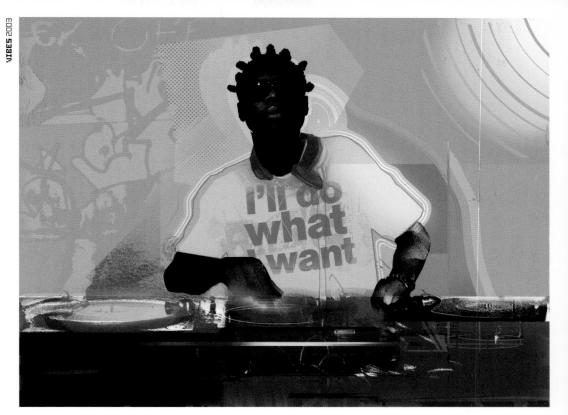

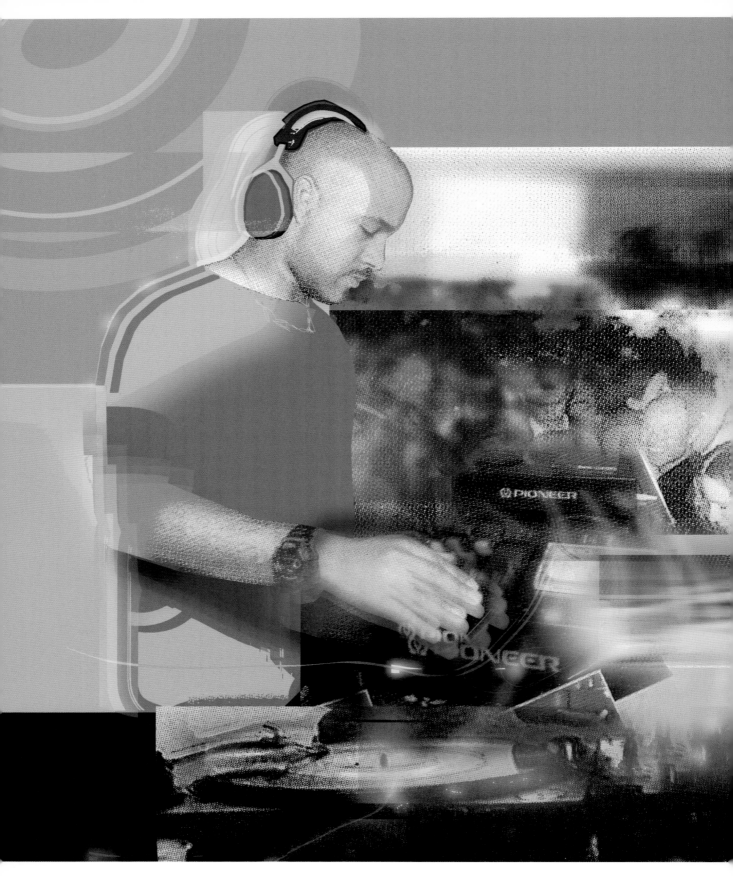

WONDERLAND – DJ 2003

XAVIER 2004　　LAURA & ATOMIC 2004

BANKSY 2003

YOLLANDA 2004

Bradford Noble wields his camera as flagrantly as Fellini's paparazzi in *La Dolce Vita*, with the consequence that "celebrity" is written all over his glamorously styled photography. These portraits function in a similar manner to Richard Bernstein's showy covers for Andy Warhol's *Interview* magazine, providing instant iconic fame for each captured sitter. There is nothing reserved or shy about Bradford's representation. On the contrary, his models flaunt and parade themselves for each predatory viewer in stylishly invented posturing that imitates the artificial hype of 21st-century media messaging. Bradford's images confirm that he is a consummate digital stylist who always buffs his models to sparkle and shine in the manner of Herb Ritts for *Rolling Stone* or Annie Leibovitz for *Vanity Fair*. He purposefully directs the flashy make-up and clothes to articulate today's visual culture. The lively invention and generous application of colour and pattern are surreal in their mix of the real and fantastic.

BRADFORD NOBLE

AMERICAN

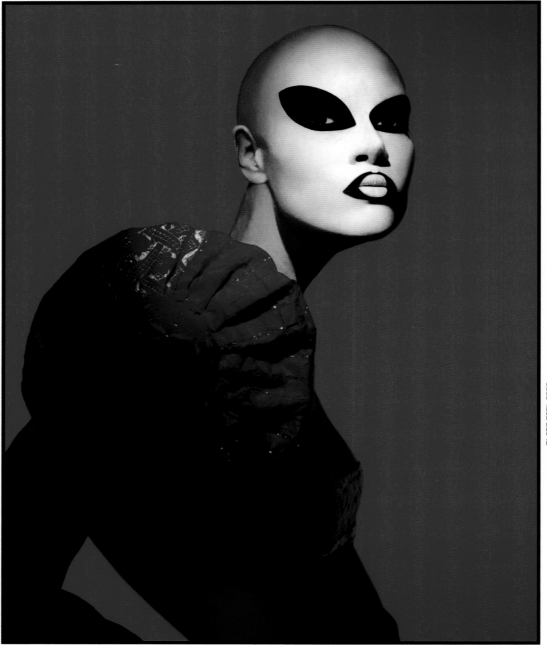

ALIEN GIRL 2003

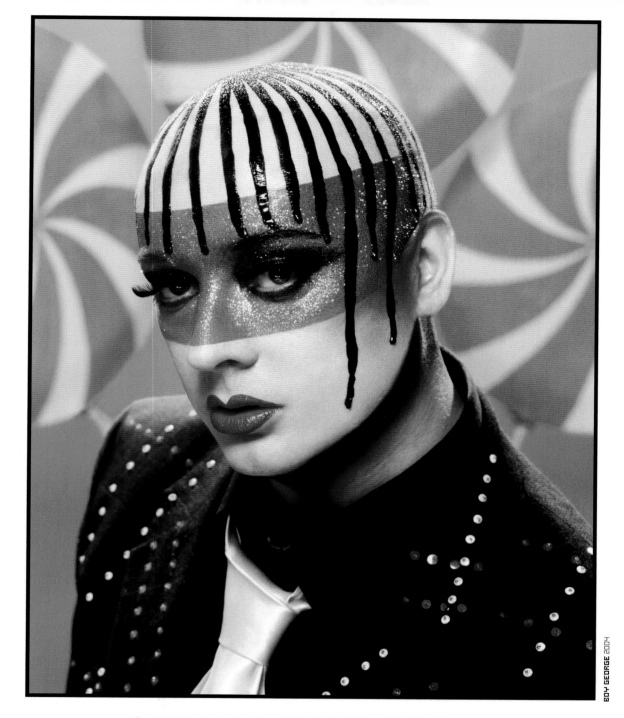

BOY GEORGE 2004

New York is the only place I could possibly live in the United States. Well, OK, Los Angeles is pretty fun, but to be successful as a photographer, New York City is the place! It is for me anyway. It's a make-it or break-it town – I thrive on this with my appetite for success. I have finally found a place that I can sink my teeth into – I'm taking a bite out of the Big Apple.

Although I consider myself a fashion photographer in my heart, it seems that America hasn't quite caught on yet. But I get to shoot all kinds of stuff and that I love almost as much as fashion, like celebrities, and beauty, and advertising. I do get to shoot my first love as well, but American fashion can so often be a bore!

It's true there are some magazines in the country that are great and take chances, but for the most part the images that fill the racks put me to sleep. I prefer to shoot strong, punchy, vibrant images that are dynamic instead of static. To make images that startle, or excite the eyes, images that jump off the page. These are the things that move me, this is my personality, and this is my world: welcome to it.

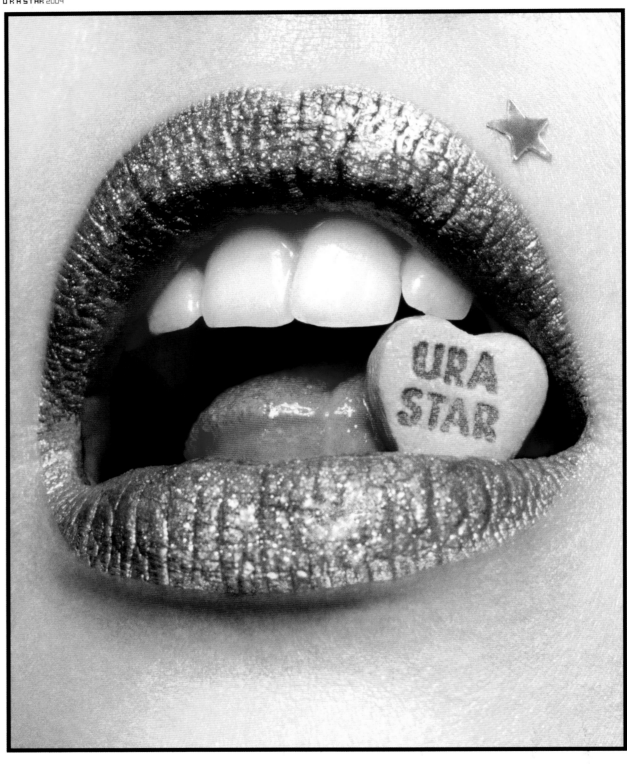

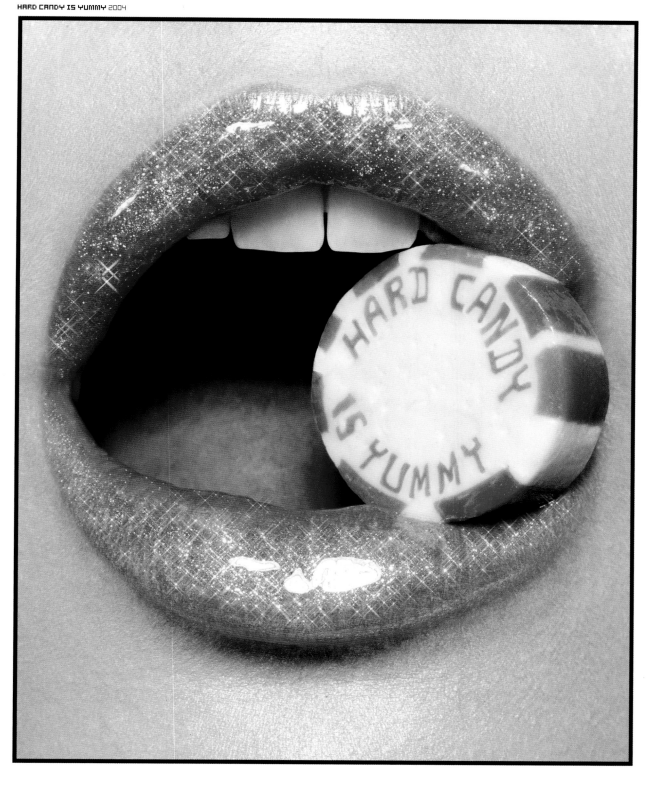

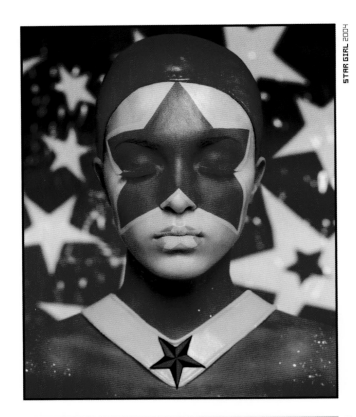

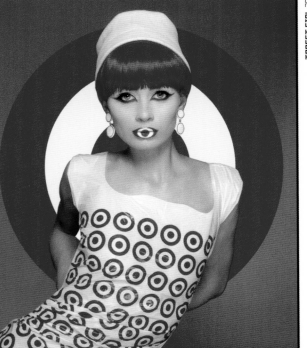

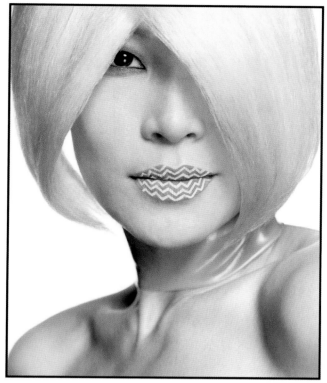

The viewer is instantly attracted to the artificial in these multifaceted images by numu (aka David Betteridge) which echo the distorted portraits of Alvin Langdon Coburn, who, in 1917, attempted to establish Vorticist photography. A sense of order is built around the mirroring of the central figure, with a rich array of exploding pattern and shape-shifting pixels. The whirling dynamic of each photograph is both rhythmic and kaleidoscopic. The reference to Russian Orthodox icons is inevitable in these exuberantly decorated portraits that fragment into multiple patterns around the sculpted face. The face itself stares out at the viewer with the deadpan gaze of a store-window mannequin. David's employment of intense decoration creates a sensual atmosphere that conjures up references as diverse as a sumptuously festooned (if bald-headed) Marie Antoinette or the haloed Virgin Mary gazing up to heaven. The visual language is rich and dense, and not just for aesthetic effect, instead it is easily accessible on a variety of levels.

∏UMU

BRITISH

SPECTRA 2003

I was born in London and have lived there ever since. My first camera landed in my lap when I was ten and I quickly became frustrated by its inability to interpret the world through any other filter than reality. It captured what was in front of it, not the interpretation that was in my head.

After I discovered the dark-room and the work of Man Ray and Moholy-Nagy, the camera became one tool in a process of creating a final work, not the only tool. I was inspired by the work of Erwin Blumenfeld and his unique combination of simple art direction, in-camera manipulation, and dark-room practice. Other influences are as diverse as Tibetan Buddhist and Central American iconography, the films of Donald Cammell, and the photography of Guy Bourdin.

I first discovered digital manipulation using video post-production technology. I work 90 per cent digitally but shoot film using a range of cameras and lenses if the look requires it, and often create effects in-camera rather than using Photoshop. Experimentation and new technology constantly add to the creative toolbox. But the most important tool is the imagination: it is through technique and technology that imagination becomes observable.

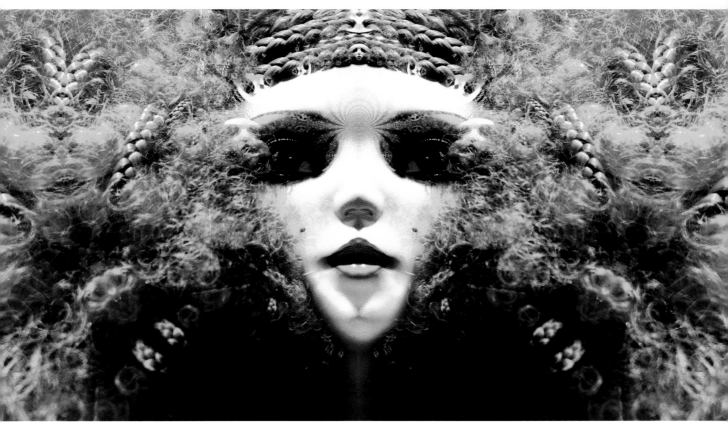

TAU 2003

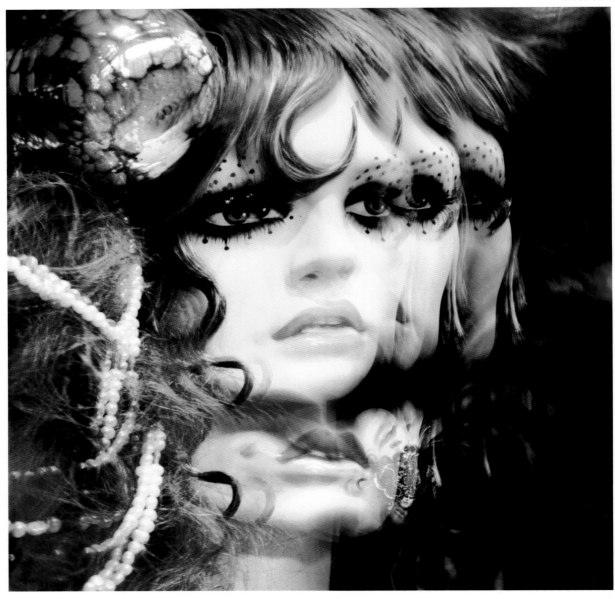

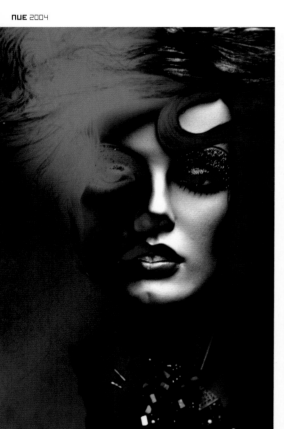

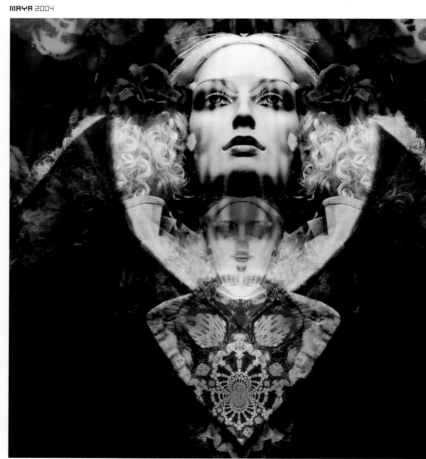

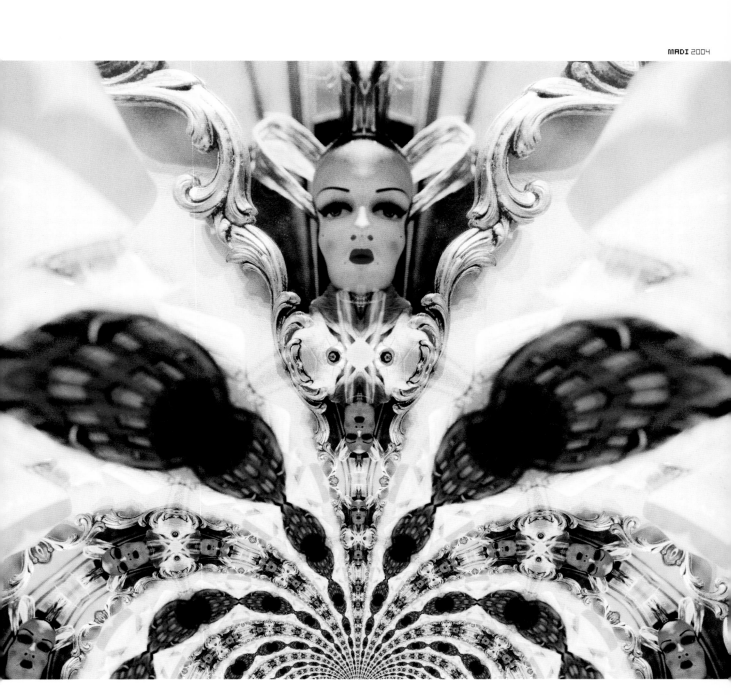

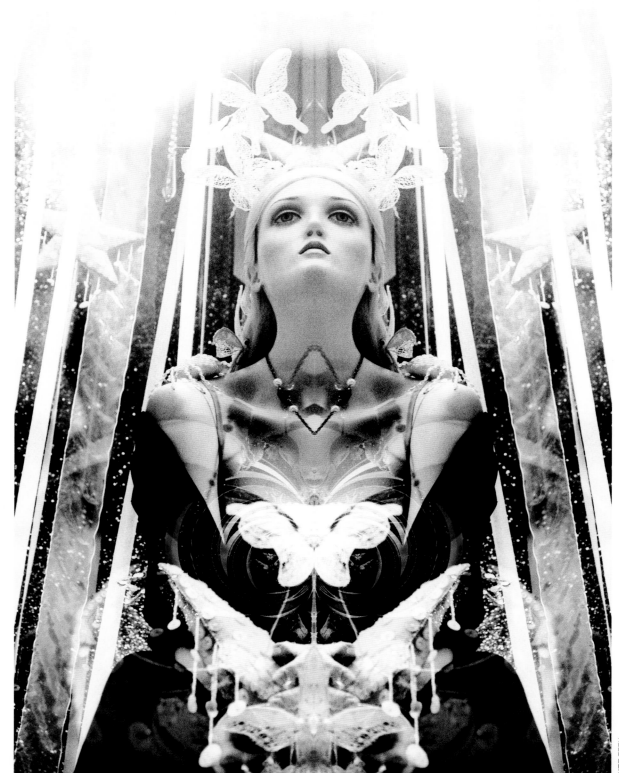

muon 2004

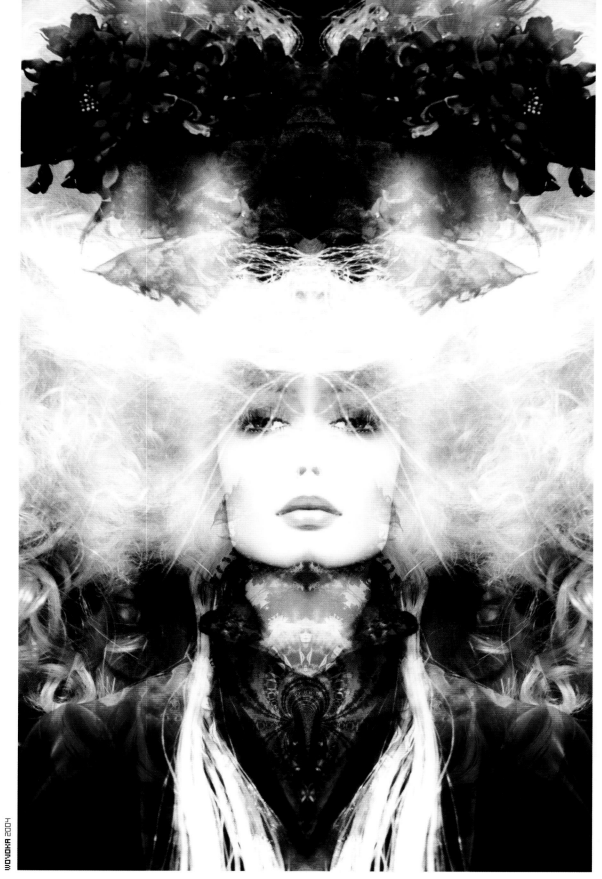

The truthfulness of the captured image is put to the test in James Porto's manipulated photographs, which immediately question the reliability of the viewer's eyes. These finely articulated representations operate like frames from the pages of role-playing games and pulp fiction, by the dramatic collision of the credible with imaginative flights of fancy. James's digital replicants inhabit the worlds conjured up by such fantasy genre artists as Rick Berry, Dave McKean, and Steve Stone. The industrialized females, wired to the same motherboard as Serge Lutens's *mécanique* photographs from the late 1980s, seem to link Classical mythology with the cybernetics of science fiction. These are godlike characters that show their strength by their imperious stare and superhuman actions. The electronic coiffure of Medusa seems to be writhing with the biomechanics associated with Swiss artist H.R. Giger. The flexibility of digital enhancement is demonstrated in the ecstatic expression of freedom as characters burst from their restrictions or seem effortlessly to run on water.

JAMES PORTO

AMERICAN

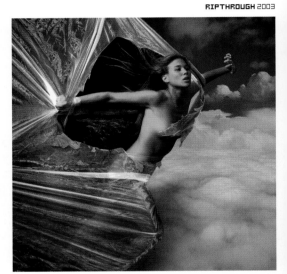

RIPTHROUGH 2003

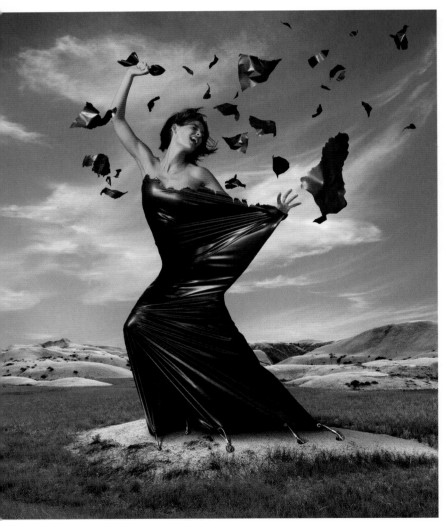

The fact that I was raised as an American in Saudi Arabia, in a media desert and in an actual desert, has informed all my work. I grew up without the hum of popular culture deafening my senses, free to reflect and to create from the recesses of my own thoughts. These factors also now leave me at a distance from the culture that I am partially forming; with no sense of the trendy, the current, I make each image with the intention of forming a timeless beauty.

At the age of 11, I learned the black-and-white process and began to photograph my friends. I became aware of the work of Jerry Uelsmann and Pete Turner, and loved the fact that they were able to create their own worlds with a camera. The works of Irving Penn, Richard Avedon, and Helmut Newton were also a great influence. The transition to digital imaging in the early '90s was very natural, as analogue manipulations were always integral to my vision.

I've done advertising and editorial projects, and I am always working on several series of personal pieces.

BREAKOUT 2003

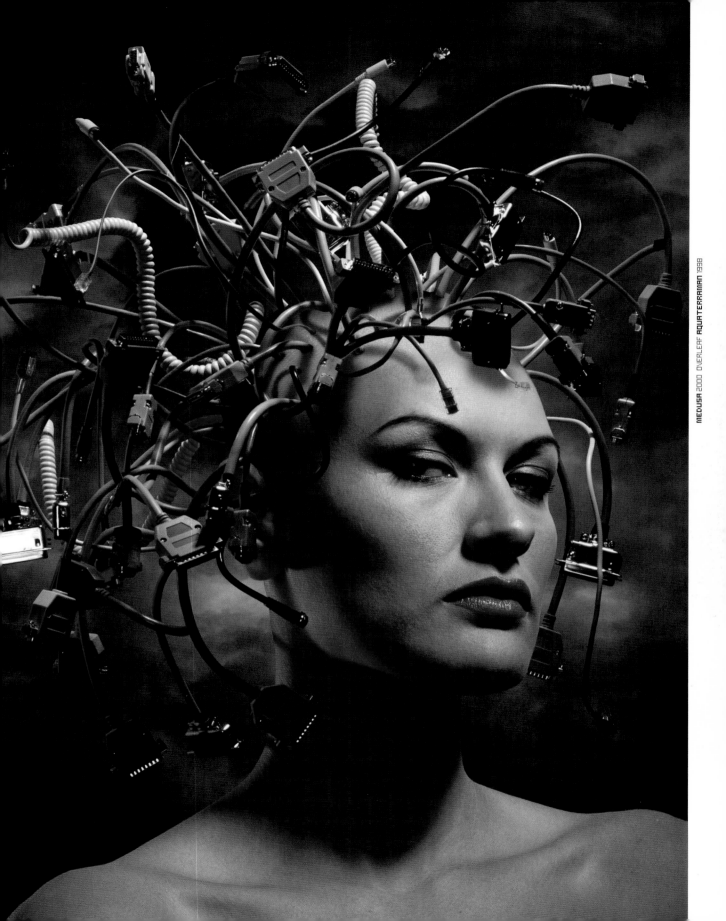

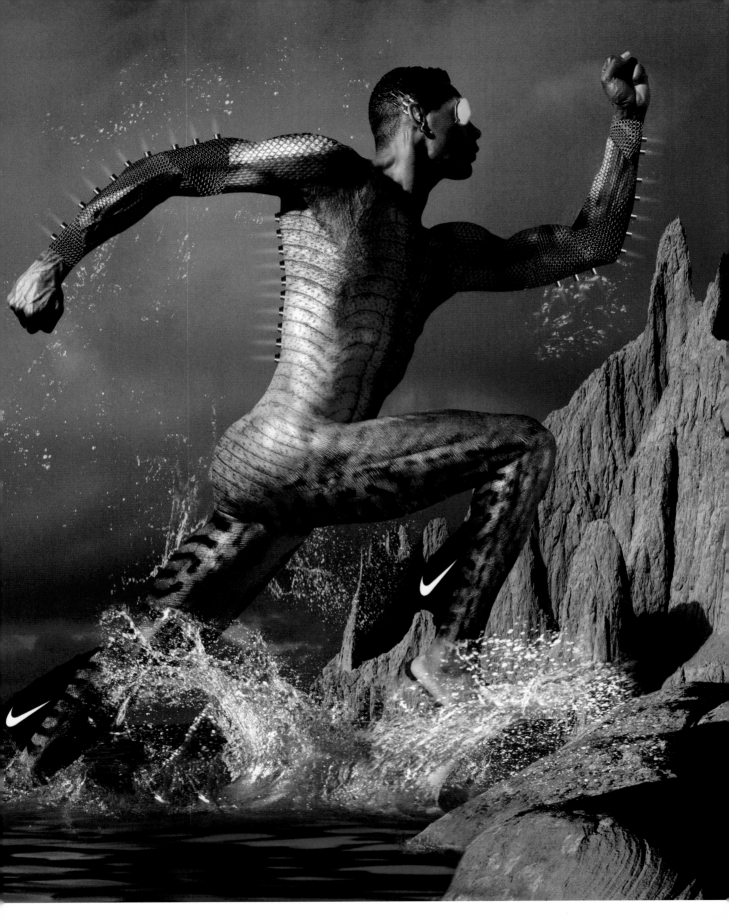

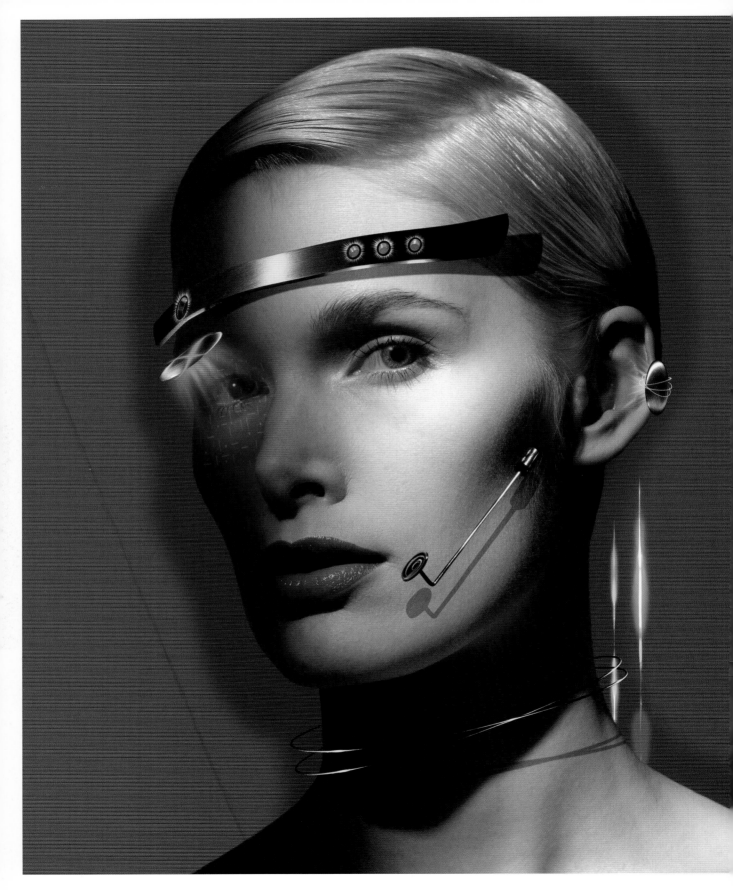

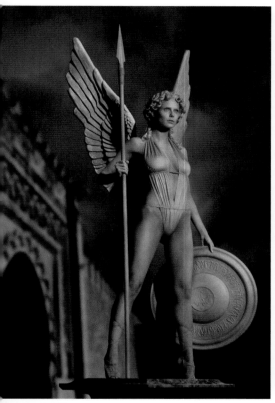

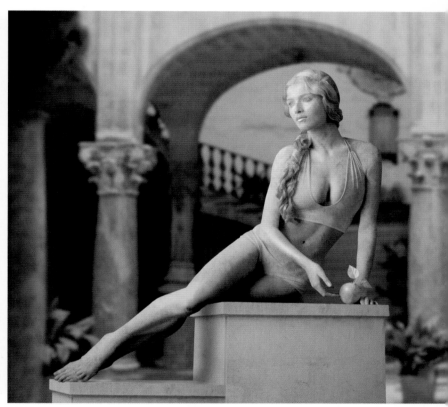

ATHENA 2001

APHRODITE 2001

These images offer a heady cocktail of image combustion and fusion. In a style reminiscent of the camp excesses of David LaChapelle, Samoamax proves himself a proficient pixel pusher in these fabulously artificial portraits. The decadent characters are captured in a hybrid alternative universe, the manipulation of each shot expanding on reality. Making little use of clothing, Samoamax's sitters are presented with chameleon-like bodies. When they are "dressed" it is more with the embellishment of body-paint, dramatically applied as a second skin, rather than with conventional clothes. Light is carefully mapped on to these faces to intensify their exhibitionist attitudes, in the manner of Helmut Newton's sexually liberated camera. There is a dark undercurrent of eroticism to much of Samoamax's soft-core iconography. The close cropping and framing of each subject is not incidental but censors the viewer's access to the rest of the scene. It also adds importance to the models' eyes, which often look out in an attitude of passionate seduction.

SAMOAMAX

DUTCH

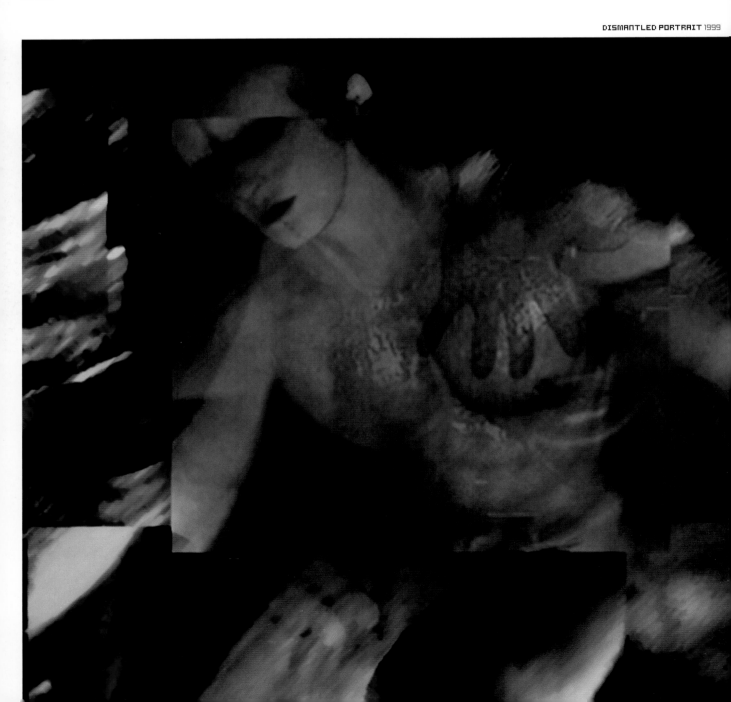

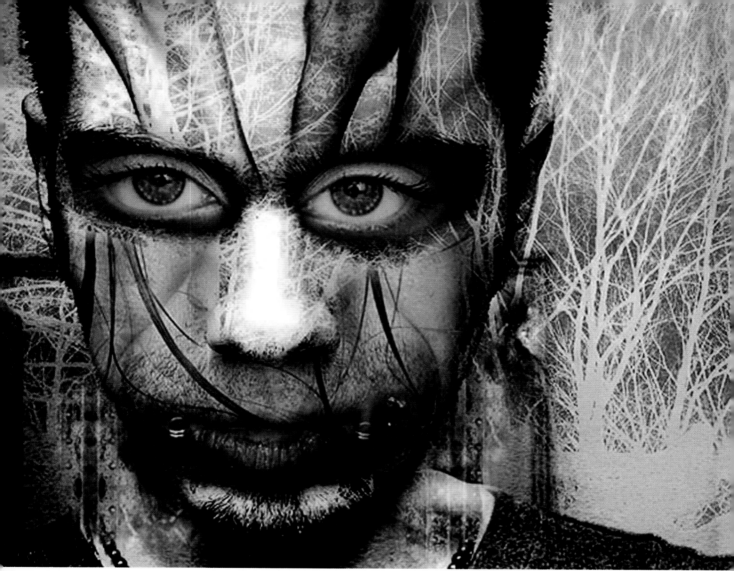

WINTER PALACE 2000

Although I was born in Italy, and now live in Spain, I am a Dutch citizen and grew up around Europe, attending the Ecole Nationale Supérieure des Beaux-Arts and the Ecole des Arts Décoratives in Paris and the Rietveld Modern Art Academy in Amsterdam.

I regard myself totally as a digital artist. For me it is all about my interaction with my computer. My computer becomes my brush. Pixels are my paint. I think anyone contemplating making a career in photography must first learn the basic elements of drawing. Photography is an extension of a person's eye and hand, and it is essential that a photographer has the same sort of creative control on pictures that an artist does on paper or canvas.

My photographs create a world of surrealism, and I combine progressive digital techniques with an intense knowledge of traditional photography. My photographs deal with contradictions. I use my images to record things by reconsidering stereotyped values and balances of light and colour, depth and surface.

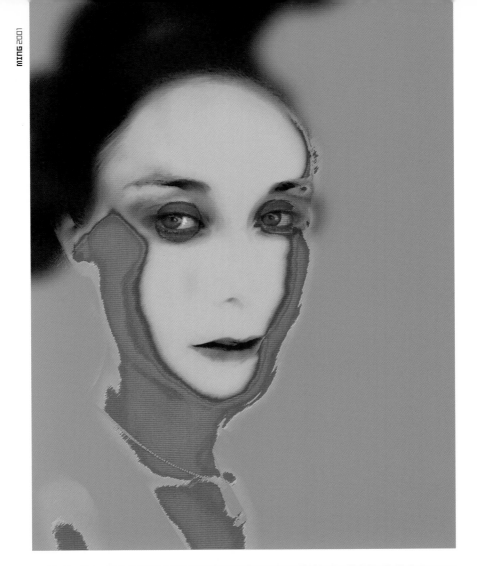

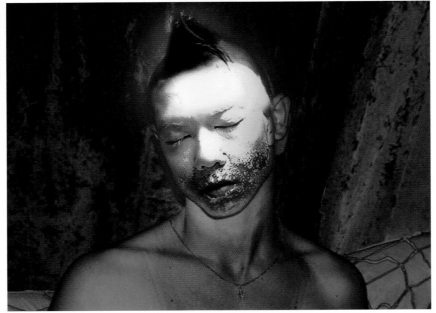

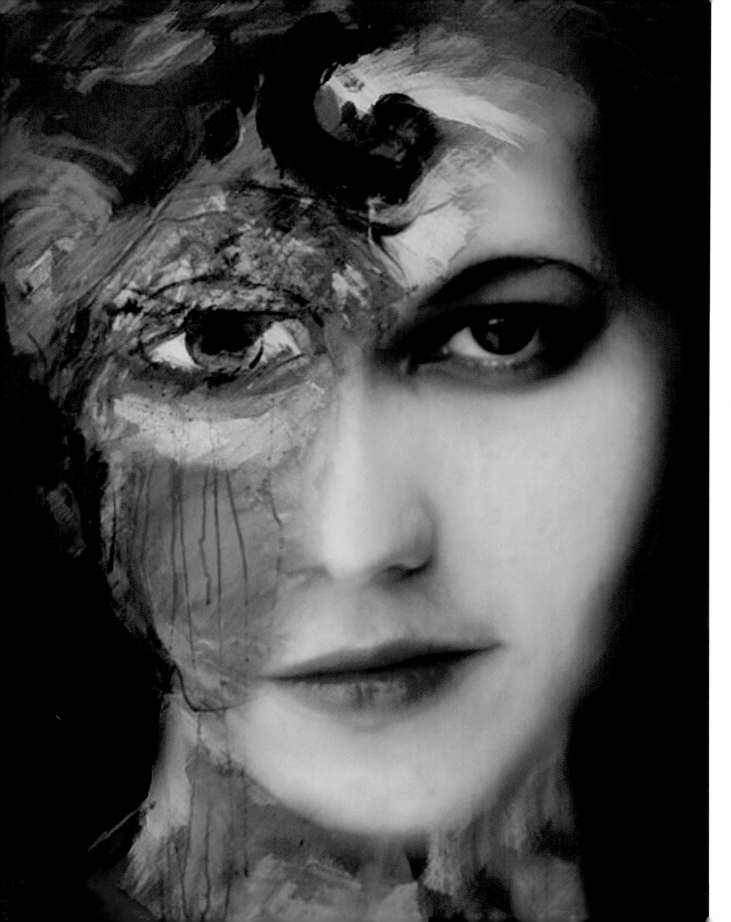

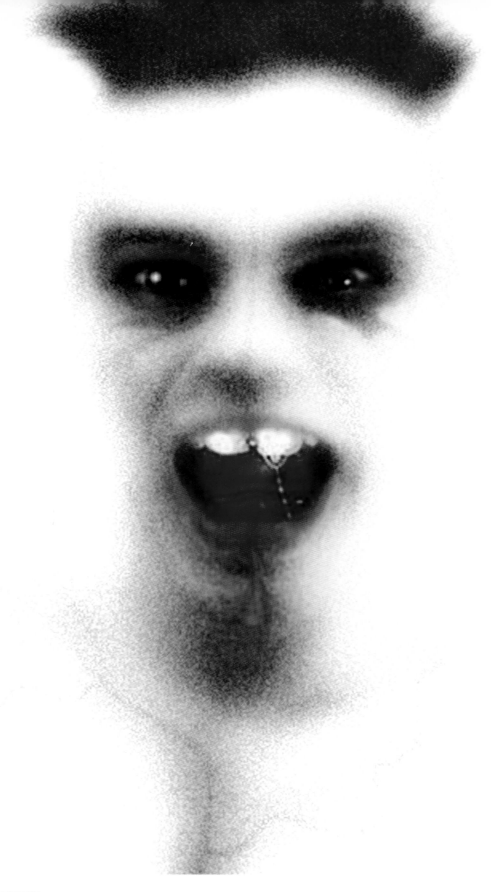

CRY BABY CRY 2000

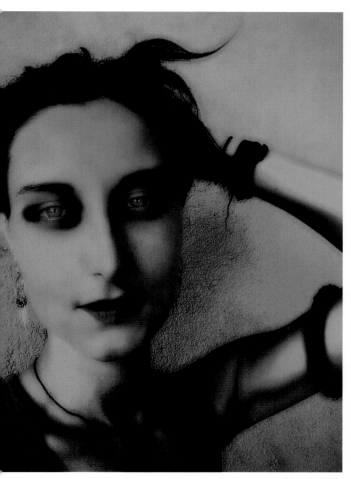

SAMURAI 2000

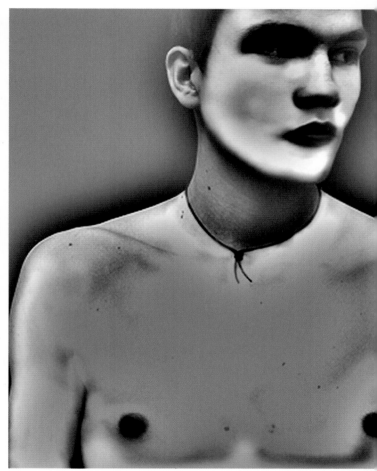

LA GARBO 2003

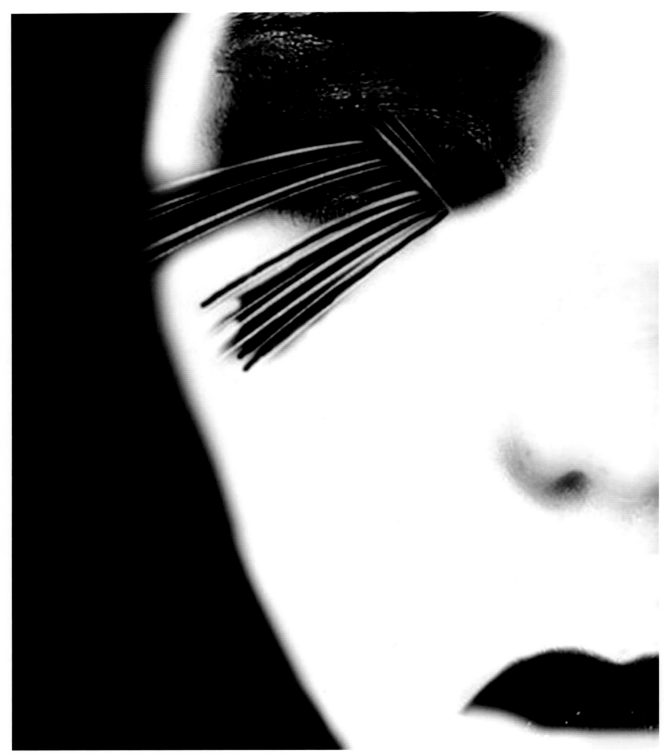

KABUKI 2004

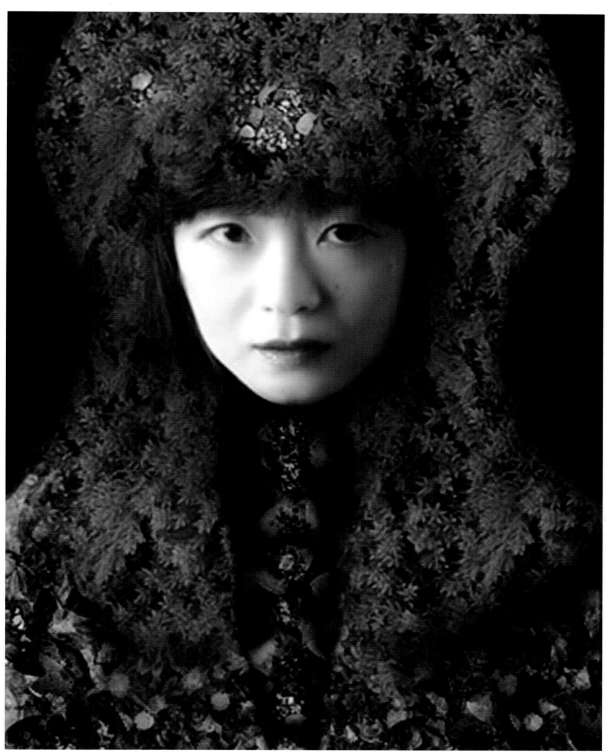

THE EMPRESS 2004

Shiv's intoxicating images have the visual immediacy of Yves Klein's "Anthropometries" body-painting prints with their startling and flamboyant expression of form over content. The definition of the female body is here reduced by Shiv's camera paintings to abstractions of graduated colour that illuminate the body with a digital tan. The body contours are registered like the thermographic vision of the alien scanning the unaware Arnold Schwarzenegger in John McTiernan's *Predator*. The images' resemblance to X-rays points towards a scientific digital dimension and detaches the viewer with its objectivity. Shiv deliberately reduces the body plane to just another surface to bounce and reflect light. Her stimulating employment of light echoes the solarization experiments that Man Ray carried out in the 1930s. Shiv's own digital intervention stimulates the viewer as she ingeniously manoeuvres her images into representations of the intangible. Reality is dematerialized and here transformed into a poetic digital dimension that tests the viewer's powers of perception.

SHIV

BRITISH

SELF PORTRAIT 2003

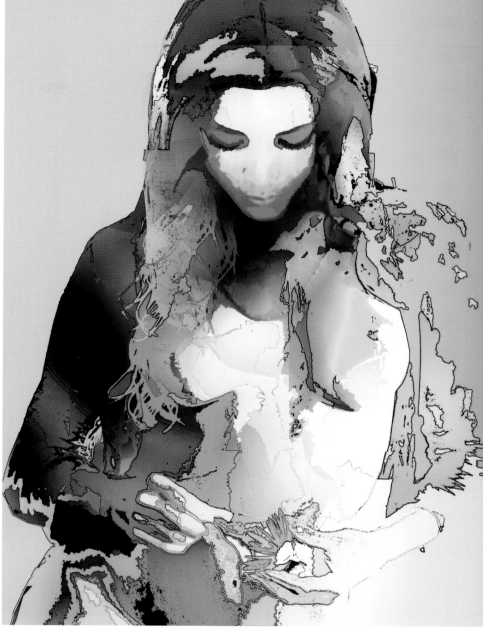

I was raised in Surrey, England, as a "not so good" Catholic girl; my real name is Siobhan and Shiv is a shortened version of this. After my foundation course I did a three-year degree in graphic design at Camberwell College of Art and Design, eventually settling into becoming more of an image-maker, mainly using collage. I never touched a computer: when type was required I used good old Letraset.

I spent six months in San Francisco working for the music magazine xlr8r, and it was here that I began to use the computer. On my return I worked for the magazine blah blah blah. I began to design albums and flyers for DJs and friends in bands; but I never really enjoyed the type side and spent most of the time creating the images, using collage and finally giving in to the power of Photoshop.

And that's how the illustration came about. I eventually stopped the graphics altogether and concentrated on the images. My experience in music and club-culture has influenced the way my work has evolved. I start with a photo of somewhere or someone that is real and then push it till it is almost abstract, deconstructing then reconstructing. That way I feel there is always a point of reference for the onlooker. This I think creates some feeling of nostalgia, but strangely, in some cases, a sense of something that is yet to come.

STELLA 2005

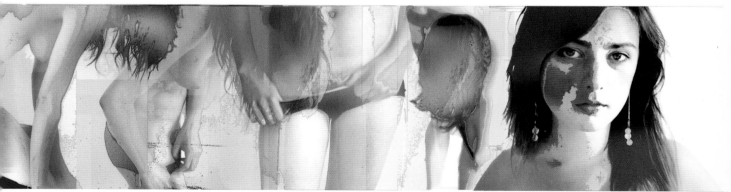

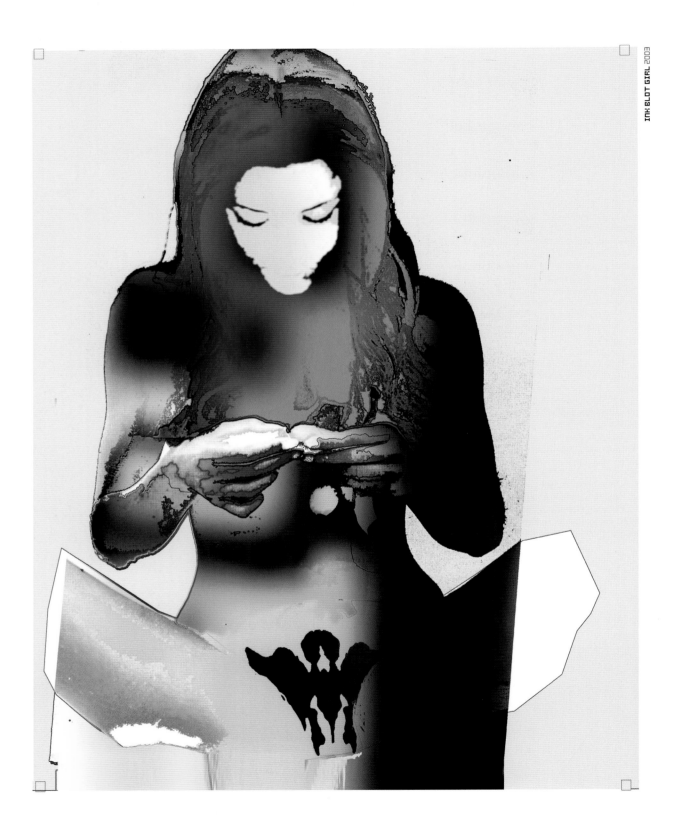

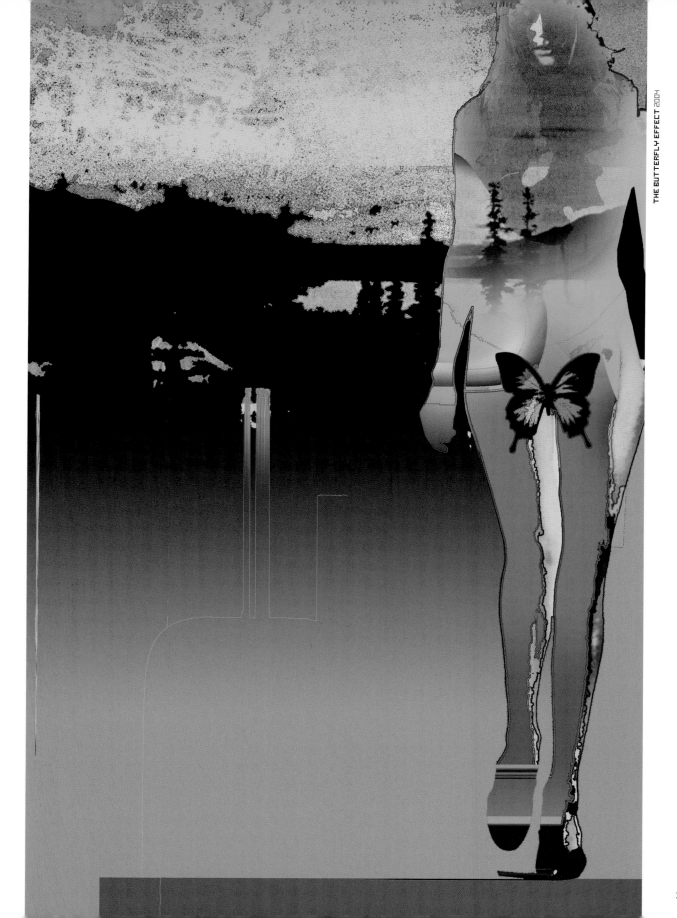

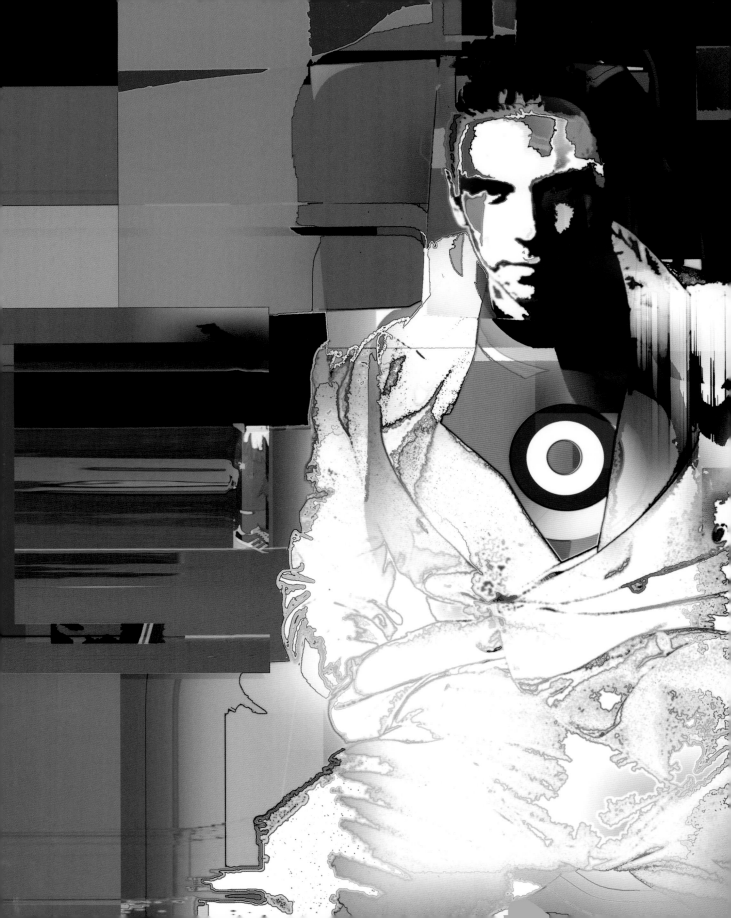

THE GOLDEN SECTION 2004

Surfacing like washed-up sirens, Marco Tenaglia's weathered temptresses emerge into a distressed digital landscape that is definitely more metaphorical than documentary. The highly charged atmosphere stems not only from the obscuring of textural detail but also from the provocative posturing of his models. In contrast to the innocent adolescent females portrayed by David Hamilton in his picture-book studies, these are *femmes fatales* compounded to gratify the appetite of the eye in these high-contrast grainy transformations. There is an eloquence and an eroticism to Marco's vamps that elevates them above the deliberate pornography that so often trespasses in current media and advertising. Here, Marco's enhanced photographic images offer a momentary allusion to the dream world of Czech photographer, Jan Saudek, whose fantasies conjure up the hand-tinted postcards of the 19th century. With careful staging and cinematic lighting, Marco also plays on the illusory nature of vision, and paints with a rough-textured lyricism that stirs new opinions and feelings.

MARCO TENAGLIA

ITALIAN

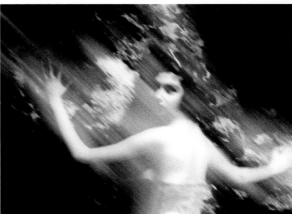

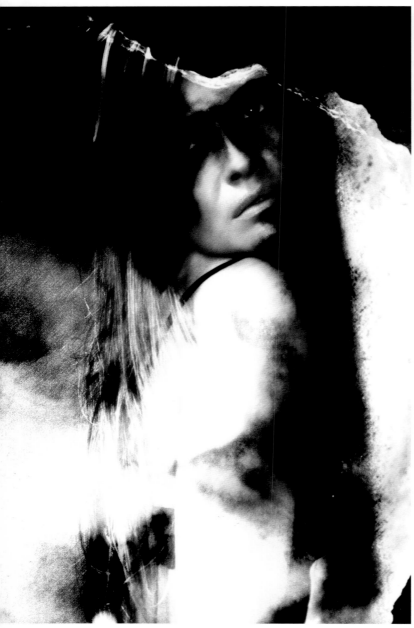

After graduating from the High Institute of Photography in Rome, I began my career as a professional in the fashion and modelling industries. Having worked in both Europe and the United States, I have been able to evaluate the differences between them. Using my artistic talents combined with my technical expertise, I try to combine European elegance with American style and ingenuity, to develop a new way of using photography to enhance the essence and beauty of both the designs and the models.

The photos shown here are from my series "Somniavi" and "Atmosfera". Both of these are based on the atmosphere of my dreams. The titles ("Somniavi" means "I dreamed" in Latin and "Atmosfera" means "atmosphere" in Italian) are not arbitrary. I consider myself a dreamer and all of my life I have dreamed. Everything I have, everything I do and everything I am, is the realization of my dreams.

"Somniavi" is dedicated to my wife. She was, and is, the dream of my life: she is the subject of the photos too. The photos from "Atmosfera" are manipulated to recreate the surreal dark atmosphere of my dreams.

VAPOR 2004

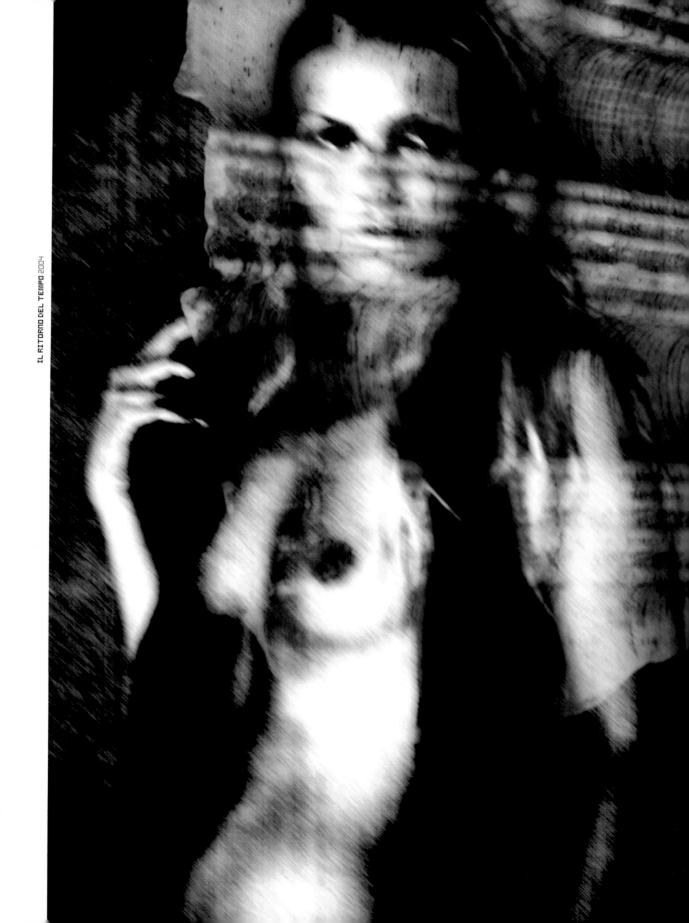

IL RITORNO DEL TEMPO 2004

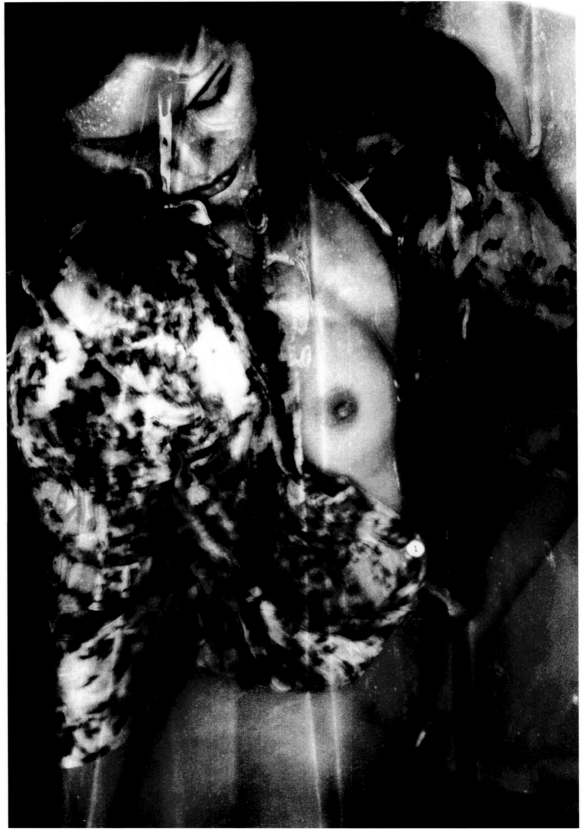

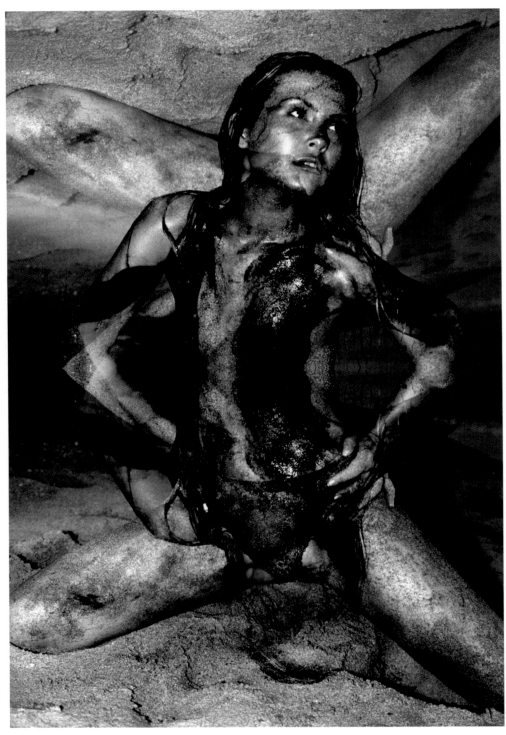

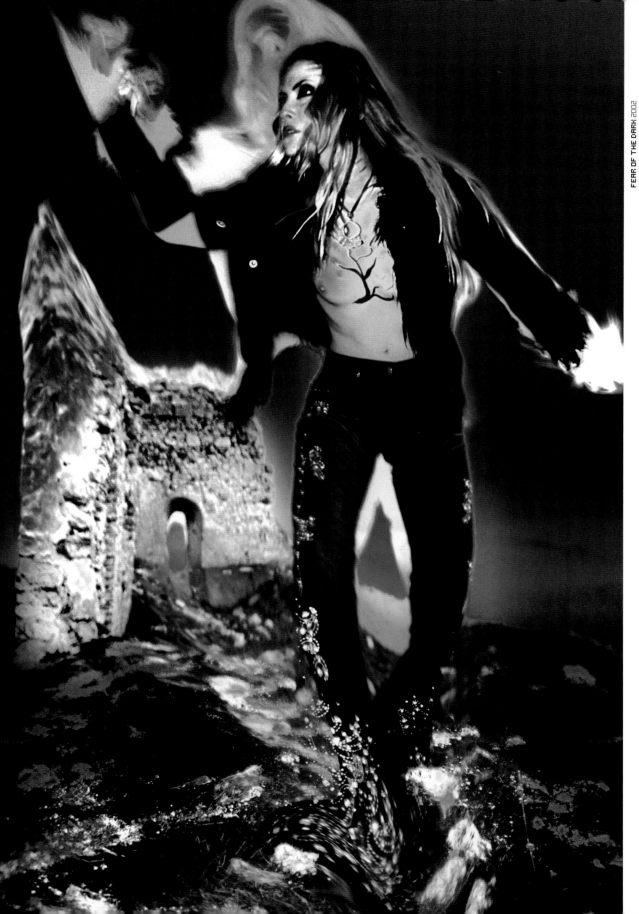

Comedy in art is often in scarce supply and, similarly, despite the obvious cartoon possibilities of digital manipulation, humour can be an elusive commodity in photo-enhancement. It is, perhaps, principally in the culture of cinema that comedy has been acknowledged as a suitable visual genre. Colin Thomas's abstractions stem from the same screwball stable as the photographic parodies of David LaChapelle and the lewd observations of Terry Richardson. Employing the visual gags of Benny Hill and Mr Bean, Colin carves his characters with artistic shamelessness and an obvious devilish delight. The viewer is instantly charmed by these kitsch representations. As the tabloids daily reiterate, there is always something mockingly comic about a person caught on camera with his mouth open: an observation that Colin takes full delight in. However, as most humorists will testify, comedy is also a serious business, a maxim that Elliot Erwitt always cited regarding his own wry photographic output.

COLIN THOMAS

BRITISH

PUNK 2000

I started out as a photographer at the age of seven when my father gave me a Box Brownie camera. After three years at art college, I made photography my career. Now I work for advertising agencies and design and publishing companies from my studio in West London, using high-end digital cameras and fast computers.

I was always interested in manipulating photographs in the way that an artist can work with a painting, and developments in digital photography have enabled this. I'm a self-taught expert in Photoshop, because I've used it virtually every day for ten years! I love the fact that, because of digital technology, the moment of clicking the shutter is now the start of making an image, rather than the end of it. We are no longer tied down by reality.

I still think of myself as a photographer, never an illustrator; I want my images to look as if they might be real … except … they can't be! If I'm working on an image for myself, my ideas come from all over the place. When I'm working for clients, my challenge is to make their idea become reality, and to add something of my own along the way.

Current society seems only to be receptive to the excessive in visual imagery and demands ever more to feed its craving. Kate Turning's output is nourishment of the highest order. The resemblance to the theatrically-staged artifice of Pierre et Gilles is unmistakable in her tantalizing vignettes. These images merge the frivolity of Jean-Honoré Fragonard's colourful Rococo canvases with the wild exuberance of today's Mardi Gras. She orchestrates her photographs like an opera composer – not in the heavy Teutonic language of Wagner, but in frothy Rossini bon-bons, bursting with detailed embellishment. In the manner of a seasoned theatrical impresario, Kate parades her meticulously arranged scenarios like the ringmaster of the Cirque du Soleil, exhibiting more and more enticing pixel performers for the audience's amusement. Through a labyrinth of tricks and effects, she skilfully expands her models into decorative forms as much as individual personalities. These charismatic medleys demonstrate that enhanced photography can also be performance art.

KATE TURNING

AMERICAN

VIOLETTE DAZZLE 2003

When I make a photograph, I try to expose the heroic nature of my subject by celebrating the sublime over the ordinary. I want the viewer to have an emotional response, so I pay great attention to the internal integrity and details of the image. The viewer can only surrender disbelief in order to experience the palette of my photo if I create a world with its own atmosphere and sense of place.

I am in love with the bending of light and the crafting of colour. The computer is my dark-room. Light is the crowbar to force open the viewer's door, and colour is the bait that captures the eye and makes a created environment real and accessible. For me, dramatic lighting and a strong sense of colour have a deep emotional impact and they figure heavily in my work.

The time I have spent working in Japan, Hong Kong and, especially, India, has influenced my way of seeing and being. I also take inspiration from the use of light and the other-worldly feel of Baroque and Pre-Raphaelite painting, as well as the naivety and colour of Indian graphics.

I currently live below the Hollywood sign and find myself spending most of my working life split between New York and Los Angeles.

PEAR ILLUSION 2004

PEACH SHIMMER 2004

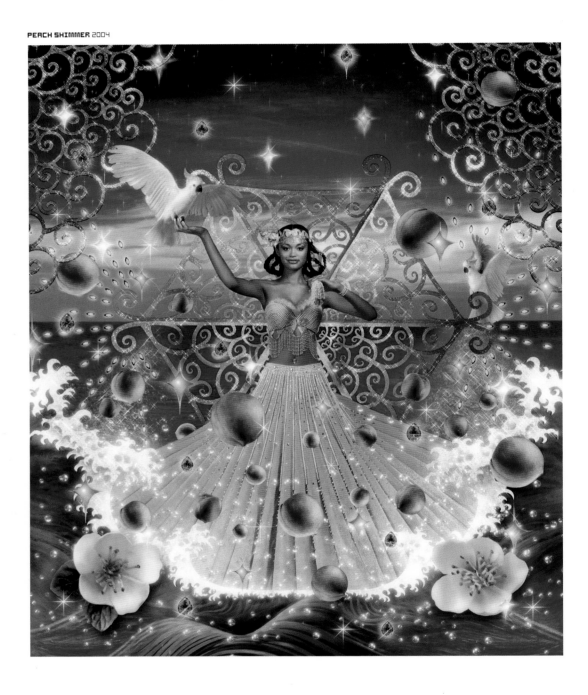

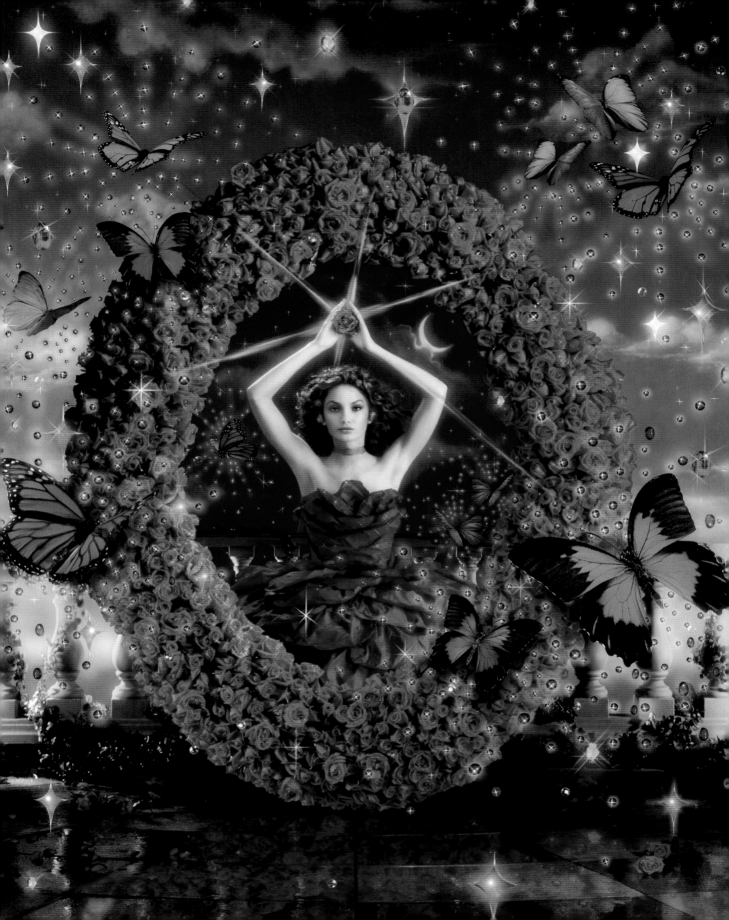

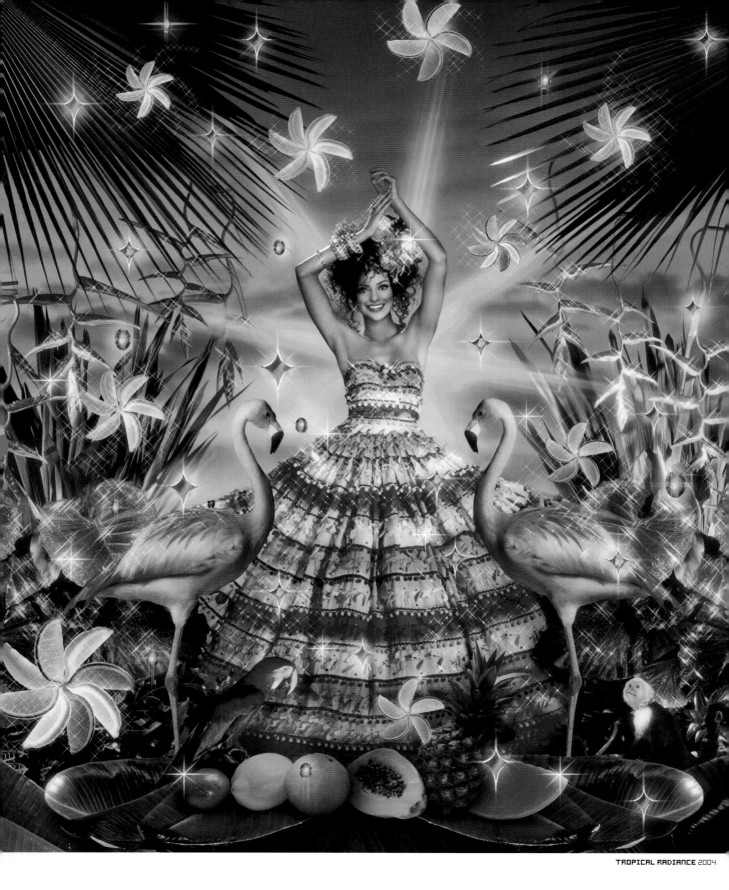

TROPICAL RADIANCE 2004

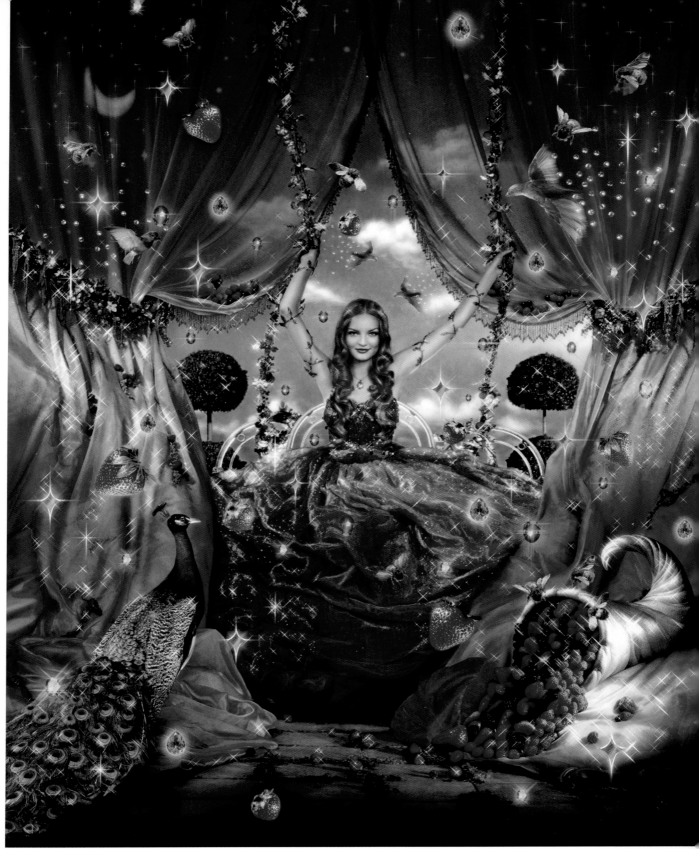

BERRY SPARKLE 2004

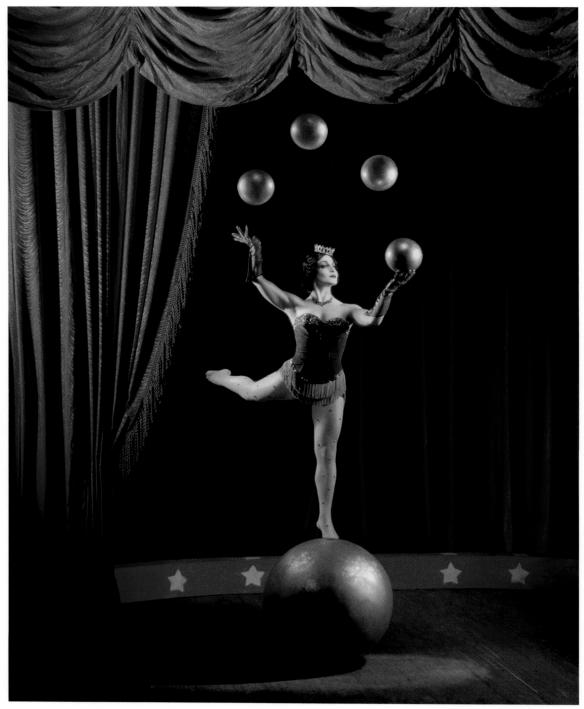

BALLS IN THE AIR 2002

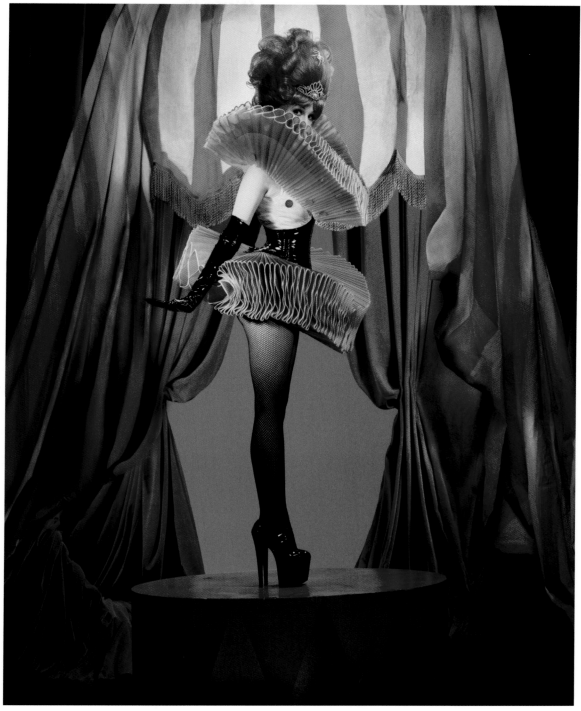

BALLERINA 1999

With today's incessant media bombardment, modern sensitivities have become numb to the representational photograph and viewers have lost their original sense of curiosity. Increasingly, editorial and advertising photographers have to embroider on the original image to attract any media pull or attention. Employing flamboyant 18th-century Rococo gestures, the team at Vault49 decorate their captured images with wild tracery that mimics the giddy linear mélange of Julie Verhoeven's fashion sketches and bears a resemblance to annotated fotograffiti. Their confections are on the cusp between styled photography and graphic illustration. These images make the viewer question the values of the accepted photographed fashion image, stimulating the senses with their juxtaposition of the real and the drawn. The striking ornamentations grow in wild profusion, sinuous and convoluted contours that never distract from the figure, but enhance and frame the subject, recalling the elegant fine lines of an Aubrey Beardsley drawing.

VAULT49

BRITISH

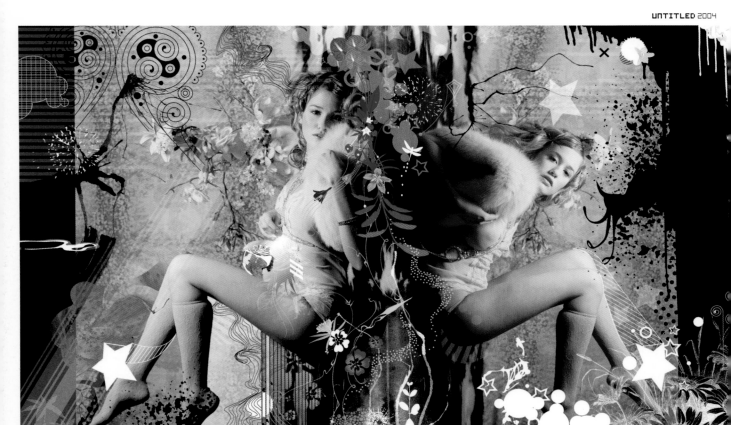

Vault49 is comprised of myself (John Glasgow) and Jonathan Kenyon. Working together between New York and London, we have collaborated with the photographer Stephan Langmanis in an exciting dynamic created by time difference, energetic telephone conversations and emails, and a shared vision of what our work represents to each other.

We came across Stephan's work in London in 2003, and it became quite clear when we met in person that, for all of us, our personal drive and the joy we find in our work take priority over all other considerations.

The danger of giving more and more of these statements and interviews is that we might start to believe our own bullshit. Instead of trying to think of interesting references, we hope the work speaks for itself. The truth is that, as our work together has evolved, we often don't recognize our influences, and it takes someone else to point them out. We just soak up all that is around us and it feeds into our work and design.

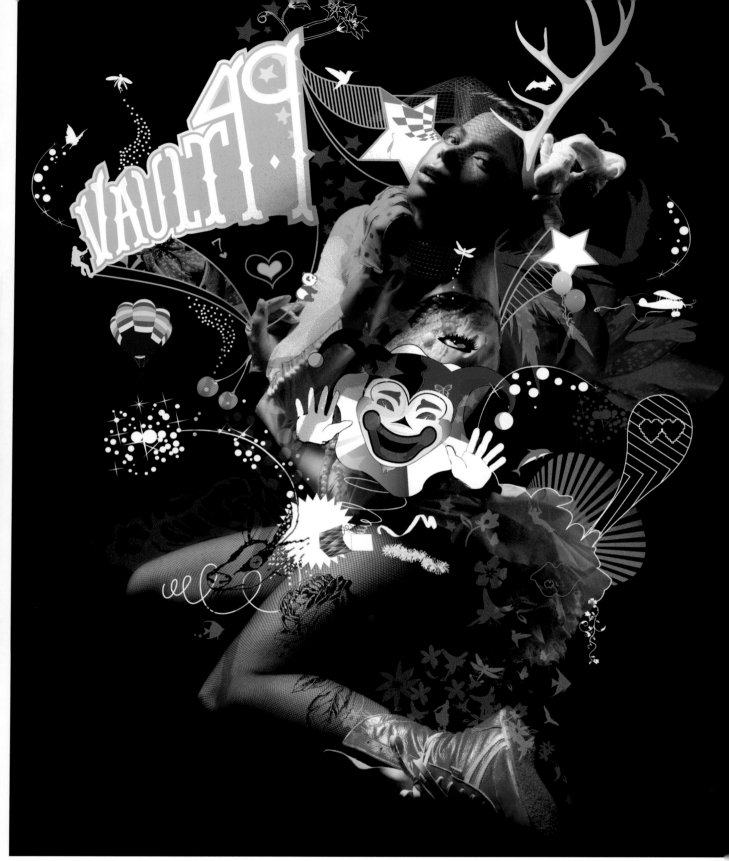

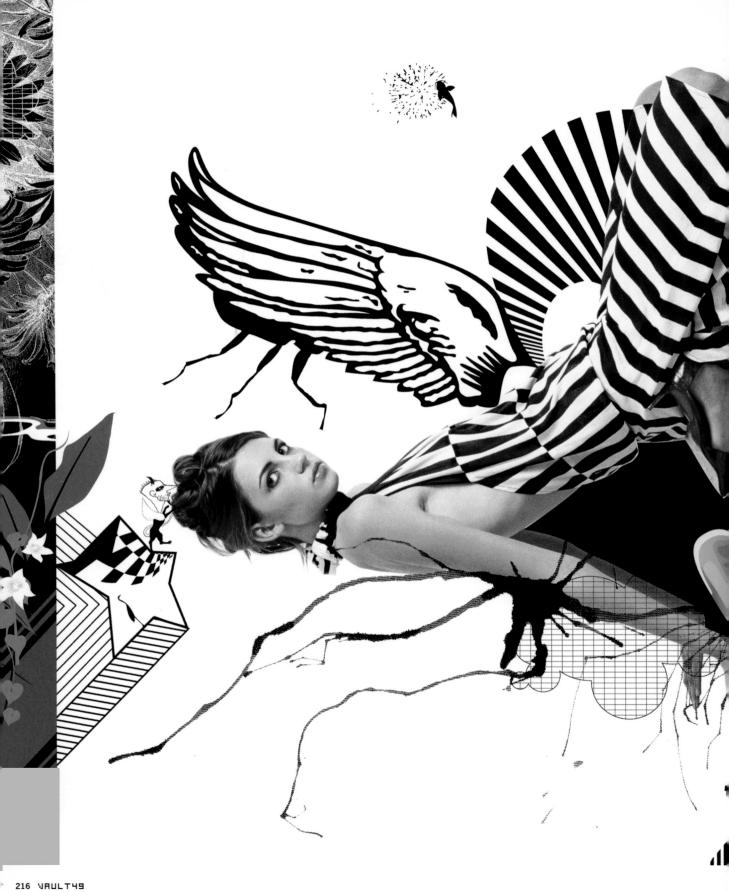

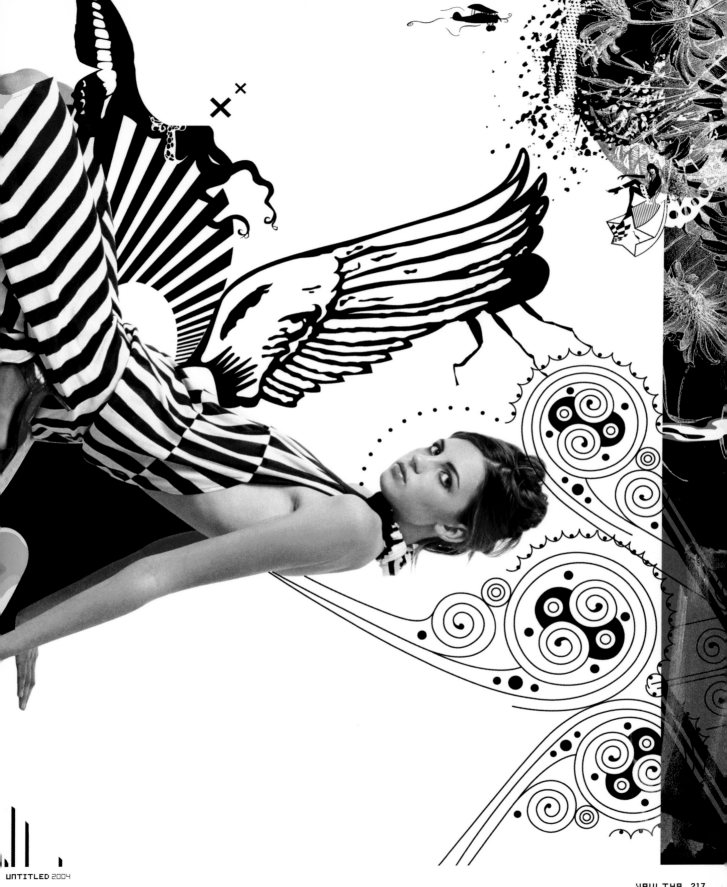

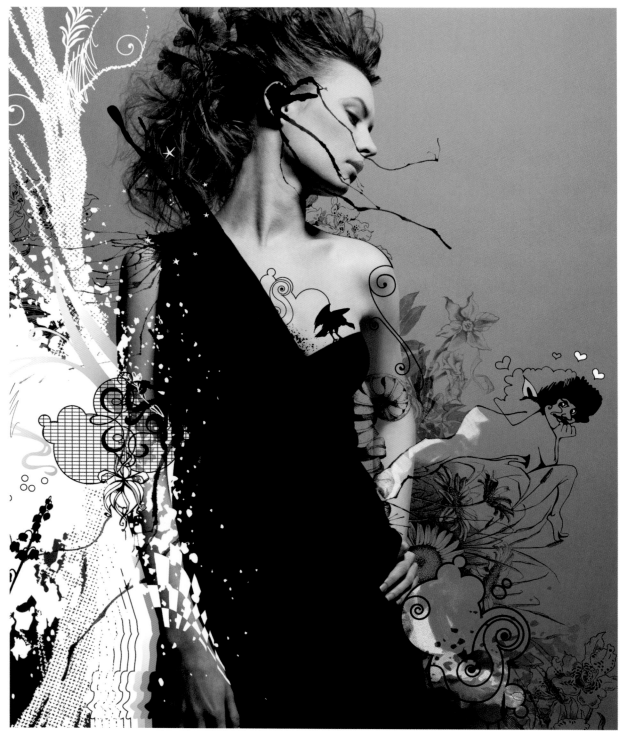

ELSA 2004

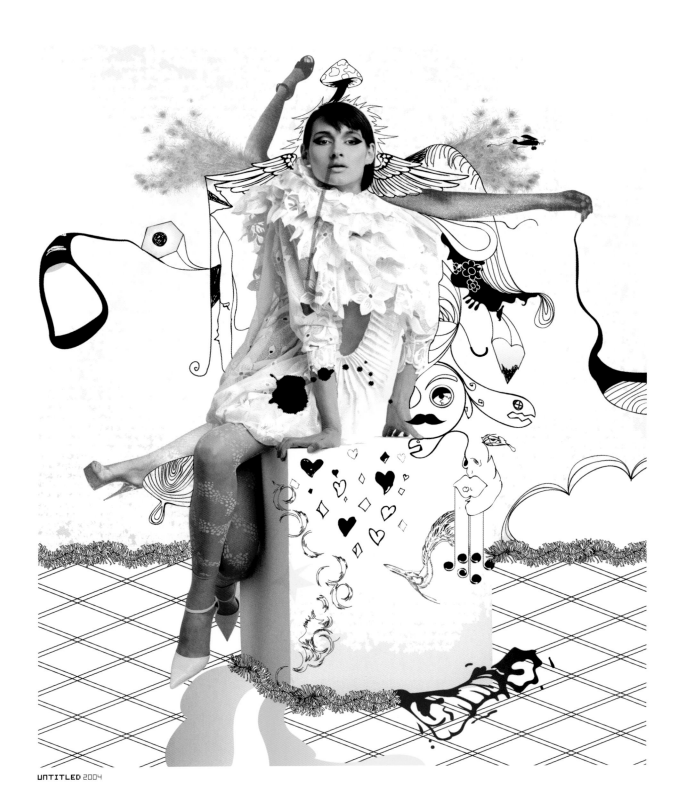

UNTITLED 2004

CONTACTS

ALEKSEY & MARINA
www.alekseymarina.com

CORRIE ANCONE
5 Pearl Street
Newtown
NSW 2042
Australia
Tel: +61 (0)41 202 6119
Email: corrieancone@optushome.com.au
Website: www.corrieancone.com

MARCELO BENFIELD
11 Rosary Gardens
London SW7 4NN
UK
Tel: +44 (0)20 7373 7818
Email: marcelo@marcelobenfield.com
Website: www.marcelobenfield.com

STEVEN BINGHAM
HC4 Box 4C
Payson
AZ 85541
USA
Tel: +1 928 474 1849
Email: Steve@KRIM-FM.com
Website: www.dustylens.com

BARBARA COLE
Email: barb@barbaracole.com
Website: www.barbaracole.com

JASON JAROSLAV COOK
Tel: +44 (0)7958 243365
Email: jc@jasoncook.co.uk
Website: www.jasoncook.co.uk

[DNASAB]
Tel: +1 917 721 4437
Email: dnasab@sintelligence.net
Websites: www.tc43.com
www.surrealistfashion.net

ANDREY EFIMOV
Pobeda 94–88
Ekaterinburg
Russia 620042
Tel: +7 343 331 1323
Email: aefimov@r66.ru

ERYK
15 Simmons Street
South Yarra
Victoria 3141
Australia
Tel: +61 3 9827 5397
Email: info@eryk.com.au
Website: www.eryk.com.au

PAUL F.R. HAMILTON
33a Saint Germain's Road
London SE23 1RY
UK
Tel: +44 (0)7761 832166
Email: me@pfrh.com
Website: www.pfrh.com

TIM HANSEN
Katarinasgränd 2b
Pl 595 33 Mjölby
Sweden
Tel: +46 (0)739 753960
Email: tim.digitalartist@gmail.com
Website: himtim.deviantart.com/gallery

ANDREW HART
Email: hartfoto@aol.com
Website: www.andrewhartphotographer.com

SARAH HOWELL
107 Upper Brockley Rd
Brockley
London SE4 1TF
UK
Tel: +44 (0)7947 873244
Email: sarahs.home@virgin.net
Websites: www.sarahhowell.com
www.debutart.com

FRANCESCO D'ISA
Via del Gelsomino 111
50125 Florence
Italy
Tel: +39 055 232 1312
Email: francesco.disa@gmail.com
Website: www.gizart.com

SEBASTIEN JARNOT
Email: contact@sebjarnot.com
Website: www.sebjarnot.com

MONET KITTRELL
Tel: +1 615 833 5921
Email: monet@mkorp.com
Website: www.mkorp.com

JO LANCE
244th Avenue, 2nd floor, #J248
New York
NY 10018
USA
Email: jolancephoto@hotmail.com
Website: www.jolancephoto.com

CATHERINE MCINTYRE
Berrydene Cottage
2 West Hill Road
Northmuir
Kirriemuir
Angus DD8 4PR
Scotland
Tel: +44 (0)1575 574465
Email: cmci@madasafish.com
Website: members.madasafish.com/~cmci

CHRISTOS MAGGANAS
c/o PVUK.com Limited (Agency)
17a Swan Hill
Shrewsbury SY1 1NL
UK
Tel: +44 (0)1743 350 355
Emails: christos@ukonline.co.uk
create@pvuk.com
Website: www.pvuk.com

ME COMPANY
14 Apollo Studios
Charlton Kings Road
London NW5 2SA
UK
Tel: +44 (0)20 7482 4262
Email: Info@mecompany.com
Website: www.mecompany.com

J. PAULL MELEGARI
c/o PVUK.com Limited (Agency)
17a Swan Hill
Shrewsbury SY1 1NL
UK
Tel: +44 (0)1743 350355
Email: create@pvuk.com
Website: www.pvuk.com

BRADFORD NOBLE
330 Haven Avenue, #6H
New York
NY 10033
USA
Tel: +1 212 543 0111
Email: bradford@noblephoto.com
Website: www.noblephoto.com

NUMU
London
Tel: +44 (0)8703 213334
Email: numu@numudigital.com
Website: www.numudigital.com

JAMES PORTO
601 West 26th Street, #1321
New York
NY 10001
USA
Tel: +1 212 966 4407
Email: info@jamesporto.com
Website: www.jamesporto.com

SAMOAMAX
Calle Tarragona 17
Edificio Los Angeles
Bloque 1, 3r, 2na
Salou
Spain
Tel: +34 686 466 543
Email: samoamax@samoamax.com
Website: www.samoamax.com

SHIV
Tel: +44 (0)20 7702 9365
Email: greg@bigactive.co.uk
Website: www.bigactive.com

MARCO TENAGLIA
Via dei Licnei 52
00147 Rome
Italy
Tel: +39 065 122 499
Email: marco@marcotenaglia.com
Websites: www.marcotenaglia.com
www.somniavi.com

COLIN THOMAS
6 Burlington Lodge Studios
Rigault Road
London SW6 4JJ
UK
Tel: +44 (0)20 7736 0060
Email: pixels@colinthomas.com
Website: www.colinthomas.com

KATE TURNING
4929 Los Feliz Blvd
Los Angeles
CA 90027
USA
Tel : +1 323 664 4751
Email: turningpix@earthlink.net
Website: turningpix.com

VAULT49
161 Ludlow Street, Studio 5
New York
NY 10002
USA
Tel: +1 212 254 0120
Email: info@vault49.com
Website: www.vault49.com

INDEX

Page numbers in **bold** refer to main entries

ACKNOWLEDGMENTS

Mitchell Beazley would like to thank all the artists, credited alongside their work, who have provided images for publication in this book. Additional credits are given below.

ALEKSEY & MARINA
All photographs – Fashion designer, stylist, make up artist, designer: Marina Khlebnikova. Photographer: Aleksey Kozlov

MARCELO BENFIELD
Page 26 *Surreal Mosque* Model: Elise Shoemaker at Click, Stylist: Angela Papadopoulos, Make-up: Natasha Severino at Randal Walker, Hair: Flavio Nunes at Randal Walker, Photographer's Assistant: Fernanda Fernandez, Shot at Studio Daguerre, Paris; page 27 *Glossy Lips* Make-up: Monique Lagnerious, Photographer's Assistant: Fernanda Fernandez, London; pages 28–9 *Creations* (for Paris Haute Couture) Model: Erika S. at Click, Stylist: Laila Hamdaoui, Make-up/hair: Nathalie Beaume, Photographer's Assistant: Fernanda Fernandez, shot at Studio Daguerre, Paris; pages 30–1 (for Paris Haute Couture) *Infrared* Model: Elena Kuletskaia at IMG, Stylist: Marina Olivati, Make-up/hair: Nathalie Beaume, Photographer's Assistant: Fernanda Fernandez, shot at Studio Daguerre, Paris; page 32 *Contact!*, Model: Daniella at Premier, Stylist: Laila Hamdaoui, Make-up/hair: Carl, Photographer's Assistant: Fernanda Fernandez, London; page 33 *Lips with Ice Cube*, Model: Daniella at Premier, Stylist: Laila Hamdaoui, Make-up: Monique Lagnerious, Photographer's Assistant: Fernanda Fernandez, London

STEVEN BINGHAM
Page 34 *Goddess* Model: Jill Valdisar; page 35 *Vulture Mine Revisited* Model: Jen Forsberg; page 35 *Lady in Blue* Model: Jen Forsberg; pages 36–7 *Aspen Grove* Model: Jill Valdisar; page 38 *Rebirth of Sarah McGee* Model: Jen Forsberg; page 39 *Dust to Dust* Model: Jill Valdisar

BARBARA COLE
Page 40 *Body Language* and page 41 *Dry Cleaning* from the exhibition "Underworld"; pages 42–3 *Legs* for *High Rise Magazine*; page 44 *Unrepentant*, page 46 *Stone Ledge* and page 47 *Indecision* from the "Painted Ladies" collection; page 44 *Mirror Mirror* for *Wedding Bells Magazine*; page 45 *Body Betrayed* from the exhibition "Survivors, In Search of a Voice"

JASON JAROSLAV COOK
Page 48 *Fern*, page 48 *Susie*; page 49 *Romantik*; page 50 *Lily*; page 51 *Kat*; page 55 *Tree* all Photography by Katja Mayer +44 (0)7792 215493 www.katjamayer.com/; page 52 *Sarah* Photography and manipulation by Jason Cook. This image appears on the royalty-free CD-rom by Digital Vision entitled Elements of State by Jaroslav (Jason Cook) www.digitalvisiononline.com; page 53 *Untitled* and page 54 *Untitled* Images were originally used by *Computer Arts* magazine by Future Publishing. Original photography was supplied by Future Publishing and commissioned by Gillian Carson.

[dNASAb]
All photographs styled by Desiree Konian www.desirestyle.com

ANDREW HART
Page 90 *Tree*; page 91 *Lake Lady*; pages 94–5 *Bats* Illustrations by Monica Hellstrom

ERYK
Page 68 *Swim pool*, Samsung, South Korea; page 69 *Sinetta* E Production, Australia; page 70–1 *Nokia*, Bates, Singapore; page 72 *Croce Colosimo Couture 1* E Production, Australia; page 72 *Croce Colosimo Couture 2* E Production, Australia; page 73 *Muzzle Depasqule*, Australia; page 74 *Pleasure* Mc Cann-Erickson, Singapore; page 75 *Vanity* Mc Cann-Erickson, Singapore

SARAH HOWELL
Pages 2–3 *Colour Me* Photographer: Chris Lane @ Justice www.cjustice.com; page 99 *Vingt Ans* Photographer: Chris Lane @ Justice, Make-up: Katrina Raftery @ Justice, Hair: James Rowe @ Holy Cow www.holycownet.com; pages 102–3 *Acid Green* CGI artist: Ben Taylor @ Um in association with Actis Studio www.um-cgi.com

FRANCESCO D'ISA
Page 104 *Double Labyrinth* Model: Katrina (photo by Geoffrey O'Donnell); page 105 *Floor* Models: Lauren Bourke (face), Amy (body), background

statue by Javier Marin, images from "Resurgere" stock; page 106 *Living Decoration* Model: Pia Kemi; page 107 *How Flowers Are* Model: Ophelia (large figure), Kiva (small figure), images from "Resurgere" stock; page 108 *Unfinished But Ended* Model: Vanessa Long, images from "Resurgere" stock; page 109 *Living Fossil* Model: Miriam Freudenberg; page 110 *Rational Pray* Models: Vanessa Long (top figure), Scarlet (Nadine Lange) (bottom figure), images from "Resurgere" stock; page 111 *Virginal Motherhood* Models: Paula Kaiser (face), Alexic (body), Cindy Frey (body)

SEBASTIEN JARNOT
All photographs – Nike Print Campaign, Apparels Spring/Summer 2002 (Black), Fall/Winter (White), Agency: Wieden & Kennedy (NL/Amsterdam), CD: Paul Shearer/Glenn Cole, AD: Merete Busk, SA: Janine Byrne, PJM/PDM: Nicola Applegate, AE: Kay Hoffman (Black Series)/Gemma Requesens (White Series), AB: Tracy Kelly, Photos: Juan Algarin (Black Series)/Alan Clarke (White Series), Illustrations: Seb Jarnot, Color Tag Creative: Frazer Goodbody, Country: International

JO LANCE
Page 124 *Virgo* (www.intraxis.com); page 125 *Peacock* Model: Sterlina/Click; pages 126–9 all images courtesy of Digital Vision (www.digitalvisiononline.co.uk)

CATHERINE MCINTYRE
Page 130 *Japanese Winter* Many thanks to NASA and the NSSDC for satellite imagery

BRADFORD NOBLE
Pages 160, 162–5: Make-up and Hair, Concept, Styling, and Art Direction: Dale Johnson; page 160 *Alien Girl* Special Effects Make-up: Derrick Becker; page 161 *Boy George* Make-up: Christine Bateman; page 164 *Target Girl* Styling: Gino Tavernaro; page 165 *Wallpaper Girl* Styling: Gino Taverna

JAMES PORTO
Page 174 *Breakout*; page 174 *Ripthrough*; pages 176–7 *Aquaterraman*; page 178 *Techbabe 2070* All model-making and styling: Scott Siken; page 179 *Athena* Courtesy *Sports Illustrated* Swimsuit Magazine 2001, Body Art: Joanne Gair; page 179 *Aphrodite* Courtesy *Sports Illustrated* Swimsuit Magazine 2001, Body Art: Joanne Gair

SAMOAMAX
Page 183 *Les Gitanes* Joint project with contemporary painter David Callau

SHIV
Pages 188–9 *Stella* Photographer: Clare Shiland

MARCO TENAGLIA
Pages 194 *Vapor*, page 195 *Il Ritorno del Tempo*, page 196 *Warmth of Cold*, page 198 *The X Factor*, page 199 *Fear of the Dark* Special thanks to my wife, Milena Georgieva, model at Blush Models Management www.blushmodels.com; pages 194 *Evanescence* and 197 *Gemini*: Special thanks to Maria Elpini, model at Blush Models Management; pages 198 and 199: Special thanks to Simona Fabi, make-up artist at www.simonafabi.it

VAULT49
Page 214 *Untitled* Photographer: Katja Mayer, Stylist: Morven Kerr, Make-up and Hair: Tomo Matsuura, Model: Florence at TakeTwo; page 215, pages 216–7, page 218, page 219 Photography: Stephan Langmanis Stylist: Ricci Stoene

Thanks to Rex Bruce, Director of the Los Angeles Center for Digital Art (www.lacda.com) and to Steve Danzig, Artist/Director, International Digital Art (www.internationaldigitalart.com)